JOHN HEDGECOE'S
PRACTICAL
LANDSCAPE
PHOTOGRAPHY

KT-171-767

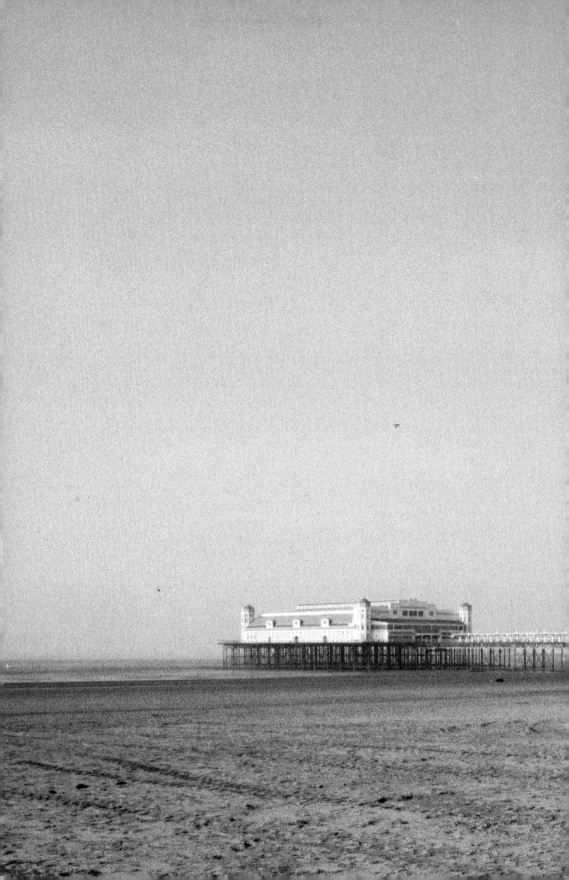

JOHN HEDGECOE'S
PRACTICAL
LANDSCAPE
PHOTOGRAPHY

EBURY PRESS
LONDON

John Hedgecoe's
Practical Landscape Photography

Published by Ebury Press,
an imprint of Century Hutchinson Ltd
20 Vauxhall Bridge Road
London SW1V 2SA

First impression 1988
Second impression 1990
Text copyright © 1989
Collins & Brown Limited
and John Hedgecoe

Photographs © 1988 John Hedgecoe

All rights reserved. No part of this
publication may be reproduced, stored in
a retrieval system, or transmitted in any
form or by any means, electronic,
mechanical, photocopying, recording, or
otherwise, without the prior permission
of the copyright owner.

Collins & Brown Limited
Mercury House
195 Knightsbridge
London SW7 1RE

ISBN 0 85223 651 4

Filmset by Dorchester Typesetting Ltd,
Dorchester
Reproduction by Reprocolor Llovet S.A.,
Barcelona
Printed and bound in Spain by Cayfosa,
Barcelona

STOCKTON - BILLINGHAM

LEARNING CENTRE 7789

COLLEGE OF F.E.

CONTENTS

INTRODUCTION

Of all photographic themes, landscape is the oldest: the very first photograph, taken by Nicéphore Niepce on to a coated pewter plate, was the landscape seen from a window of the photographer's house. Niepce chose a landscape not for aesthetic, but for practical reasons: the coating on his photographic plate was so insensitive that to form an image he needed the combination of brilliant sunlight and a subject that would remain static throughout the course of a day-long exposure.

For a century and a half since this first landscape picture, the subject has continued to fascinate photographers. In technical terms landscape photographs are no more difficult to take than any other kind of picture, and perhaps simpler. No, the challenge of landscape lies in the immutable nature of the subject: the shape of the land yields only to nature, not to human hand.

In all other areas of photographic endeavour, the subject matter itself is in the photographer's control to a greater or lesser extent. The still life photographer, for example, chooses props that enhance or support the principal subject; the beauty photographer can use make-up to create a fantasy image of the sitter. By contrast, the landscape photographer enjoys no such advantages.

A direct consequence of this lack of control is that when there is a landscape in front of the lens, personal style and approach to the subject matter are especially important. To make a picture stand out from a row of similar images of the same subject, the photographer must choose a unique and personal way of seeing and representing the scene. This doesn't mean using a special filter, or a novel lens: the approach to the subject means much more than technical wizardry. For some people, it means taking up a principled stance about our rural heritage, and expressing this in

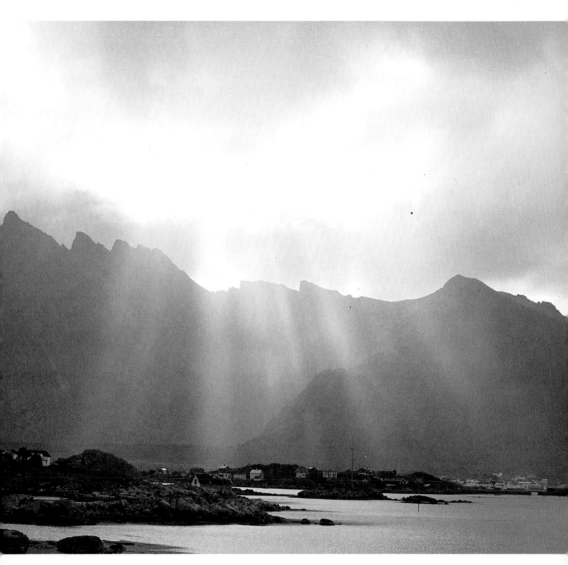

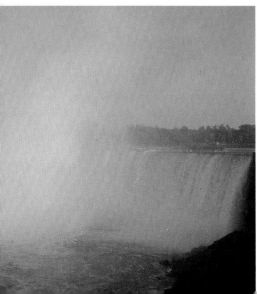

▲ Dramatic light
For this photograph,
which relies on the potent
combination of the
towering peaks and the
radiant light breaking
through the clouds, I
chose to put the
mountains into silhouette.
I achieved this quite
simply by adopting the
exposure suggested by the
camera's meter. In such
lighting conditions the
meter registers the strong
backlight only. If you
want to avoid a silhouette,
increase exposure by
at least one stop.

Olympus, 35mm,
Ektachrome 64, 1/125,
f/5.6.
**◄ The moving
landscape**
Landscape is by no means
all about static views.
Moving water is a prime
example of the ever-
changing aspect of the
natural scenery that
surrounds us. I was lucky
enough to be near the
waterfall soon after a
storm, when a rainbow
was in evidence, adding a
splash of muted colour.
Olympus, 28mm,
Ektachrome 64, 1/60, f/2.8.

landscape pictures. Another photographer's personal approach might be to use the landscape to make a statement about aesthetic issues, such as the ways in which we perceive spatial relationships, form, or colour.

Throughout the book, you'll see examples of many different approaches to landscape. However, it's in the later pages that photographic style is centre stage. Part 3, *Learning to See* introduces the many different ways of looking at the landscape, and portraying it on film. Part 4, *Composition*, provides the tools that you can use to express your own personal vision of the world. Part 5 explains the variables that make every view unique, and the final section of the book covers landscapes categories area by area, explaining the special demands that each makes on camera and photographer, and the style best suited to each terrain and locality. Throughout the book, I have explained how selection, technique and composition work in combination to create a powerful image which makes a definite statement. Each of the pictures carries a message: perhaps about the landscape in general: maybe about a specific place; about light and colour, or sometimes a broad political or social statement.

However, before you can develop a style of your own, there are some basic bridges to cross. So the early pages of the book deal with the nuts and bolts of landscape photography: how to choose equipment, and how to master the camera's controls so that you record the landscape as you see it. With modern cameras, this means understanding automation and getting it to work for you, not against you.

This book is not intended to be an exhaustive study of the wide range of approaches that can be adopted to landscape photography. Such a catalogue would be unhelpful, and probably impossible. Rather, it's a point of departure for your own experiments in landscape photography, and puts into context the techniques and understanding that are essential for the mastery of this fascinating subject.

▶ *Framing the subject*
Naturally, landscape photographs often embrace man-made structures such as this isolated cottage. The near-symmetrical contours of the rocks, coupled with the strong horizontal of the sea, form a perfect frame for the central subject and lend atmosphere.
Pentax, 35mm, FP4, 1/125, f/22.

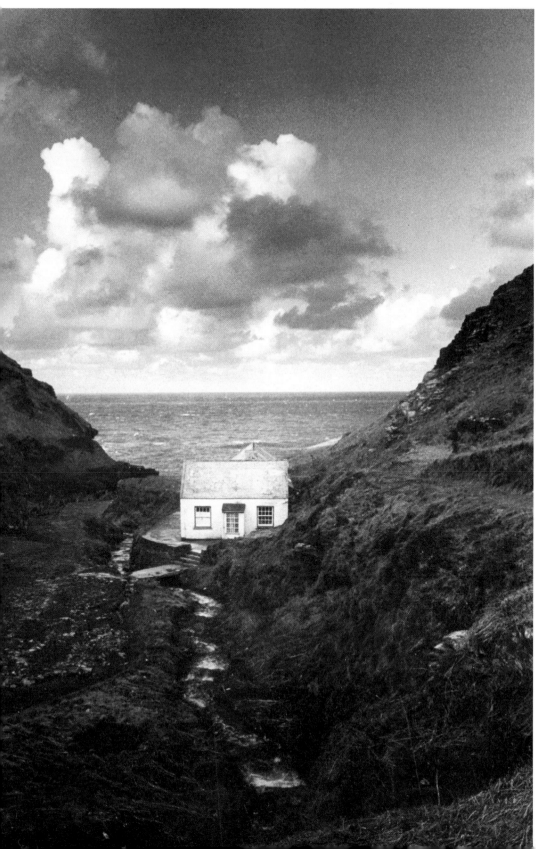

EQUIPMENT

Photographers working in other areas have highly specific needs that are not shared by the photographer of landscape: for example, the sports specialist would find it hard to function without fast long lenses and a motor drive. Nevertheless, versatility of equipment and approach is just as vital whether the subject is a gently flowing river or a sprinter breasting the tape. It's a lot easier to convey exactly what makes a place unique if you can call on the hardware you need to support a wide repertoire of photo-techniques and approaches.

One of the beauties of landscape photography is that the subject matter lends itself to a minimalist approach: you can make striking landscape pictures with the simplest of cameras. However, this doesn't mean that the quality and capabilities of your equipment are less important than in any other photographic specialization. Indeed, some aspects of photo-hardware, such as reliability, are more important than ever. Ruggedness is a factor, too, because the environment in which the landscape photographer operates can be a hostile one and the needs of portability and protection for equipment are often incompatible. Foam-padded alloy cases are great for transporting cameras in a car, but for scrambling up a hillside covered in loose pebbles a backpack is more useful.

The pages that follow provide an objective overview of the more useful equipment for landscape photography. However, subjective factors are often as important in the field as the widest aperture of a lens, or the fastest speed of a shutter. If you're buying a camera primarily for landscape photography, think carefully about the conditions in which you'll be taking

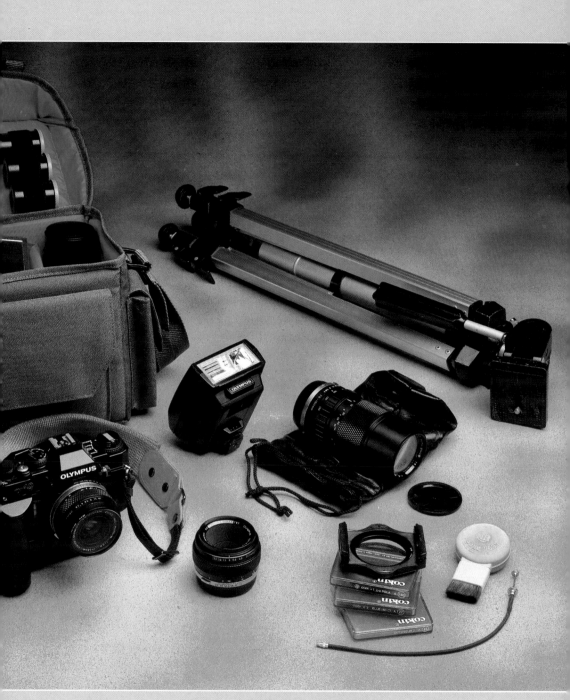

pictures, and how simple the camera will be to use. If you shoot a lot of snowscapes, assess how easily you can operate the controls when you're wearing gloves. In brilliantly sunny conditions, you may want to protect your eyes with sunglasses: will this prevent you from seeing the whole of the viewfinder? Factors such as these can help you to make a choice between two cameras with similar specifications.

▲ **Travelling light**
What to pack for a landscape trip is never an easy decision: this outfit, with 35mm, Macro and 75-150mm lenses, is a good compromise of versatility and weight.

THE 35mm SLR

The 35mm single lens reflex camera is such a versatile instrument that it should not come as a surprise to find it's the camera of choice for many landscape photographers. Although 35mm film was once regarded as a miniature format, recent advances in film and lenses have done much to change this situation, and today the best 35mm pictures can stand comparison with those from larger cameras at all but the biggest enlargements.

The reflex design of the SLR has unique advantages for landscape. It makes it easy to change lenses and the viewfinder shows exactly what you'll see on film. Though this is most important in close up and with long lenses it's also a considerable benefit when you're trying to position the camera so that a leaf on a branch in the foreground conceals an ugly factory on the horizon.

Landscape photography is a natural partner for other outdoor pastimes such as rock-climbing, back-packing or bird-watching. In all these pursuits equipment weight and bulk are major considerations, and it's true that the SLR is not the smallest of cameras. However, by choosing carefully, going for a straightforward model, you should be able to create a system that's compact enough to carry almost anywhere, without sacrificing the advantages of the SLR design.

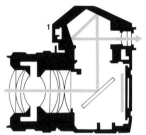

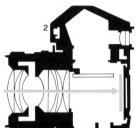

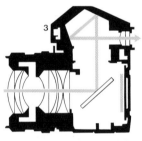

◄ The reflex principle
The viewfinder of the single lens reflex (SLR) camera incorporates a pivoting mirror that directs the image from the lens upwards to the eyepiece for viewing and focusing (top). Above the mirror, a five-sided prism flips the image (which is normally inverted and reversed left-to-right), so that it appears the right way round, and right-side up. When the shutter release is pressed, the mirror swings quickly out of the way (middle), so that the image can reach the film. After exposure, the mirror drops down again, so that the image reappears in the viewfinder (bottom).

▼ State-of-the art SLR
The most sophisticated modern SLR cameras automate practically every camera function, making them ideal for the novice landscape photographer with more enthusiasm than technical knowledge.

► Budget SLR cameras
Long-established non-autofocus SLRs are a bargain for photographers who want total control. Manual exposure metering and focusing may be slower, but they encourage a methodical, considered approach.

SEE · ALSO
Parallax error p. 15
Exposure pp. 26-7

SYSTEM FEATURES

1 Shutter
Top speed rarely matters, but a high flash synch speed is an advantage if you use fill-in flash. Look for a "B" or "T" setting at the slow end of the scale.

2 Viewfinder
A removable prism makes low-angle shots easier to compose.

3 Focusing screen
The facility to swap screens is useful if you find conventional focusing aids distracting: some landscape photographers prefer a plain screen with etched lines to aid composition.

4 Autofocus
If you normally wear glasses, you'll probably find autofocus makes operation faster and more positive, but it is rarely essential.

5 Lenses
Check that there's a good range available, including extremes, not just mid-range zooms.

6 Maximum aperture
Fast lenses are bulky and weighty, so choose more modest lenses – they're cheaper too.

7 Automation
Avoid cameras that don't permit full manual control over shutter, focusing, film speed and aperture.

8 Depth-of-field-preview
Valuable but vanishing control helps you to check sharpness.

9 Motorized advance
Can prove useful, but adds weight.

10 Self-timer
Use it to cut vibration when you don't have a cable release.

COMPACT AND ROLL-FILM CAMERAS

When weight and size are the most important factors, a compact 35mm camera may be a better choice than an SLR. It's true that the smallest 35mm compacts fit easily into a cigarette packet, but on the other hand, some models that feature a "tele" option are actually bigger and more costly than small SLRs.

Most compact cameras made today fall into the "auto-everything" category, like the camera shown below. However, a few, such as the prestigious Leica, still use a manual rangefinder design. Compared to the SLR, this configuration offers no significant advantages that are specific to landscape photography. However, rangefinder cameras tend to offer a greater degree of manual control than autofocus models, and you may prefer one for this reason.

ROLL-FILM CAMERAS

Roll-film cameras (also called medium-format or one-twenty cameras) are much bigger and heavier than 35mm SLRs, and at a glance, this might disqualify them from consideration for landscape work. However, photographers are prepared to shoulder the extra weight because the film format is typically four times bigger than 35mm, and pictures are proportionately sharper. There are other benefits: roll-film is usually loaded into a chamber that you can remove from the camera body at any time, so you can switch in mid-roll between colour and black-and-white, or to instant film.

If you want medium-format quality without the weight, look for a folding roll-film camera. A few are still made, but unfortunately they are costly.

COMPACT CAMERA FEATURES

1 Autofocus
Look for "focus lock" control, or you'll be able to focus only on centrally placed subjects.

2 Telephoto option
Adds versatility – but weight and bulk too.

3 Lens cover
Like a cap you can't lose, this is a useful way of keeping the lens clean.

4 Filter thread
If your camera lacks this, you can tape gelatin filters over the back of the lens inside the camera – but filters can then be changed only between films.

5 Film speed
Look for several sets of DX (film speed) sensors in the cassette chamber. A single set means you can use only ISO 100 and 400 film.

6 Tripod socket
Valuable for dusk and night pictures.

7 Exposure control
Most compacts set everything automatically, but some have a "backlight" button for extra exposure.

8 Contoured body
Makes "one-handed" pictures possible – vital for rock climbers.

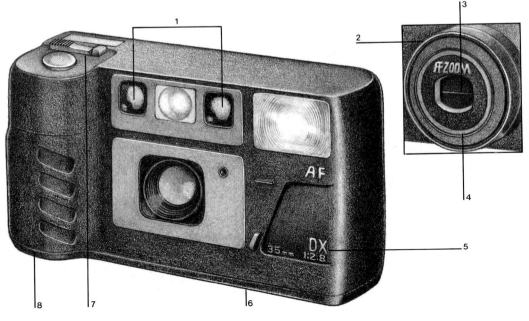

Parallax error

Non-SLR cameras use two separate lenses: one for viewing the subject, and the other for taking the picture. While these non-reflex viewfinders are perfectly satisfactory for most subjects, occasionally they can introduce "parallax error". In the example on the right the viewfinder shows the sun obscured by a leaf (1), but the lens sees a slightly different view, with the result that glare from the sun spoils the picture (2).

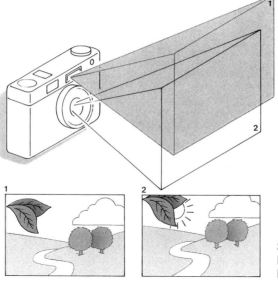

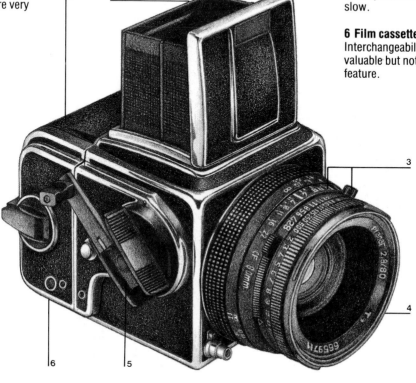

SEE · ALSO
Filtration pp. 50-3
Lens choice pp. 18-21

ROLL-FILM SLR FEATURES

1 Film format
The smallest (16 pictures on a roll) models yield negatives 3× the size of 35mm. The largest models give a negative six times as big as 35mm, but are very heavy.

2 Viewfinder
The standard finder has no prism, so the landscape appears reversed left-to-right on the screen.

3 Controls
Mostly manual – the more conservative makes don't even have a meter built in.

4 Lenses
Costly, but you can manage with just a couple, because roll-film stands greater enlargement than 35mm.

5 Film advance
Usually manual – and slow.

6 Film cassettes
Interchangeability is a valuable but not universal feature.

OTHER CAMERA FORMATS

Large-format cameras are cumbersome and slow to use, and even seem outmoded when 35mm cameras can produce such good landscape pictures. Nevertheless, landscape traditionalists often choose a large-format camera because the film needs minimal enlargement; because exposures can be processed individually, rather than 36 at a time; and because large-format cameras incorporate a range of adjustments not found on smaller models.

The size handicap need not be crippling; wooden cameras fold up into a small package, and some weigh less than an SLR. Film is perhaps more of a problem, because the bulky film holders contain just two exposures each, and must be loaded in darkness – this usually means carrying a light-tight changing bag as part of the outfit.

INSTANT CAMERAS

Instant cameras are widely regarded as toys by serious photographers, but for landscape they have their uses like any other camera.

Folding integral-film models create jewel-like images that have attractive, rich colours and a unique depth. Peel-apart film can be loaded into many medium-format and all large-format cameras to give a preview of exposure and colour. The monochrome version is capable of producing a good negative in addition to an instant print.

SPECIALIST CAMERAS

Panoramic cameras arguably provide the most lifelike view of the landscape. There are three distinct categories: fixed-lens and fixed-film models produce least distortion, but are very costly and bulky. Fixed-film/swing-lens models bend lines parallel to the film, but are cheaper and more compact. Panoramic cameras, where lens and film move, provide 360° coverage, but are costly and mechanically complex.

All-weather cameras are sealed against dirt and water, and may be the wisest choice if you are planning to take pictures in areas where these hazards abound.

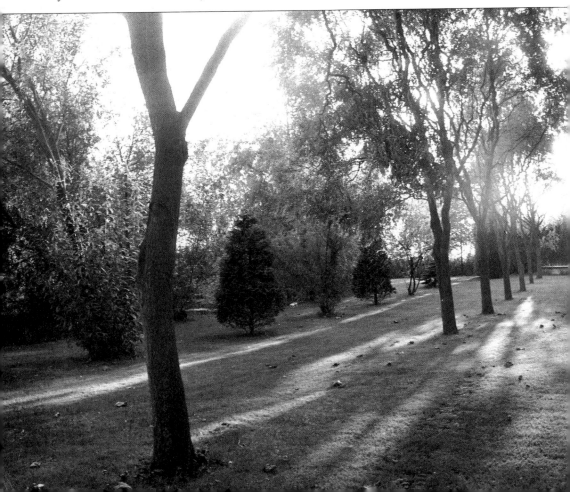

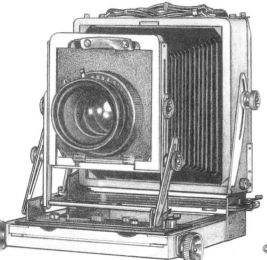

Other film formats
Large format cameras (above) produce superb quality, despite an antiquated appearance. Instant cameras (above right) make learning faster – you can see what went wrong. Panoramic cameras (right) draw the viewer right into the scene (below).
Widelux, FP4, 1/125, f16.

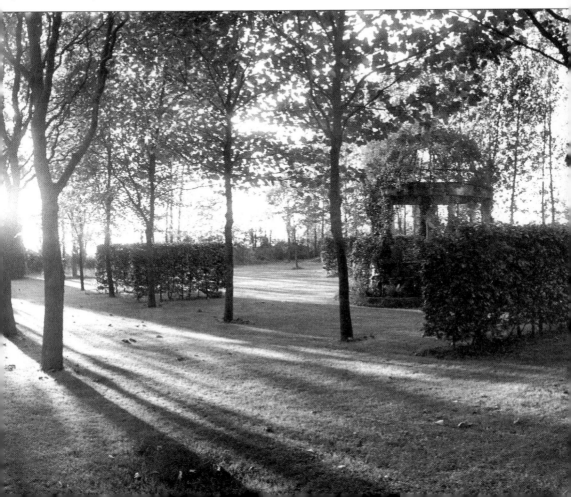

LENS CHOICE

One of the principal advantages of the 35mm SLR is the option of changing lenses, and in the next few pages we'll examine the full range and how you can use them in the context of landscape photography. However, let's first take a look at lenses in general.

It's easy to be seduced into collecting lenses by the expectation that the object itself will help you take better pictures. It won't. Lenses are like spanners in a tool box: you can tackle most jobs with a limited range of sizes, or with just one adjustable spanner; extra spanners don't make you a better mechanic, though they will extend the range of tasks you can tackle.

Lens quality is another trap. Most lenses for SLRs provide extraordinarily good quality, so that unless you make giant enlargements, you'll probably never fully exploit the optical capabilities of your lenses. Remember that many factors affect the sharpness of your pictures, and lens quality is just one of them. Unless you habitually use a tripod, camera shake is likely to set a limit on picture sharpness much sooner than lens resolution, and over long distance, heat haze and mist are also factors. Tests in camera magazines may enable you to make objective comparisons between lenses, but they are carried out in an optical laboratory, and in practice you'll probably notice only the grossest of differences in the finished picture.

Finally, bear in mind that what you carry in your camera bag is there to aid you, not to be a burden. If you hesitate about carrying your camera bag half a mile across sand dunes, it's time to take something out of it.

▶ **Telephotos take you closer to the subject**
A telephoto or a long zoom is a sensible second lens if you already have a standard 50mm lens for your SLR. Landscape photography will often present physical obstacles that prevent you from getting close enough to the subject: telephoto lenses bridge the gap.

◀ **Travel light with a mid-range zoom**
For maximum versatility and minimum weight, mid-range zoom lenses are unequalled. The most versatile lenses have focal lengths ranging from 28mm to 200mm, but watch out for hidden drawbacks – these wide-range zooms often focus no closer than 7 feet (2 metres), and have small maximum apertures, limiting low-light use.

▶ **Expand the horizon with a wide-angle lens**
The qualities of a wide-angle lens are easy to appreciate in practice. With a wide-angle lens on your SLR, the foreground looms larger, and the background recedes into the distance; small changes in camera position radically alter the appearance of the picture. Wide-angles are small and light, too – you'll hardly notice the extra weight.

FOCAL LENGTH

Changing lenses is like looking at the landscape through different windows. A standard lens – that is, one of around 50mm in focal length – gives a view of the scene that approximates to human vision and is consequently often referred to as a normal lens. The wide-angle lens is the landscape photographer's picture window, recording on film a broad swathe of the scene. Telephoto lenses are like cottage windows – distant details easily fill the frame.

Choosing the right lens isn't just about fitting everything into the picture, though, because focal length affects the image in other ways. One of these is depth of field: long focal length lenses reduce depth of field, so that less of the landscape is in focus on film; wide-angle lenses keep more of the image sharp. So if you want to isolate just a portion of the scene, and throw other subject planes out of focus, use a telephoto lens, or a "tele" setting on a zoom lens. For maximum sharpness, select the smallest aperture.

Different lenses give you a wider choice of viewpoints, and this in turn affects the appearance of the picture. If you use a telephoto lens, you'll need to back away from the subject to fit everything in, and the distant viewpoint tends to flatten perspective. With a wide-angle lens, you can picture the same subject from a close viewpoint. Things near to the camera seem proportionately bigger, and the background seems to recede.

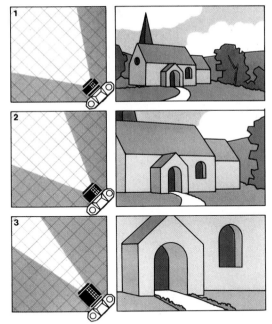

▲ **Angle of view and focal length**
In theory, focal length is the distance between two points in the lens, but in practice, it is a quick way to specify angle of view. Most wide-angle lenses (1) have focal lengths ranging from 13mm to

35mm, and fields of view from 118° to 62°. 50mm standard lenses (2) take in 46° across the diagonal of the frame, and telephoto lenses (3), ranging from 85mm to 2000mm, have fields of view from 16° to 1°.

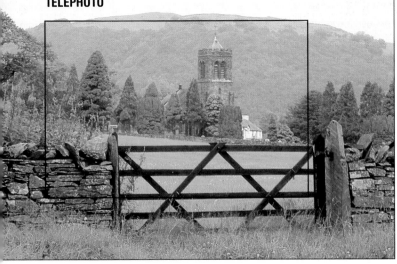

TELEPHOTO

◀ **Cropping in camera**
Zoom lenses make cropping in camera especially easy: not only do they save you the trouble of constantly switching lenses, but they also provide intermediate focal lengths – such as 130mm – for fine-tuning composition.
Pentax, Ektachrome 64, 1/30, f/4, full view: 50mm; crop: 130mm.

SEE · ALSO
Aperture pp. 41-3
Perspective and scale pp. 104-5
Image planes pp. 56-7

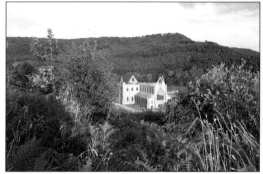

STANDARD LENSES AND MID-RANGE ZOOMS

Most people buy a 35mm SLR with a 50mm standard lens or a wide-to-tele zoom, such as a 35mm-70mm. These lenses make an ideal introduction to landscape photography because they provide a way of seeing that closely resembles normal human vision. There's no apparent distortion to cope with, and you don't need to take any special precautions when using the lens.

A mid-range zoom gives you more versatility than a fixed-focal-length standard lens, though zooms are usually more costly and have a smaller maximum aperture, making focusing a little slower.

▲ The standard view
The great value of a standard lens is its ability to record the scene much as the eye sees it. Here I used a standard lens to suggest the way Fountains Abbey was revealed as I approached the gap in the hedgerow. Lenses with different focal lengths would have produced a less natural-seeming perspective.
Pentax, Tri-X, 1/60 f/11.

▼ Pull in the distance with a telephoto
A 200mm lens allowed me to bring the mountains forward, and thus exaggerate the "striped" appearance of the different terrains. Extra exposure kept the snow looking white.
Pentax, FP4, 1/125, f/11.

TELEPHOTO LENSES

Telephoto lenses give you the power to select portions of the landscape, and enlarge them on film, so that you can pick out details of the scene and frame them up for intense scrutiny. Most telephoto lenses provide quite a modest degree of enlargement: at its longest setting, for example, an 80-200mm zoom enlarges the subject by just four times – much less than the average pair of binoculars. Nevertheless, this is sufficient for most landscape pictures, and most photographers choose a lens in the 70-250mm range as their first telephoto.

If you find yourself frequently cropping in on the central area of pictures shot with a moderate telephoto, you may be tempted to buy a longer focal length. Bear in mind, though, that lenses with focal lengths longer than 250mm tend to be heavy, costly and cumbersome. It is best to borrow or hire such a lens before buying. You can cut bulk and weight two ways – by using a mirror lens, which is half the size and weight of its conventional counterpart; or by coupling an existing lens to a teleconverter. Unfortunately both these solutions have drawbacks. Neither produces such sharp pictures as a conventional lens used on its own, and mirror lenses have a non-variable aperture.

WIDE-ANGLE LENSES

As the name implies, wide-angle lenses enable you to take a broader look at the landscape than the standard lens permits. Some find this a more natural and convenient way to look at the world: many photographers keep a 28mm or 35mm lens on the camera most of the time, relegating the 50mm lens to the same role as the telephoto – a means of cropping in on detail.

Using a wide-angle lens perhaps requires a little more thought than a telephoto lens. Its most noticeable feature is the ability to cram more of the landscape into the frame, but paradoxically "more" can sometimes mean "less". Often pictures taken on a wide-angle lens come out as a mass of busy detail, lacking a centre of interest. The reason lies in the way we look at the landscape with our eyes: we scan across it, often turning to follow the horizon from left to right. The camera, of course, doesn't scan the scene, and although a wide-angle lens may take in the same sweep of horizon, it also includes much of the sky above the horizon, and the land in the foreground. Unless there's interest in these areas, the picture as a whole will be disappointing. To avoid this problem, look at the subject very carefully when you've got a wide-angle lens on the camera. Scan the sky and the foreground, and move the camera around so that each and every area of the frame contributes to the overall image.

Because wide-angle lenses take in a broader view, they sometimes appear to distort the landscape image. The most conspicuous distortion is the convergence of parallel vertical lines: trees, for example, may appear to lean together at the top.

Lenses with focal lengths shorter than about 28mm may introduce another distortion, smearing and elongating objects at the corners of the frame. The only solution here is to keep objects with familiar shapes near the middle, where they are least affected.

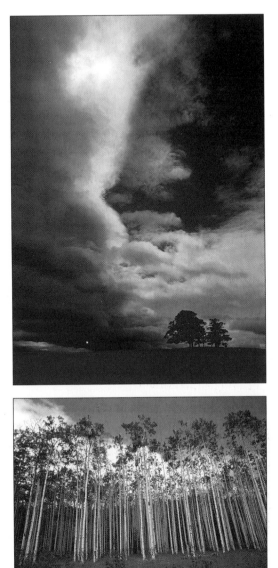

▲ **Wide-angles add a sense of space**
With a 24mm lens fitted, I tilted the camera up to include more of this dramatic sky (top). The 84° angle of view of this lens takes in the scene from the horizon almost to the zenith – a wonderful sweep of sky that you'd normally see only by turning your head. Olympus FP4, 1/500, f/8. Tilting the camera with a wide-angle lens fitted

makes vertical lines converge. Some call this distortion, but you can use the convergence to advantage. Here it makes a dull woodland scene look much more dynamic. Olympus, 28mm, Tri-X, 1/125, f/5.6.

SEE · ALSO
Snowscapes pp. 154-7
Using exposure creatively pp.28-9
Filtration pp. 50-3

ACCESSORIES

Camera support is as important in landscape photography as in any other specialization, but the landscape enthusiast faces an unusual dilemma. The stability of a tripod generally rises in proportion to its weight, but so too does the reluctance to carry the thing more than a few yards. Photographers have found various partial solutions: for example, some pile rocks into a bag slung between the tripod legs to add weight and equilibrium, but essentially the problem remains. If you want to use slow film or long exposures, you must be prepared to carry the weight of a tripod.

When preparing for a landscape trip, everybody packs a number of other essentials besides lenses, cameras and film. For critical work with transparency film, an incident light meter is a prudent precaution: it also provides a handy way of checking that the meter in your camera is functioning properly. Spot meters require very methodical use, but give pin-point accuracy.

Using filters is covered in detail on pages 50-53, but you can buy the filter hardware in

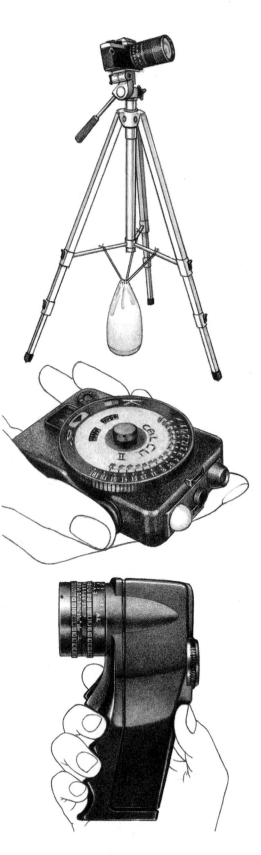

▲ **Pocket-size flash**
A small flash might seem useless when you're photographing vast landscapes, but a pocket-size unit like this is capable of lighting subjects up to 10 feet (3m) from the camera. In sunlight, you can also use flash to reduce contrast by throwing light into the shadow areas of subjects that are nearby.

EQUIPMENT CARE

Later pages of the book cover details of equipment care that are specific to particular hazards (see pp. 136 and 181) but there are a few routine steps you can take to prolong the life of a camera or lens. This kit of camera-care accessories costs almost nothing to assemble, yet it's often sufficient to get you out of trouble.

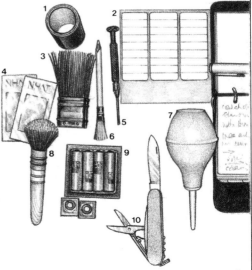

1 Black PVC tape holds damaged bits together and keeps light out

2 Labels, pad and pen are vital for caption notes and special processing instructions. Spirit markers are best – they will write on film leaders.

3 1-inch paint brush for removing dust from non-optical surfaces

4 Moist wipes are sealed against dirt until you open them to clean lenses

5 Jewellers' screwdriver – take both flat and X-head styles

6 Typewriter eraser is invaluable for cleaning battery contacts

7 Bulb syringe to blow fine dust off lenses (cans of

compressed air can cause damage and are heavy)

8 Soft paint brush for cleaning lenses and filters

9 Spare cells for camera, flash and motor drives

10 Swiss army knife for odd jobs

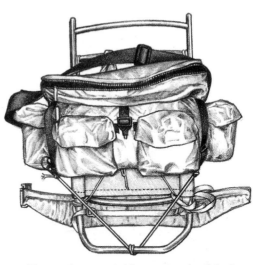

◄ *Accessories that add quality*

In strong wind, even quite heavy tripods need extra anchorage. Rocks in a specially-made bag (top) add stability. Hand-held meters simplify exposure, and weigh almost nothing; look for one that has no moving parts (centre) – they stand up better to field use. Spotmeters (bottom) let you pinpoint the best exposure for the most distant subject.

a variety of forms. The popular square system filters fit all sizes of lens, but are made of plastic and scratch easily. Glass filters are optically superior, but more expensive. When weight is critical, choose wafer-thin gelatin filters and a suitable holder.

If you take a lot of night landscapes, you'll find a small flash unit a valuable ally. Use it with a wide-angle lens, and you can light the entire foreground of the scene.

CARRYING EQUIPMENT

In many parts of the world, it's possible to take excellent landscape pictures without moving more than a few yards from a road, and in these areas, packing and carrying equipment isn't really a problem. Often, though, you'll find that roads act as a magnet for intrusions such as telegraph poles, litter, people, and of course vehicles. If you don't want these in your pictures, you'll need to carry equipment some distance.

The only practical way to do this is on your shoulders – preferably both of them. Ordinary soft camera bags are fine for short distances, but most have a single shoulder strap that puts the weight on just one side. Backpacks distribute weight more evenly, but are rarely suitable for cameras, and some photographers create a hybrid form by attaching a regular soft camera bag to a backpack frame.

Remember to pay as much attention to your own safety as to that of the camera. See, in particular, pages 160-1.

PHOTOGRAPHIC CONTROLS

Sophisticated modern technology has brought us cameras that are capable of making technical decisions about photography completely unaided. Gently press the shutter release of an autofocus SLR, and the landscape snaps into sharp focus in the viewfinder. Press harder and the camera assesses light levels, focal length and perhaps even subject contrast before setting the aperture and shutter speed and taking the picture. The result is technically perfect: correctly exposed and needle-sharp.

But let's take a closer look at what we mean by "technically perfect". Cameras are designed to cope best with average scenes: those that are an approximately equal mix of dark and light areas, with the most important subject in the middle of the frame. If you point the camera at a scene that's widely different from this rather arbitrary "average", you may not be so happy with the result.

For example, even simple cameras can cope adequately with a riverside landscape that features trees, pale rocks and water in roughly equal proportions. The brightness of the rocks compensates for the dark trees and, taken overall, the scene conforms to our hypothetical "average". A ploughed field fringed with yew trees presents a different problem, though. The whole of the subject is dark, and reflects perhaps only a third as much light as the average scene. Even the most advanced camera has no way of knowing this, and will blindly set what it thinks is the "correct" exposure. In practice this is the exposure which will produce an average print or transparency. Unless you intervene and actively control the camera, all parts of the picture will turn out to be too light. In this example, you will wish to set the camera manually in order to

take a picture that more closely resembles the original landscape. But often you'll want instead to use photographic controls to create an image that expresses how you felt about the landscape. There's no way to literally capture searing heat in a picture, but by slightly overexposing a desert scene, you can at least suggest the blinding glare and soaring mercury of an equatorial noon.

In the pages that follow, we look at the photographic controls individually, but reading is no substitute for practice. To really get a feel for how each of these controls affects the landscape image, you need to go out and take pictures. To avoid confusing the effects of several different factors, you may find it helpful to take several pictures of the same scene, changing just one control at a time.

Catching atmosphere with filters and exposure
This hill-top castle had a brooding presence, but "correct" exposure would have drawn attention to fussy detail in the foreground. So I cut exposure by three stops to create a silhouette, and fitted a red filter to increase the contrast between clouds and sky. Olympus, 20mm, FP4, 1/500, f/11.

EXPOSURE

Your camera probably takes care of exposure metering for you, setting either the shutter speed or the aperture (or both) according to how much light the subject reflects, and the speed of the film you're using. But as explained in the introduction to this section on page 24, misleading subjects can lead to exposure problems.

The key to anticipating such problems and minimizing the consequences is to understand that the meter in your camera is essentially unthinking – an obedient but stupid slave that obeys a series of simple rules. As long as you know the rules, you'll get good exposures every time.

These are the two basic rules that most meters obey. First, the tone of the subject averaged over a selected area is neither light nor dark but an intermediate shade. Second, that the middle of the picture is more important than the corners. If you're faced with a subject that breaks these rules, you must compensate and set exposure manually, or intervene in some other way.

METERING SOLUTIONS

There are several ways of doing this. The simplest is to find an area of the landscape that does obey the rules, and meter from

there. On a white sand beach, you might close in on a grey rock, take a reading, set exposure manually or store the meter reading in the camera's memory, then move out to recompose the picture as you want it.

The other commonly-used method is to meter the scene normally, then apply some compensation to take account of the subject's unusually light or dark tones. In snow, for example, you might choose to set the camera's exposure compensation dial to +1 or ×2. This would have the effect of overexposing the film by one stop, so that the snow comes out realistically white, not grey. There are other ways to apply the same compensation, as outlined in the chart below.

EXPOSURE COMPENSATION		
To alter exposure using:	Overexposure	Underexposure
Film speed dial	Set lower speed	Set higher speed
Exposure Compensation dial	Set positive or multiple values (+1, +2, ×2, ×4)	Set negative or fractional values (−1, −2, ×½, ×¼)
Backlight control	Usually adds one or 1½ stops	not applicable

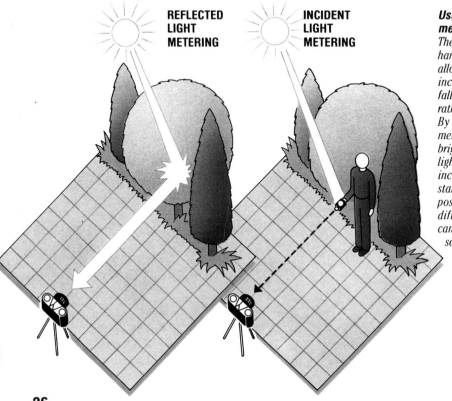

REFLECTED
LIGHT
METERING

INCIDENT
LIGHT
METERING

Using a hand-held meter
The chief advantage of a hand-held meter is that it allows you to measure the incident light – the light falling on the subject – rather than reflected light. By comparison, built-in meters gauge the brightness of reflected light only. To use an incident light meter, stand at the subject position and direct the diffusing dome at the camera, not the light source.

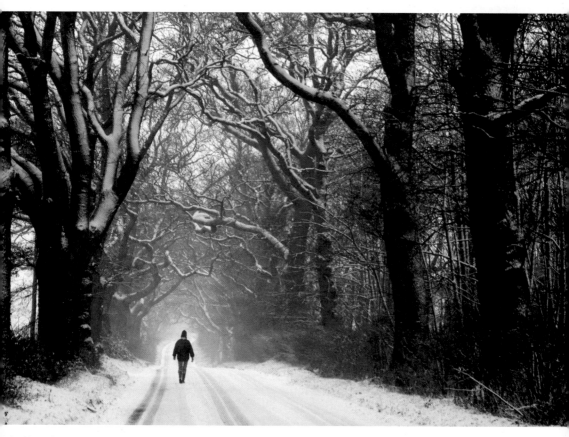

▲ Metering snow scenes

Like many cameras, my Olympus has a meter that is weighted towards the lower centre of the frame. The lower half of this image is dominated by snow, and relying on the meter would have resulted in insufficient exposure. To avoid this, I took a reading not from the snow, but from the mid-grey sleeve of my jacket. Agfa CT18, 1/30, f/8.

▼ Painting with flash

At night you can make the most of a small flash by repeatedly pressing the 'open flash' button while the camera shutter is open. As shown here, walk round the subject between flash 'pops' so that you get even illumination. However, don't stand between the camera and the area you're lighting or your outline will appear on film.

LIGHTING LANDSCAPE

Landscape doesn't lend itself to the use of supplementary lighting to the same degree as other branches of photography, but nevertheless there are some circumstances where you can use artificial light to great effect. For example, if you are content to light just the foreground of the picture, you can even use a portable flash unit to add illumination to your landscape pictures.

Flash has the advantage that it is a purpose-made light source. And while low output is certainly a handicap, you can multiply the power of a flash unit by locking the camera's shutter open, and firing the flash several times to light different parts of the scene. Check your meter before you start, to ensure that the ambient light won't swamp the flash light during the long exposure.

USING EXPOSURE CREATIVELY

Earlier pages detailed how you can use the camera's meter and exposure controls to make landscape images that look as much like the original scene as possible. Creative use of exposure is just as important, though. If you're using slide or instant film, extra exposure makes the picture lighter, and reduces the saturation of colours, so that they come out more like pastel shades. Conversely, reducing exposure makes everything darker, and makes colours look richer and deeper on film.

Cutting and boosting exposure provides a valuable creative tool. With extra exposure you can make landscapes look light, airy and refreshing, you can burn out highlight detail to white, and focus the viewer's attention on shadow areas of the picture. Cutting exposure introduces a sombre note, and concentrates attention on the highlights – shadows turn dense black.

If you use negative film, the printing process masks creative use of exposure. To take full advantage of the effects of exposure changes, you'll need to print pictures yourself, or pay extra for a "custom print" or "hand print".

BRACKETING : HEDGING YOUR BETS

Sometimes it's worth taking three or more pictures of the same scene at different exposure settings, to be sure of getting what you want. This is called "bracketing" your exposures. Make one exposure at the setting indicated by the meter, underexpose the next frame, and overexpose the one after. In most instances, one stop over- and underexposure is sufficient, but in high-contrast situations such as sunsets, it's wise to bracket at one-stop intervals over a five-stop range: -2, -1, 0, +1, +2. It is hard to predict the results when you bracket exposure, but all the shots will inevitably have a mood of their own and each needs to be considered on its own merits, not simply in relation to "correct" exposure.

Interpreting the scene
Contrejour lighting creates more contrast than any film can cope with, and varied exposures yield widely different results. To capture the sparkle in this scene, the reflected sun on the water had to appear brilliant white, so I took a meter reading from the water's surface well away from the reflection, and bracketed the pictures two stops over and under the reading. Local bleaching on the print eliminated all traces of tone in the highlights. Leica, 21mm, Tri-X, 1/250, f/11.

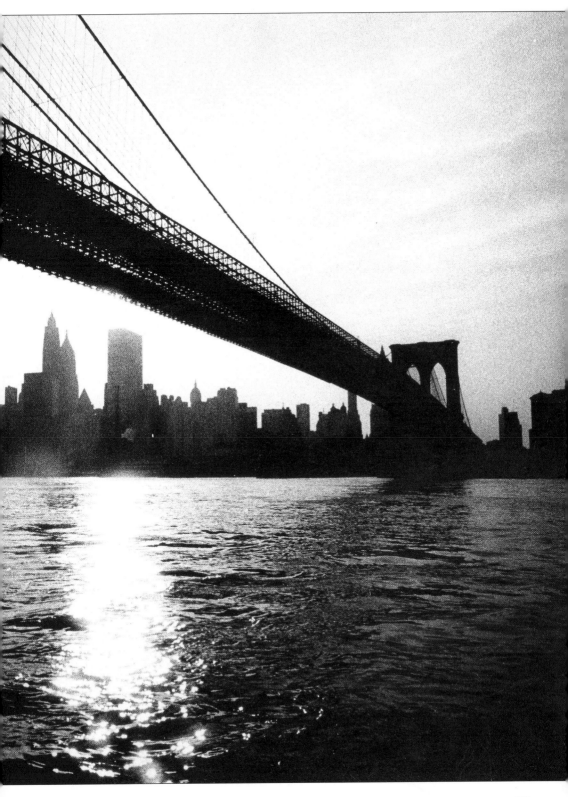

▼ Sky as background
The sky is much lighter than the land beneath, so it makes an ideal background for silhouettes. To retain a trace of detail in the figures, I metered from the sky, then gave one stop extra exposure. *Olympus, Plus-X, 28mm, 1/125, f/8-11.*

▶ Multiple readings
Tonal qualities were all-important in this dawn scene, so although I exposed for the sky, I also took four other meter readings, to assess how other parts of the subject would be recorded. *Olympus, 28mm FP4, 2 seconds, f/8.*

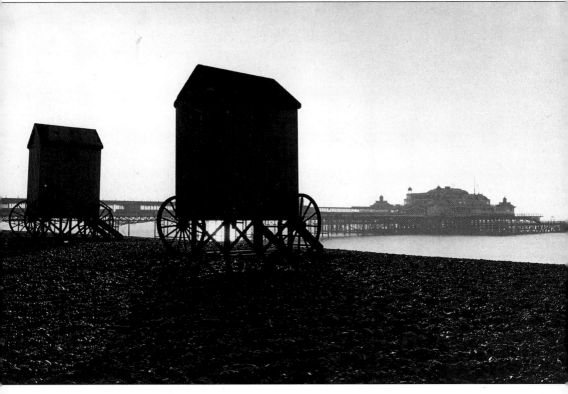

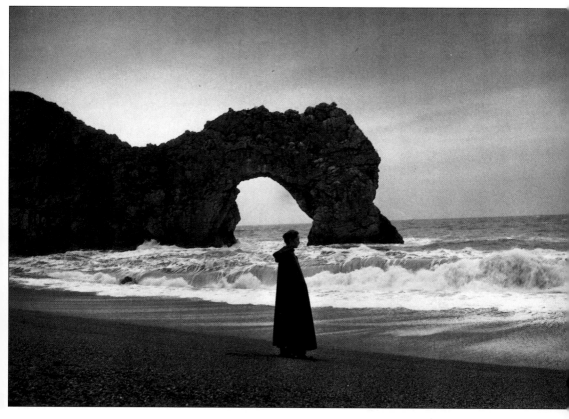

▲ Metering the subject
To make a pure
silhouette, I took a meter
reading from the face,
then closed the aperture
three stops.
Olympus, 50mm, FP4,
1/15, f/8.

◄ Sparkling highlights
I left the camera on
automatic for this image,
guessing that the bright
highlights would fool the
meter into underexposing
the bathing machines.
Olympus, 35mm, Tri-X.

► Picking a key tone
I needed to retain detail
in the delicate tracery of
steam, so I took a meter
reading from the plumes,
and gave two extra stops
exposure.
Hasselblad, 150mm, Tri-X,
1/125, f/8.

FILM CHOICE

Choice of film is perhaps not the most obvious way to manipulate the landscape image, but in some respects this is among the most fundamental photographic controls. You can change other controls such as shutter speed and aperture at whim, but once you've loaded the camera with film, you're committed. When the sun is about to dip below the horizon, there just isn't time to reload the camera with a more suitable film.

The principal choice to make is between the four types of film: colour prints; colour slides; black-and-white; and instant film. Colour negative film, processed to produce prints, is the most familiar and convenient type. Wallet-sized prints are easy to look at, you can get them processed quickly almost anywhere, and further copies or enlargements are inexpensive. A less obvious feature of colour negative film is its forgiving nature: even quite large exposure errors can be corrected at the printing stage, and normally you don't need to use filters to match film sensitivity to the prevailing light. Finally, there's a further advantage if you have a darkroom at home: you can use special printing techniques to reveal features that would normally be hidden in deep shadows or brilliant pools of light.

USING SLIDE FILM

Slide film – also called transparency, reversal, diapositive or chrome film – requires more methodical use than negative film, but the benefits more than repay the extra care needed. Slides – within the film's limitations – faithfully record the image that you see through the lens, because there is no intermediate printing stage: the film in the camera is processed in a single step to form the finished image. Slides are potentially sharper, more colourful and more richly detailed than colour prints, so printers prefer a slide when making plates for reproducing a book like this one. On the debit side, you must expose slide film very precisely, and you need to take special care with filters or your pictures will look off-colour. Also, slides look best when projected in a darkened room, which sometimes makes viewing inconvenient.

INSTANT PICTURES

Instant film is traditionally associated with snapshot photographs, but many landscape photographers also make use of Polaroid film both as a medium for test exposures,

and to create finished images. You don't necessarily need a special camera to shoot instant film: all large-format cameras, most rollfilm cameras, and a few 35mm cameras can be fitted with adapter backs, so that you can preview a shot while you're on location.

Black-and-white film has a special appeal to photographers who like the abstraction offered by the translation of a colour scene into a broad tonal range from black to white and who want to do everything themselves. In a home darkroom you can make a whole gallery of different prints from a mono-

▼ **Grain effects in monochrome**
The prominent grain structure of fast film can make pictures look very atmospheric. To enhance grain in this low-contrast subject, I deliberately overexposed ultra-fast Kodak recording film. Leicaflex, 135mm, 1/15, f/8

▼ **Slow film for detail**
Surface texture and fine detail were the essence of the shot below right, so I chose Ilford Pan F – an ISO 50 film with outstanding resolution. Pentax, 50mm, 1/125, f/8.

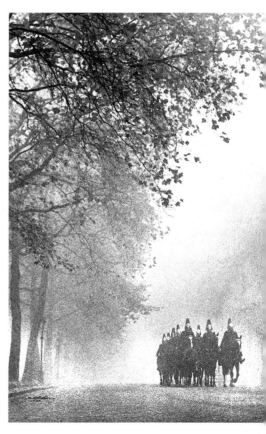

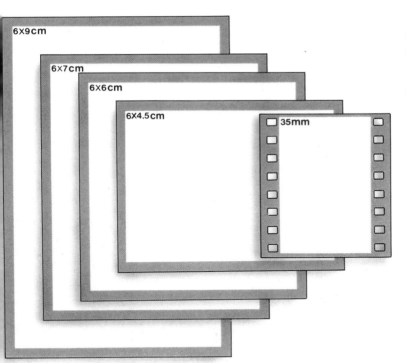

◀ *Film formats*
Image quality depends not only on how good the film is, but also on how much you enlarge the picture. The biggest of the roll-film formats shown here is some six times larger than 35mm film – therefore quality is proportionately better.

▶ *Painterly prints*
(overleaf)
Like its monochrome counterpart, fast colour film – especially print film – has a pronounced structure suggestive of a painted canvas. So Kodacolor 400 was the obvious way to add an echo of impressionism. Olympus, 85mm, 1/250, f/16.

chrome negative, conjuring many different moods from just one landscape. Black-and-white film is also the most economical and permanent of all photographic media, so it's ideal for photographers on tight budgets, and for those who want to pass on their pictures to their great-grandchildren.

FILM SPEED

Within these four groups of film, there's also a choice of film speed. Fast films – those with a high ISO number – require little light to make a good picture. Slow films have a low ISO number, and need brighter light, slower shutter speed, or wider apertures for correct exposure. Fast films are more versatile, but produce pictures that have a more pronounced texture or grain, and are not as sharp and colourful as those shot on slow film. However, you'll only really notice the difference in prints larger than about 8 × 10in (20 × 25cm).

Ultimately, your choice of film depends on several objective factors, including how you want to view the pictures, how big you'll enlarge them, and whether you do your own processing or printing. There's a subjective factor, though, too: many photographers use one particular make of film for the simple reason that they prefer like the way it records the hues and tones of the landscape.

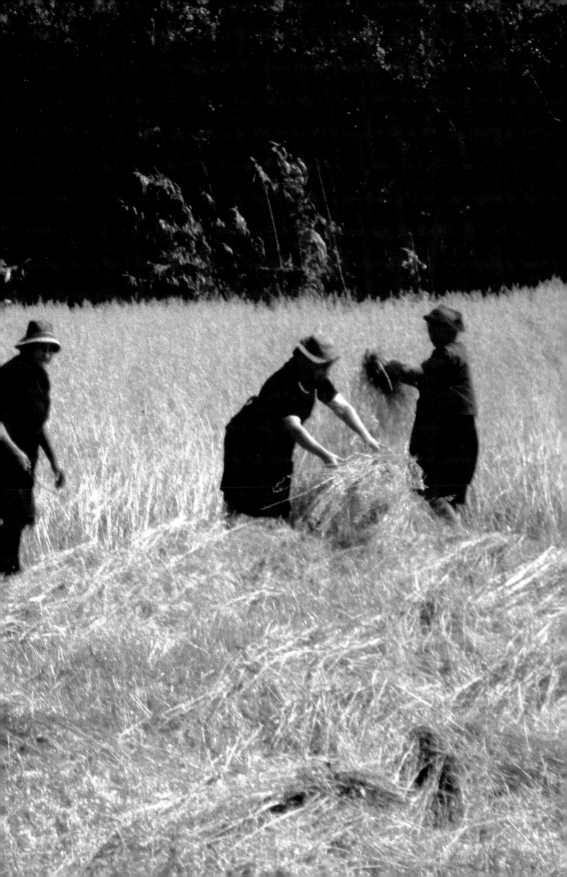

INFRARED FILM

Infrared radiation belongs to the same family of waves that includes other familiar forms such as visible light, X-rays and radar. On special film, you can take pictures using what is called "near infrared"; this is the part of the spectrum that lies between what our eyes see as deep-red visible light and what we feel on our skin as radiant heat.

Infrared black-and-white film is sensitive both to visible light and to infrared, and this broad sensitivity provides extra creative opportunities. By using filters, you can choose exactly what part of the spectrum you record on film. Without filtration, the landscape looks quite normal, though the images are fairly grainy. However, if you fit red or orange filters, such as Kodak Wratten 15, 25, 29 or 70, you'll find that all traces of haze (but not mist or fog) disappear from the landscape, so that even far-distant subjects can be seen clearly.

The filters that have the most radical effect, though, look black to the eye. These are the Wratten series 87, 87C or 88A. Photographed with any one of these filters, foliage appears white, and blue sky, black. These filters stop visible light, but not infrared, so don't hold them up to the sun – you'll see no light, but your eyes will be damaged, perhaps permanently.

Focusing and exposure require extra care with infrared film. Focus the camera lens normally without a filter in place, note the subject distance, and then move the focusing ring until the distance setting is alongside the orange IR focusing index on your lens. To set exposure, meter without the filter in place using a setting of ISO 50 with filters you can see through, or ISO 25 for "black" filters.

You'll also need to take special precautions to guard against fogging. Load the film into the camera in total darkness, and store unused cassettes in a freezer before use, giving them time to thaw before loading.

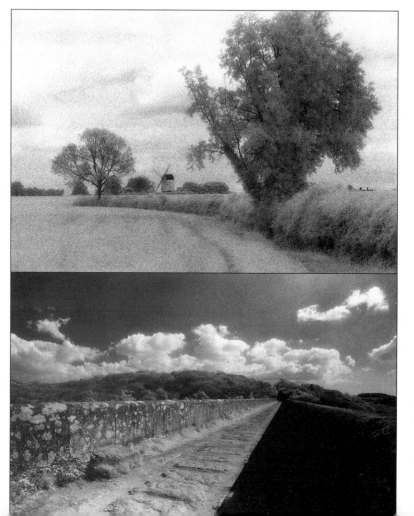

◀ **Red filtration**
For subtle infrared effects, use red, orange or yellow filters, and take pictures in overcast weather. Remember that on 35mm, coarse grain hides fine detail.
Olympus, 50mm, 1/15, f/8.

▶ **"Black" filtration**
Visually opaque filters produce the most dramatic results with infrared film. To turn foliage pure white, I fitted a Kodak Wratten 87 filter. I used a rangefinder camera so that I could leave the filter on the lens and still see through the viewfinder.
Leica, 21mm, 1/8, f/16.

◀ **No filter**
Using infrared film without a filter creates dream-like images with empty shadows – but without the tonal changes in foliage.
Olympus, 28mm, 1/125, f/11.

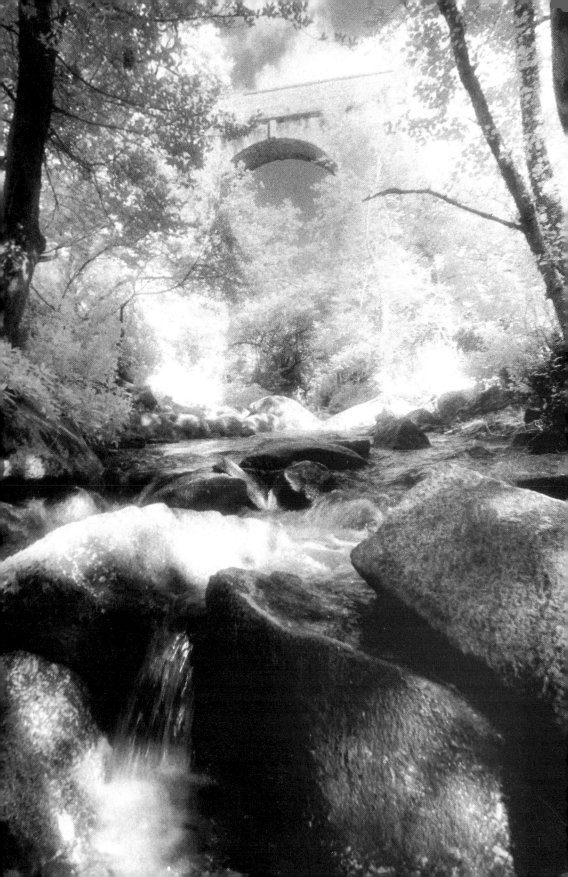

SHUTTER SPEED

The precise choice of shutter speed may not at first glance seem to be of great importance to the landscape photographer. The land itself is a static subject, literally as steady as a rock, but nevertheless, shutter speed provides a valuable and versatile control over the appearance of those parts of the subject that are not firmly anchored to the earth.

In fact, the list is quite long: most small plants move in a slight breeze, and whole trees sway in stronger wind. Fields of crops form swirling patterns as the wind chases across them, and smoke or clouds drift quickly across the sky on even quite still days. All these subjects look quite different depending on whether you picture them with slow or fast shutter speeds, but the landscape subject that is most profoundly affected by shutter speed is water. As shown here, moving water can take on a multitude of disguises, turning from cotton-wool soft at a two-second exposure, to frozen crystal at $^{1}/_{1000}$ sec or faster.

Man-made objects move, too, leaving trails across your picture if you leave the shutter open for long enough. Aircraft and cars leave behind straight traces from their lights; ships' lights dip and turn on film.

Choosing a fast shutter speed to freeze an active landscape usually creates few problems: set a fast speed using your camera's

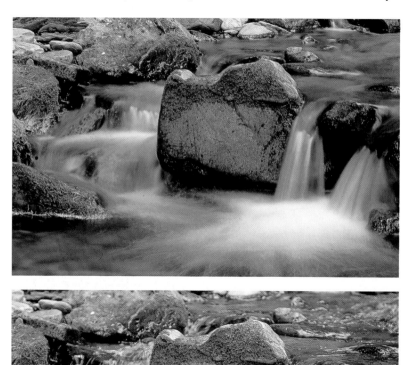

◀ Changing shutter speeds
Fast shutter speeds record moving water as shining crystal: the top image here was shot at 1/250. Longer exposures – 2 seconds in the lower picture – make water look soft, and more like mist. Olympus, 50mm, Kodachrome 25.

▶ Making surf look natural
Splashing water frozen into ice-like globules rarely looks genuine, an water blurred by a very long exposure looks equally strange. So if you're aiming for pictures that look natural, it is advisable to use shutter speeds between about 1/60-1/125. Here I picked the fastest of these speeds in order to retain some of the shape of the wave as it struck the rocks.
Leicaflex, 200mm, High-speed Ektachrome, 1/500, f/8.

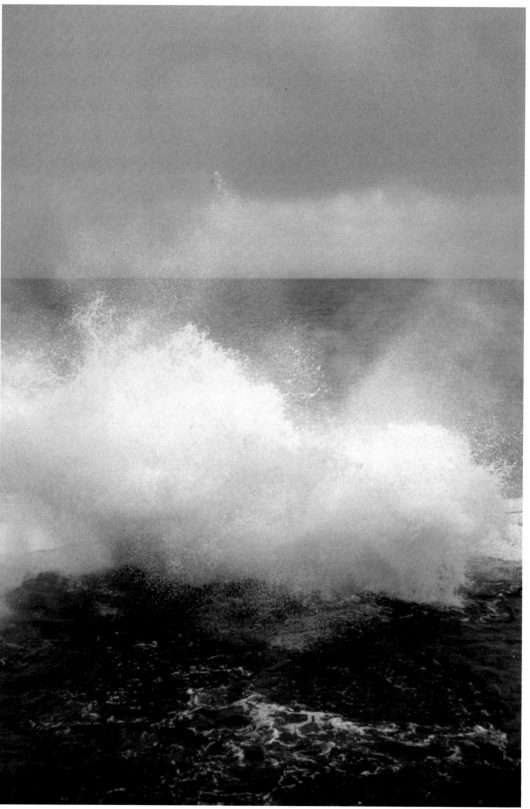

aperture-priority mode, or with the camera on "manual". You'll probably need to select a wide aperture, and use a fast film unless the light is bright.

To blur moving objects you must use shutter speeds so slow that you can't hand-hold the camera, so use a tripod (see page 22) or another support.

SLOWING THE SHUTTER

In sunlight, the slowest shutter speed you can use with the lens set to minimum aperture is likely to be around 1/30 sec – faster if you use sensitive film – and this isn't slow enough to get the full effect of blurred moving water. If you want a softer image, you'll need to fit a neutral density (ND) filter that cuts down the amount of light reaching the film. The most suitable filter has a density of 2.0, and cuts down the light reaching the film by 99%. This filter lets you set a shutter speed nearly seven stops slower, so that in sunlight you can use an exposure measured in seconds, not fractions.

▼ **Suggesting activity**
Figures add life to landscape, but they can also distract attention from the principal subject. Careful choice of shutter speed allows you suggest the human element without it being too intrusive. For this shot I enlisted the help of a passing child, setting a shutter speed of 1/8. Rolleiflex, Plus-X, f/11.

▼ **Using ND filters**
*I wanted to blur the water so that its texture would match that of the bank-side moss, but even with the lens set to f/16, the slowest speed I could set for correct exposure was 1/60. Fitting a 2.0 ND filter allowed me to leave the shutter open for 1/15 instead.
Olympus, 35mm, Kodachrome 25.*

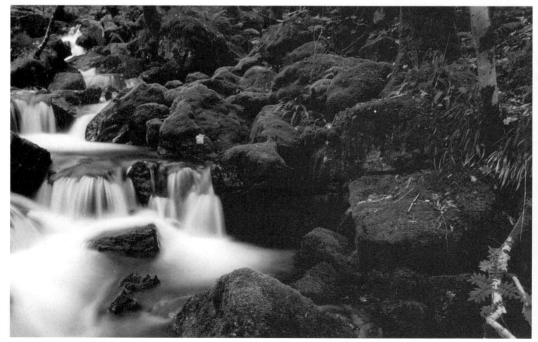

APERTURE

Like shutter speed, the camera's aperture plays a dual role: the size of the aperture controls .how much light reaches the film, and how much of the picture is sharp. The camera's meter generally takes care of the first of these functions, letting you know whether the aperture you've chosen is too large or too small for correct exposure with the film you're using. Control of sharpness, though, is up to you. Setting a small aperture increases depth of field, keeping more of the picture sharp, as explained in the diagram below. Wide apertures have the opposite effect, blurring subjects on either side of the zone of sharpest focus.

Usually you'll want as much of the picture sharp as possible, right out to the far distance. To help you make the most of all the available depth of field, use the scale on either side of the focusing index mark on your lens. Instead of focusing in the normal way, set the infinity symbol on the focusing scale alongside the depth of field mark for the aperture you're using. Zoom lenses lack a depth of field scale, but the lens manufacturer generally supplies a chart showing how much depth of field there is at each aperture.

If you take pictures with an SLR camera that has a depth-of-field preview or stop-down control, you can use this to check how much will be sharp. When you operate the control, the lens closes down from its widest setting to the aperture at which you'll take the picture. The focusing screen may darken, but you'll see more clearly how much of the landscape will be sharp on film.

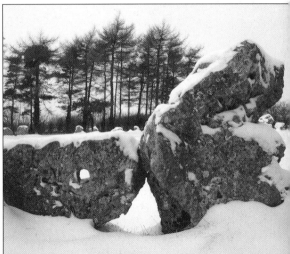

◀ **Depth of field**
At its smallest aperture of f/22, and focused on a subject 15 feet (4.5 metres) away, a 50mm lens keeps everything sharp from about 7 feet (2 metres) to the far distance (1). At f/8, the zone of sharp focus extends from 11 feet (3.5 metres) to 30 feet (nine metres) (2). And at full aperture, the picture is sharp only in a region 20 inches (0.5 metres) behind and in front of the figure (3).

▲ **Making the most of depth of field**
Dull weather forces you to use wide apertures, so depth of field is at a premium. For maximum sharpness, I focused 1/3 of the way between the foreground and background, because at moderate distances depth of field extends twice as far behind the plane of sharpest focus as in front. Olympus, 28mm, Tri-X, 1/8, f/4.

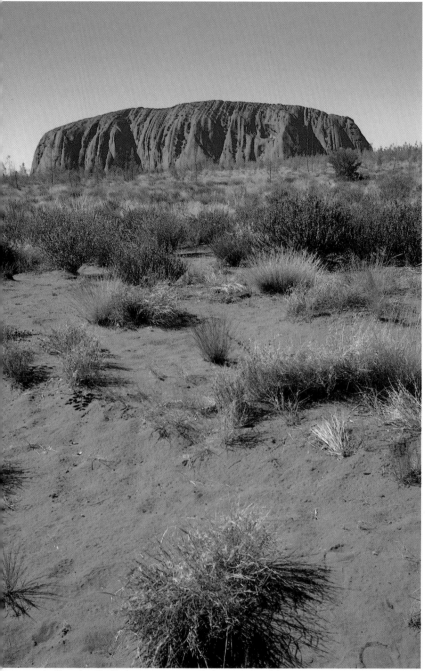

▲ Keeping it all sharp
Aperture is not the only factor that affects depth of field: focal length is just as important. The shorter the focal length, the more depth of field there is, so for maximum depth of field, use a wide-angle lens. In this example it was essential to keep distant Ayres Rock sharp, but I also wanted to retain detail in the nearby grasses, so I fitted a 20mm lens. Minolta, Kodachrome 25, 1/30, f/11.

▼ Stopping down long lenses

Long telephoto lenses have very little depth of field, even when focused on a subject a considerable distance away. I used a 300mm lens for this view of St Michael's Mount, and to record the dark foreground frame as anything but a formless blur, I had to stop the lens down to f/11.
Olympus, Kodachrome 64, 1/125.

CONTROL IN BLACK AND WHITE

Photographic control doesn't end when you've pressed the shutter release. You can continue to exert control over the landscape image in the lab, in the developing tank, and in the home darkroom.

Many processing controls are simple but effective changes of film speed. It's possible to boost or cut the speed of most slide films by simply increasing or reducing the time the film spends in the first bath of developer. Labs call this process "pushing and pulling", and you can specify the speed change you need when you take the film in to be processed. Just tell the lab the number of stops by which you want the speed changed – you don't need to know the new process times.

Why should you want to change film speed after exposure? There are many reasons: perhaps you inadvertently set the film speed dial to the wrong ISO number; or maybe you simply decided that the whole film would look better slightly darker than usual. Note, though, that the whole film is affected, and you can't specify a speed change for just a few frames. If you are unsure what effect the speed change will have, ask for a "clip-test". The lab will cut the first few frames from the roll, and process these in advance of the rest of the roll. Clip tests can of course be pushed and pulled quite independently of the rest of the film.

PUSHING AND PULLING

Some photographers use pushing and pulling to change other characteristics besides speed. Pushing film tends to increase grain size, and increase contrast, and these changes subtly alter the appearance of the landscape images. The changes are most dramatic when the base speed of the film is itself high, and the film is pushed two or three stops.

This versatile control over film characteristics is not available to users of negative film, but there are compensations. When printing negatives, it's possible to shade parts of the print during the exposure, to increase shadow detail, and to give extra exposure to the highlights, so that they appear darker in the print. If you have access to a darkroom, these "local" exposure controls are easy to master, or alternatively you can specify them when instructing a lab.

PRINTING CONTROLS

The principal attraction of black-and-white film is the enormous potential for control that the medium offers. Some of the controls, such as exposure, resemble those available to the photographer working in colour, but others are quite unique.

The first opportunity for control lies in processing the film. Prolonging development

increases the density of the black-and-white negative overall, but the effect is more marked in the denser parts of the image – those areas that will form the highlights of the print. Increased development makes the highlights much brighter, but with little change to the shadows. So by changing the development, you can exert precise control over negative contrast.

This control over contrast continues at the printing stage. Black-and-white printing paper is available in a wide range of contrasts or grades, so that you can potentially make several different prints from the same negative, simply by changing paper. Variable contrast paper make the change even easier: you just slide a different coloured filter into the enlarger.

As with colour printing, it's possible to change the tones of any area of the black-and-white print, simply by altering the exposure given to the individual areas of the print. You can use this facility to hide portions of the landscape in deep shadow, or perhaps to darken the sky several tones.

◀ **Dodging for emphasis**
To highlight the figures I shaded the sky and ground areas.
Pentax, FP4, 1/250, f/11.

▼ **Printing for grain**
For enhanced grain, print on hard paper such as grade 4 or 5.
Pentax, Tri-X, 1/15, f/8.

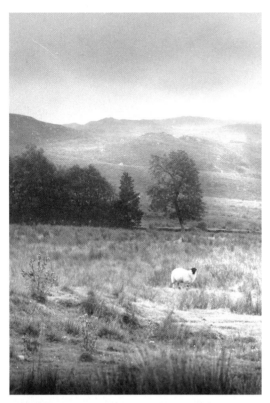

◀ Printing for impact

This Scottish landscape had a malevolent presence when I shot the picture, yet a straight print from the negative (top) was rather disappointing. I used several different darkroom techniques to put back some of the atmosphere of the place as I remembered it. A simple change in cropping moved the sheep closer to the edge of the frame, focusing attention more on the landscape behind. But it was local exposure control – burning in – that really changed the mood of the shot. The overall exposure for the print was 12 seconds, but I burned in the top and bottom, giving the sky and hills a further 15 seconds, and the foreground 20 seconds, to darken these areas, and make the print more low key and sombre. Minolta, 105mm, FP4, 1/8, f5.6.

▶ Bleaching detail

Here I first made a straight print, then painted over the coat with rubber solution. Immersing the print in bleach (see glossary) made other tones paler. Masked by the glue, the coat was unaffected. Hasselblad, FP4, 1/60, f/4.

▼ High contrast

I made the silhouettes of these rooks more graphic by increasing negative development to push contrast, and by printing on extra-hard (grade 5) paper. Burning in retained detail in the tree. Leicaflex, 200mm, Tri-X, 1/500, f/11.

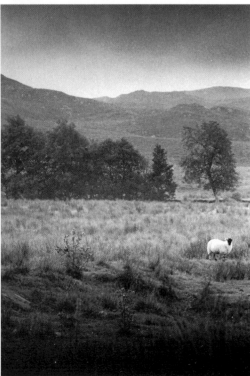

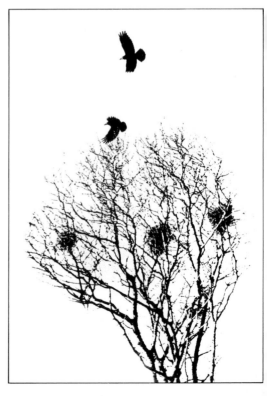

TONAL REVERSAL

Anyone who's made the mistake of turning on the darkroom light while the print is in the developer will have noticed the strange tonal reversal this produces. With a little care, you can harness this error to create unusual landscape images like those shown here.

This tonal reversal, usually called solarization, is characterized by a darkening of the lightest areas of the print, and by a wiry line that traces abrupt changes in density. You can produce the effect on film, but solarizing paper is more predictable and repeatable.

Start with a negative that has bold shapes and high contrast – fiddly detail soon gets lost in the process. Make a test strip in the normal way on hard resin-coated paper (grade 4 or 5) to determine the correct exposure, but develop the test in *undiluted* paper developer. Next, remove the negative from the enlarger and make a second test strip – of plain white light. From this test, note the aperture and shortest exposure time that just causes the paper to darken. This is your "fogging exposure".

Return the negative to the enlarger, and expose a print for the time determined in the first test. Then remove the negative, and prepare the enlarger for the fogging exposure. Put the print into the developer, and as soon as the image starts to appear, transfer the paper to a dish of plain water. Now place this under the enlarger, and give the fogging exposure. Finally, return the print to the developer, and process as normal.

You'll probably find that the resulting print is very dark. If so, rinse and dry the paper, and press it into contact with a fresh sheet, emulsion-to-emulsion. Cover both sheets with a piece of glass, and shine light from the enlarger through the sandwich to make a contact print. This process usually creates a copy with a lot more contrast.

Negative printing creates images which resemble those produced by solarization. If you shoot colour transparencies, you'll have no difficulty making negative prints – just put a transparency into the enlarger in place of a negative, and print on ordinary black and white paper. You'll need a soft grade, preferably 1. This will not give a tonally correct result – red areas of the transparency, for example, print as white – but in negative form this hardly matters. If you don't use transparency film, simply copy a negative onto black and white film to create a positive monochrome transparency, then use this in place of the negative.

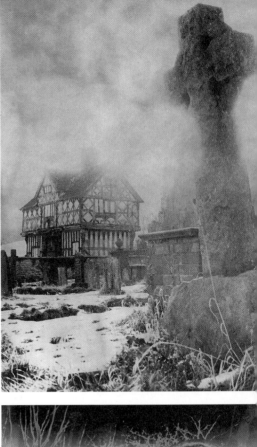

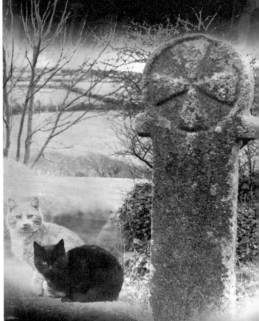

▲ High-contrast cats
I picked this subject for solarization because of the stark contrast between the black and white cats. The tonal reversal brought about by the process is especially clear in the lines around the twigs at the top of the image.
Rolleiflex, Tri-X, 1/125, f/4.

▶ Negative printing
I printed this picture from
a slide – paper is sensitive
to only blue light, so the
blue dress prints black.
Nikon, 50mm,
Ektachrome 64, 1/30, f/5.6.

▲ Solarized cemetery
The solarization process
is especially well suited to
off-beat landscapes like
this graveyard in a Tudor
village. When the print
had been in the developer
for about 40 seconds, I
placed it in a water-bath
and exposed it to white
light, while shading the
bottom half of the
picture. As a result, only
the misty sky was
affected.
Hasselblad, 50mm, Tri-X,
1/250, f/8.

▶ Mixing techniques
Solarization creates a
dark image overall, and
one way to get round the
problem is to use bleach
(see Glossary) to brighten
the highlights – the swans
in this example. I also
retouched the print with
black ink, to sharpen
outlines and add detail to
the bills.
Hasselblad, 80mm, FP4,
1/60, f/2.8

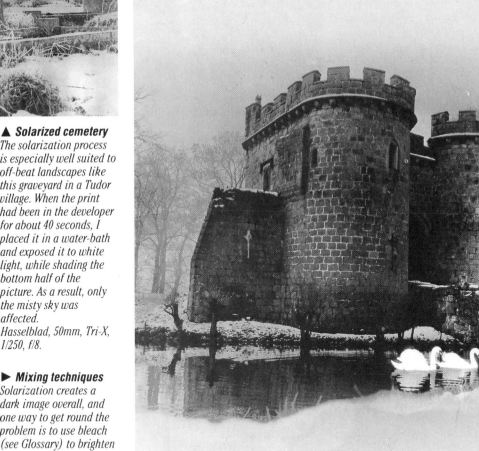

FILTRATION

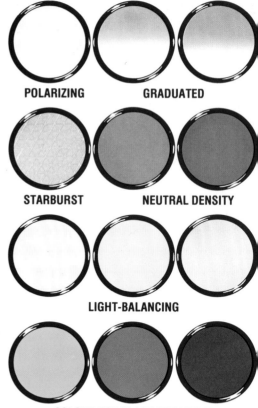

POLARIZING **GRADUATED**

STARBURST **NEUTRAL DENSITY**

LIGHT-BALANCING

COLOUR FOR BLACK AND WHITE

E ven the most humble photo store now stocks dozens of filters in every possible hue, to distort and manipulate the image before it reaches the camera's lens. However, the most valuable filters for landscape photography are not these special-effects filters, but a handful of rather plain filters in shades of grey or pale colours.

The most useful of these is probably the polarizing filter. This acts just like Polaroid sunglasses, cutting reflected glare from non-metallic surfaces. You can use a polarizer to eliminate reflections from the surface of water, to darken the colours of sky and foliage, and to reduce the effects of atmospheric haze. To make best use of a polarizer with an SLR camera, fix it to the lens, then rotate the filter mount while looking through the viewfinder. You'll see when the effect is most pronounced. With non-SLR cameras, you'll need to rotate the filter in front of your eye, then retain the orientation when fitting the filter to the lens.

USING GRADUATED FILTERS

Graduated filters are coloured at one edge, fading to clear at the other. They are especially valuable for reducing the brightness of the sky – grey is the best plain filter for this purpose. Used sparingly, the other colours can be useful for adding brightness to a dull scene.

Neutral density filters are grey overall, and their function is simply to absorb light without changing the colours of the scene. These filters are useful if you want to introduce movement blur to your landscape pictures by using a slow shutter speed.

Some special-effects filters find occasional use, even though most of them languish at the bottom of the camera bag 364 days of the year. For landscape photography, the most useful ones are those that act only on the highlights of the image, such as starburst or diffraction filters.

LIGHT-BALANCING FILTERS

If you use slide film you'll need to use "light-balancing" filters to match the hues of daylight to the colour sensitivity of the film you're using. Most slide film is designed for use in sunlight, and in overcast weather, for example, pictures shot without filtration have a blue colour cast. You can correct the colour cast using the yellow Wratten 81 series filters: 81, 81A, 81B, 81C, 81D, and 81EF . The 81 filter is the palest yellow, and the filters get progressively darker – the 81EF

▲ *Cutting filter costs*
A set of filters for landscape, as shown here, can be a heavy investment, but you don't need two sets if your lenses have different thread diameters. Buy filters to fit the larger size, and use a "stepping ring" adaptor on smaller lenses.

▲ *Filter systems*
These square plastic filters are very much cheaper than glass filters, and are just as good optically. However, they need extra care in use, because the plastic surface scratches easily. Though the holder can accommodate up to three filters, don't use more than two at a time, otherwise you'll have problems with flare.

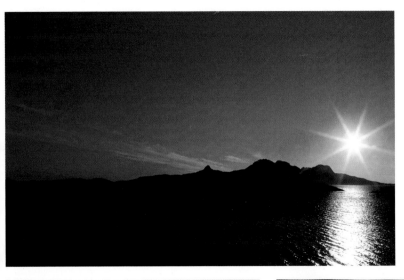

◄ Sunset starburst
Starburst and diffraction filters are effective only when there's a brilliant point source of light. The effect varies according to the aperture you use, so on an SLR, preview the picture by stopping the lens down to the working aperture. Pentax, 50mm, Ektachrome 64, 1/500, f/11.

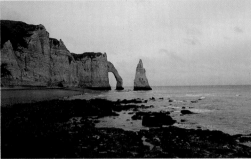

▲ Mono filters and colour film
The strongly coloured filters usually reserved for monochrome film are sometimes valuable allies with colour film. This bay was essentially colourless, so I fitted a yellow filter. Pentax, 50mm, Kodachrome 25, 1/15, f/4.

▲ Light-balancing filters
To add warmth to the setting sun, I used an 81EF filter here. The filter absorbed two stops of light, so I was able to set a wider aperture, and keep the foreground blurred. Olympus, 50mm, Ektachrome 64, 1/125, f/8.

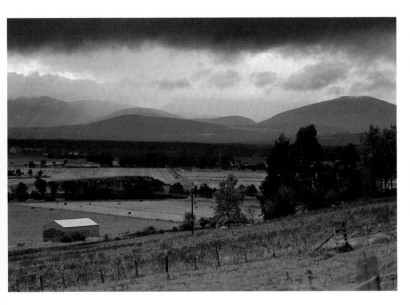

◄ Graduated sky
Even a grey sky is several times brighter than the ground beneath, and an exposure that suits one area usually sacrifices detail in the other. Graduated filters redress the balance, and can make gentle showers look like hurricanes. For this shot I used a tobacco graduated filter. Gandolfi, 210mm, Ektachrome 64, 1/2, f/22.

SEE·ALSO
Focal length p.19
How daylight changes the landscape pp.124-7
Shutter speed pp.38-40

is sepia in colour. For precise control of colour, you may want more than one of these filters, but for most purposes an 81C filter provides just enough correction.

Most filter manufacturers pack details of exposure compensation factors with their filters. These indicate how much light the filter absorbs, but you'll need to take this factor into account only when using a hand-held meter. Built-in light meters compensate automatically.

BLACK-AND-WHITE FILM AND FILTERS

When using black-and-white film, you can use deep-coloured filters to control how col-oured objects appear on film. For example, if you were photographing mixed woodland in autumn, you might have difficulty separating golden-leafed deciduous trees from a back-ground of conifers. Though the foliage of both types of tree is easily distinguished in colour, on monochrome film each appears the same tone. However, fitting a red filter would lighten the golden leaves, darken the pine needles, and also turn the sky black, creating a dramatic separation.

The most popular filters for monochrome are yellow, orange and red – all three espe-cially valuable for darkening blue skies. Red has the most effect, yellow the least.

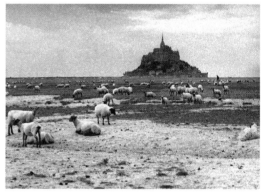

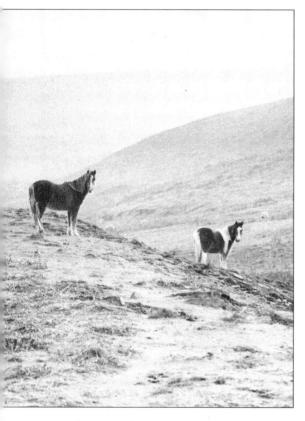

▲ Yellow filter
The moderate effect of a yellow filter is ideal for pictures where you simply want to put extra tone in the sky. This pastoral scene at Mont St Michel would have looked gloomy had I used a red or orange filter. Linhof, 210mm, Tri-X, 1/125, f/16.

▼ Using a green filter to lighten foliage
Any filter transmits light of its own colour, and stops other hues. Here I used a green filter to lighten the lush grass of a Scottish meadow in early autumn, and darken the brown leaves on the trees. Hasselblad, 80mm, Tri-X, 1/125, f/11.

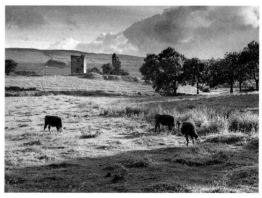

▲ Orange filtration
Orange filters are best used where you want to enhance yellow or brown tones. Autumn had turned the bracken on this Welsh hillside a golden brown colour, so I fitted an orange filter over the camera lens. This had the effect of lightening the
warm colours of the foliage, making the ponies stand out more clearly from the valley behind. Hasselblad, 120mm, FP4, 1/30, f/5.6.

Red filters for drama
The principal use of a red filter in landscape photography is to darken blue sky, which in turn tends to emphasize the white of the clouds. The effect is similar to that of orange and yellow filters, but much more dramatic. Without filtration, the sky above the house in the picture below would have looked flat; the filter adds texture.

Nikon, 28mm, FP4, 1/15, f/8.
Burning in the sky area during printing makes the effect of the red filter even more emphatic, right.
Pentax, 105mm, Plus-X, 1/8, f/11.

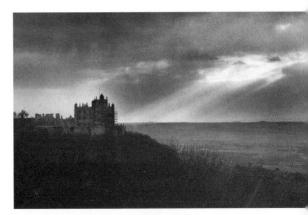

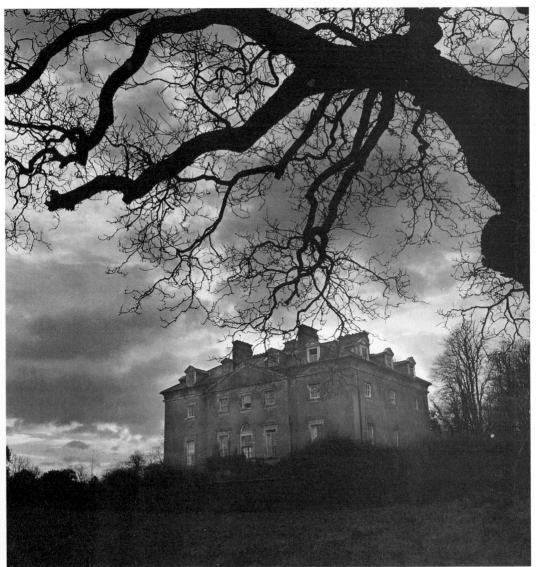

LEARNING TO SEE

The most important skill for a photographer to acquire is the ability to look at the landscape and visualize what the camera will record. This is never a single vision, but a multitude of possibilities, because photography offers a versatile range of controls and devices with which to manipulate the appearance of the image. The next few pages show the ability of the photographer to select and edit a landscape, but to understand how this happens, it is helpful to look first at how human vision differs from the camera's viewpoint. The eye and the camera both have a lens that's capable of focusing on objects over a range of distances; both use a light-sensitive medium to record images; and each has a variable aperture to control the quantity of light that enters. Stretching the metaphor a little, the eyelid is like the camera's shutter: an opaque barrier that opens to let light in.

While this is a convenient analogy in the context of the classroom, the eye/camera comparison isn't valid when the time comes to take pictures. Our eyes may resemble the camera, but the act of looking has little in common with the art of picture-taking. The image projected by the camera's lens appears faithfully reproduced on film, but the image we see when we look directly at the subject is filtered and interpreted by the brain, which combines previous experiences of the subject. Our eyes scan back and forth across the subject over a period of several seconds, as we examine in detail just one part at a time. And though we have the impression that we've seen everything sharply, our eyes actually perceive fine detail over just a small area in the middle of the field of view. The rest of the eye forms a much less detailed picture of the scene. The brain, however, remembers the whole scene – all the elements that add up to a comprehensive view of the subject.

Since we have two eyes, we see two, slightly different, views of the scene. The difference between them allows us to see depth and spatial relationships.

The camera views the scene quite differently. The shutter opens and closes very quickly, so the picture shows how the

landscape looked at just one instant in time. And because there's no "scanning", the camera records only one part of the subject in sharp focus; areas closer and farther away look less sharp. The camera registers a fixed rectangular or square part of the scene, with hard edges, like looking through a window on the world. Incidentally, the normal lens of around 50mm in focal length has a field of view that is the closest to that of the human eye. But despite this, the single eye of the camera makes pictures that lack depth – although the photograph retains indirect pointers that provide hints about the distances between parts of the landscape.

In practice these limitations allow you to select parts of the landscape that are capable of expressing more than a broader view would ever do.

▲ *Chasing rainbows*
Even faint rainbows are easy to spot in the sky, because they move across a static background when you move. On film, though, they often appear fainter than you remember. So to make this bow more prominent, I drove until I could frame it against a patch of dark cloud where I knew the colourful arc would stand out clearly.
Leica, 28mm, Ektachrome 64, 1/30, f/5.6.

IMAGE PLANES

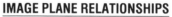

An open landscape forms a continuous vista that starts at your feet and stretches away to infinity. There are no sharp divisions to break up the scenery conveniently into separate regions for the camera. Nevertheless, it's often useful to divide up the scene with imaginary boundary lines. Sliced up into zones at different distances from the camera, the landscape takes on a more manageable form.

For most purposes, we create three zones, at progressively increasing distances from the camera: foreground, middle distance, and background. The division is completely arbitrary, and in the film industry, for example, script-writers may further divide these regions in order to specify their shots more concisely.

The division between adjacent zones is equally arbitrary: it would be absurd to say that the foreground extends exactly 20 feet from the camera, or that the background starts a mile away. Not every picture contains all three image-planes, either – distant scenes may be all background, with no middle distance or foreground.

Nevertheless, these loose definitions provide a useful vocabulary when we talk about the construction of landscape images.

IMAGE PLANE RELATIONSHIPS

Most pictures, of course, contain more than one of the three individual planes. Interaction between different subject planes can make an image dynamic, or placid; disquieting or reassuring. Broadly speaking, the foreground is dark-toned, the middle distance is mid-toned, and the background is lighter in tone. This effect is known as aerial perspective and is caused by haze and dust. Images that reinforce each of these characteristics fulfill our preconceptions of the landscape view, and we find them comforting, or calming. Usurping any of these values, though, tends to give the landscape image uncanny qualities.

By exploiting the effects of light and shade you can alter aerial perspective with startling results. Reflections in a lake, for example, frequently reverse the structure of the image, so that the distant elements of the scene appear lower in the frame than closer ones, which creates a visually exciting image. Storm light also produces an inversion, darkening the background while the sun lights the foreground. Similarly, low-lying mist creates striking imagery because it makes foreground detail less distinct and shrouds the background.

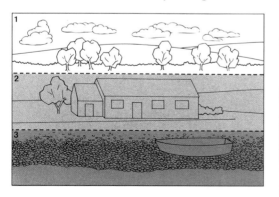

▲ **Levels of detail**
Subject planes hold different levels of detail in a photograph: in the foreground, the camera records even fine detail such as peeling paint-work. In the middle distance, coarse textures, such as brick-work, still appear. But in the distance, only bold shapes are recorded clearly.

▶ **Darkening skies**
When the distant view is darker than the foreground or middle distance, the picture is almost always tuned to a minor key. A straight print from this negative lacked the drama felt by every visitor to Mull, so I printed in the sky when I made the second print. Olympus, 50mm, Plus-X, 1/30, f/5.6

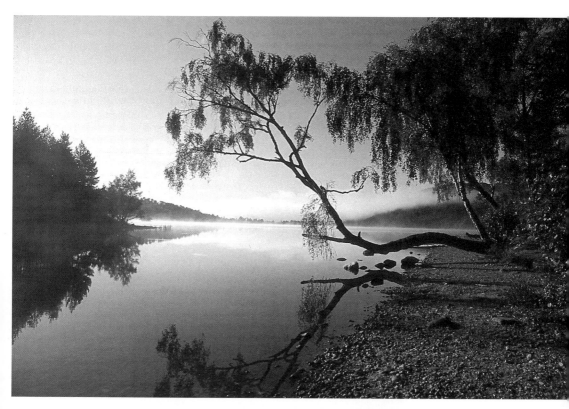

▲ Receding planes
The tranquility of this lakeside scene is enhanced by the change in tone between the foreground and the background. I used a polarizer to darken the water at the lakeside. Olympus, 28mm, FP4, 1/125, f/8.

◄ Juxtaposing near and far
The interest in this picture lies in the contrast between the distant view and the highly detailed foreground. If you cover the horizon, the interaction stops, and the picture is immediately less interesting. Pentax, 28mm, Tri-X, 1/250, f/11.

THE FOREGROUND

As a general rule, the foreground carries more specific information than any other part of the image. Because this image plane is closest to the camera at the moment of exposure, small features and fine textures appear sharp and clear on film, and not masked by image haze or mist. Though this is usually an advantage, it can also impose special compositional pressures: if the foreground is to be subject to close inspection, there must be something interesting.

Pictures dominated by the foreground always look specific: the image evokes a particular scene, carries a particular message, rather than just symbolizing, say, a mountain landscape. But when the background provides the main interest, the exact nature of the foreground is often less important, although it should play a supporting role.

The foreground can provide an excellent point of access to the picture: a detailed foreground catches the viewer's attention, then draws the eye on into the photograph, to explore fully the more distant elements, which are characterized by a progressive lightening of tone. But bear in mind that if the foreground is too busy, the detail there will overwhelm the rest of the picture.

▶ **Retaining distant detail**
Though flowers in the foreground dominate this image, their role is primarily to draw the eye into the scene, so it was essential that the image should be sharp from back to front. To obtain the maximum depth of field, I used a 28mm wide-angle lens, stopping down to f/16. Olympus, Ektachrome 64, 1/30.

DOMINANT FOREGROUND

If the foreground dominates your picture, think carefully about the role played by the other subject planes: if you exclude the middle-distance and background entirely, you may sacrifice the landscape character of the picture, and simply create a natural-history still-life; or in an example of urban landscape, a city detail. Background and middle-distance do not have to be critically sharp, but one or other should appear somewhere in the image.

Lens choice and camera angle provide valuable controls over how much foreground appears in your picture. The function of camera angle is obvious – point the camera down, and you include more foreground – but focal length has a more subtle effect. Telephoto lenses have a narrow field of view and the closest sharp point that appears in the picture is quite distant. Wide-angle lenses, though, include more above and below the lens axis, taking in more sky and more foreground, and giving maximum definition. Therefore, when you are using a wide-angle lens, you always need to pay special attention to those parts of the subject that are close to the camera.

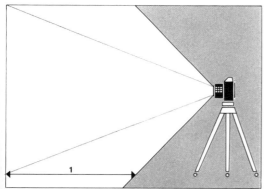

▲ Foreground and focal length
Wide-angle lenses take in more foreground than other focal lengths. Here, changing from a standard to a wide-angle lens has increased the foreground area by the distance marked 1 above.

◄ Supporting roles
*The repeated motif in the foreground of this image provides only pace and tempo, so it did not need to be critically sharp, and so I focused instead on the house.
Olympus, 50mm, Kodachrome 25, 1/15, f/4.*

▲ Cropping out other planes
*The foreground fills this image, but it still remains a landscape because a hint of a horizon peeps through the stalks.
Olympus, 35mm, Ektachrome 64, 1/125, f/8.*

▲ Framing the Foreground
*This is a picture dominated by the foreground. I wanted to frame the tree against the valley behind, and eliminate the horizon, so I scrambled a few yards up the hill from the road to get a higher viewpoint.
Hasselblad, 120mm, FP4, 1/8, f/16.*

THE MIDDLE DISTANCE

In landscape pictures dominated by the middle distance, details are close enough to the camera to be clearly visible, yet small enough for the image to lack clarity. The middle-distance puts the environment into context, so that the viewer sees broad landscape outlines without the scene appearing anonymous.

Pictures that highlight the middle-distance are as much in the control of the photographer as those in which the background and foreground dominate, yet the photographer's intervention in these images is less immediately obvious. Constructing the composition around the middle distance provides an uninvolved view in which the scene is at a safe remove from the viewer, and perhaps sets the scene for close-up and long-shots that might follow in a sequence of images such as a slide show.

But emphasizing the middle distance is not without risks. The most significant of these is that the principal subject matter of the picture may not be immediately identifiable. When composing the image, make sure that you've identified the subject element that you consider to be the main subject, then use less important parts of the picture in a subsidiary role to channel attention towards the subject in the middle distance.

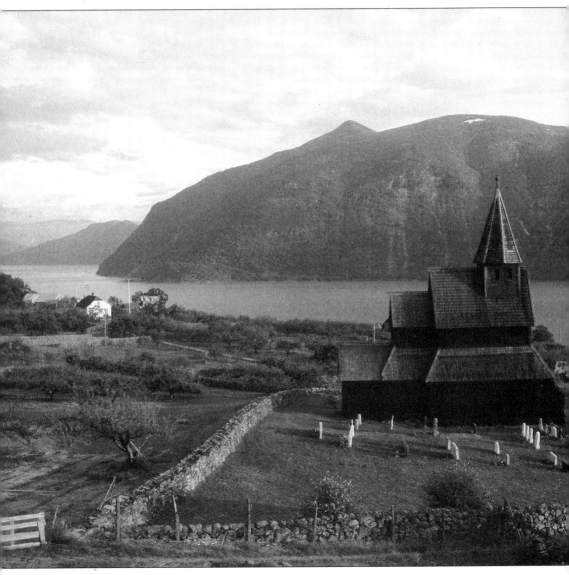

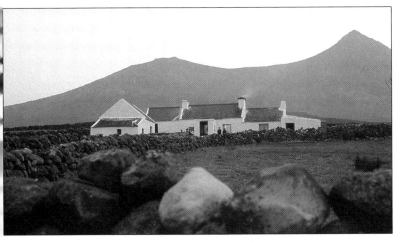

▲ The importance of setting

My first reaction when I saw this scene was to find a high viewpoint, and let the house fill the frame. Isolating the building from its surroundings, though, diluted the impact of the scene. Pulling back, and placing the house in the middle distance shows it in the context of its surroundings, and conveys the atmosphere of the place much more clearly. Hasselblad, 80mm, High-speed Ektachrome, 1/8, f/5.6.

◀ Setting the scene

I chose this picture as the first image in a sequence of the Norwegian church. Placing the building in the middle distance sets the scene, showing it in the context of a landscape that is uniquely Scandinavian. In other shots I explored different planes. Pentax, 28mm, Tri-X, 1/30, f/8.

▲ Eliminating the foreground

One very effective way to direct attention to subjects in the middle distance is to simply crop out all detail in the foreground. You can do this by using a telephoto lens or, as I did here, by looking down on the subject from a high viewpoint. Canon, 50mm, FP4, 1/60 f/8.

THE FAR DISTANCE

Just as foreground-dominated pictures emphasize specific aspects of landscape, so background-dominated pictures can highlight distant elements of a scene. For example, to create an image that simply conveys the idea of the sea, you might start by composing a picture of a wind-tossed seascape, cropping out cliffs in the foreground and coastline in the middle distance. The shot could have equal relevance to viewers familiar with any one of the Seven Seas.

Images that are composed exclusively of background, though, are unusual. They are mainly pictures of sunsets in which forms are silhouetted against the sky. Most often, though, the background plays a supporting part, and the principal subject falls in one of the other image planes. If you're focusing – either literally or metaphorically – on the foreground then the background provides a canvas on which to paint your view of the landscape. Remember that in these instances, the background need not be a specific landscape feature: often you'll wish to use the sky as a background.

If you choose to close in on the background at the expense of other subject planes, you'll find a telephoto lens a valuable aid. The narrow field of view of these lenses helps to isolate the most interesting sections, compressing the various planes together into a tight composition.

▼ **Suggesting distance with filters**
Aerial perspective makes distant subjects bluer and lighter, so we tend to associate blueness with distance. I fitted a Wratten 82C blue filter in order to make the far-off hills seem even farther away, and gave two stops additional exposure to make the picture lighter and to compensate for the light absorbed by the filter.
Olympus, 200mm, Ektachrome 64, 1/30, f/8.

▶ **Leading the eye**
Although this picture includes all three subject planes, there can be no doubt that the far distance is the main subject. I chose to include foreground and middle distance because these areas contain elements- such as the figure walking into the distance-that lead the eye back into the picture.
Olympus, 200mm, Ektachrome 200, 1/60, f/11.

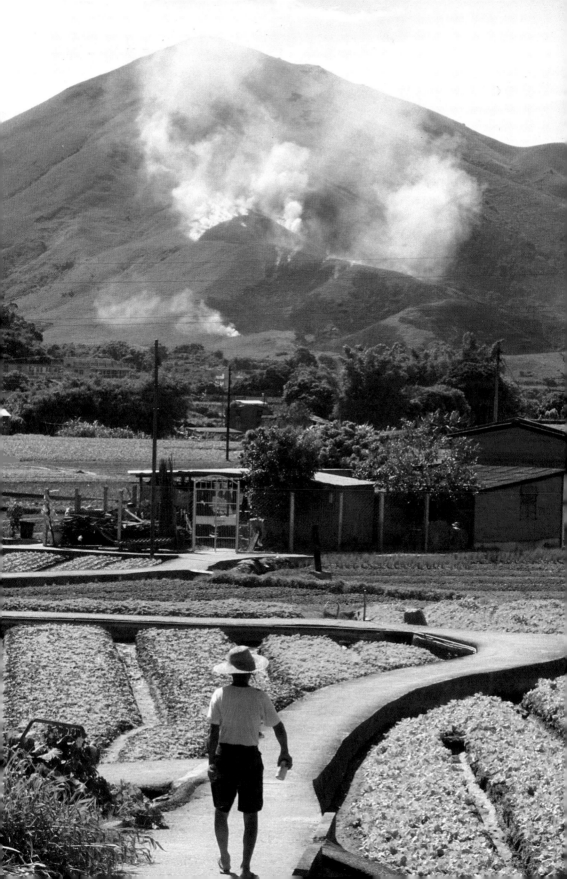

VIEWPOINT

Mobility is a more valuable photographic accessory than even an armoury of lenses. By moving around the subject, you can totally change the composition of a picture, aligning different foreground and background elements, or cropping out unwanted detail close to the camera. Crouching down near to the ground provides yet another view of the scene: from a low viewpoint, nearby subjects loom larger, and trees converge steeply skyward.

Changing viewpoint has the most dramatic effect when you use a wide-angle lens or the "wide" setting on a zoom. Since wide-angle lenses include more of the subject close to the camera, moving just a yard or two left or right brings a totally different foreground into view. With a telephoto lens, on the other hand, changes of viewpoint have a more moderate impact on the picture, and you'll need to move farther before you see any difference in the viewfinder.

Changes in viewpoint affect objects in the far distance very much less significantly than things nearby. Taking this principle to the extreme, moving the camera has no effect whatsoever on objects at an infinite distance – such as the sun and moon. So when there's a good sunset or moon-rise, take full advantage of this fact, and move around until you frame the sun or moon against a dramatic foreground landscape.

▼ **Eliminating unwanted subject elements**
Few photographers spend enough time moving around before taking pictures, yet careful choice of viewpoint can radically alter the appearance of the landscape. In this schematic example, the two camera angles tell completely different stories: from one direction, we see an idyllic valley, but a slightly different viewpoint includes features that paint a far less pastoral picture.

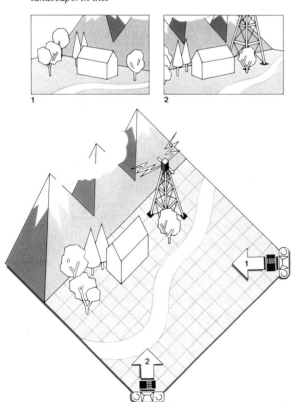

▲ **Moving round the subject**
Changing viewpoint adds variety to landscape pictures. A distant view gives a sense of the scale of London's Albert Memorial, but tells us little about the decoration (top left). Closing in, the monument is still framed by trees but appears in a grander perspective (top right). Moving closer still, shows detail, but strips away the context, and with no guide to scale we could be looking at a table decoration (above left). Finally, a close-up of the flanking statuary mocks the mawkishness of Victorian sentiment. Olympus, 28mm, FP4.*

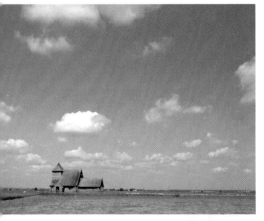

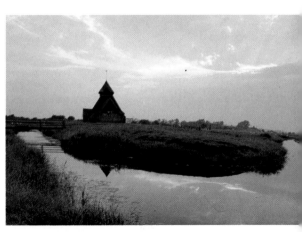

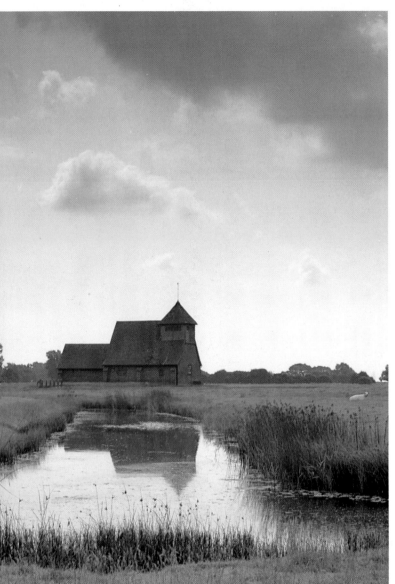

Viewpoint as one of many tools

Changing viewpoint is just one of many photographic techniques, and often you'll alter exposure or focal length when you move to a new camera angle. Visitors to this isolated marshland church can't help but be struck by the vast openness of the sky above, so I chose a distant viewpoint and a low horizon to dwarf the building (top left). Later in the day, I moved closer and underexposed by two stops to silhouette the church, and to show its relationship with the nearby dike (above). Changing from a wide-angle to a standard lens and picking a side-on view (left) gave a better impression of the church's structure.
Olympus, 28mm and 50mm, Ektachrome 64.

SEE · ALSO
Exposure pp. 26-7,
Positioning the horizon pp. 94-5
Reflections in water pp. 150-3

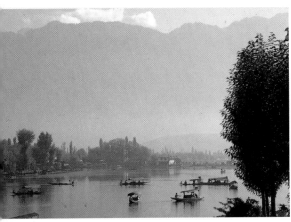

▼ **Wide-angle lenses exaggerate changes in viewpoint**
Wide-angle lenses include more of the foreground, so when you're using a short focal length lens, you'll find that moving the camera radically alters the picture. These two views were shot from spots separated by only a few yards, and yet each scene is totally individual, because the two foregrounds are so different.
Minolta, 28mm, Kodachrome 64, 1/125, f/5.6 (left) 1/30, f/11 (right).

▲ **Lenses and viewpoint**
A distant viewpoint allows you to use a long lens, and thus bring the background forward. I fitted a 200mm lens to make this mountain loom large over the quiet scene at its foot.
Olympus, Ektachrome 200, 1/125, f/8.

▼ **Viewpoint and timing**
Soon after passing this jogger I found a viewpoint where the rising sun cut across the water. When the runner approached I shot with a motor-drive to get a choice of images.
Pentax, 85mm, Ektachrome 400, 1/250, f/2.8.

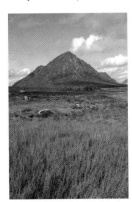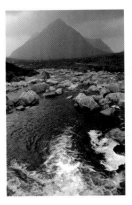

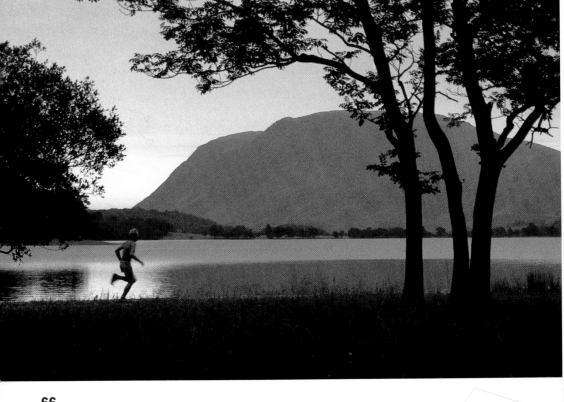

AERIAL PHOTOGRAPHY

Naturally enough, aerial views of the landscape tend to look radically different from pictures taken at ground level, but the difference is really just a matter of degree. Aerial photography simply takes the adoption of a high viewpoint to the logical conclusion.

Around take-off and landing you can take satisfactory aerial landscapes from a commercial passenger aircraft, provided that you avoid the vibration of the fuselage and reflections from the window. A rubber lens hood pressed up against the glass helps in both these respects.

Exposure meters often give misleading readings in aerial photography, so take a reading on the ground before take-off, and a second in-flight. Split the difference to find the ideal setting. Depth of field is not a problem, because the whole scene is distant, so set the fastest shutter speed you can.

The principal enemy in aerial photography is haze, so a clear day is best. Take pictures as soon after dawn as possible: later in the day heat blurs the view. Photographs taken in the early morning have the additional advantage of long shadows, which pick out indistinct marks on the ground.

▼ *Aerial technique*
Hot air balloons rise rapidly, so don't skimp on film while the gondola is still close to the ground (below). Higher up you may see only roofs.
Nikon, 28mm, Ektachrome 200, 1/125, f/11.
For the picture at the bottom *I asked the pilot to circle, bank the light aircraft, and slip towards the subject – this provided me with a stable, slowly-changing view. Shooting in early light helped to pick out the texture of the cut crop.*
Olympus, 50mm, Ektachrome 64, 1/250, f/4.

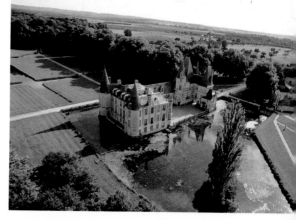

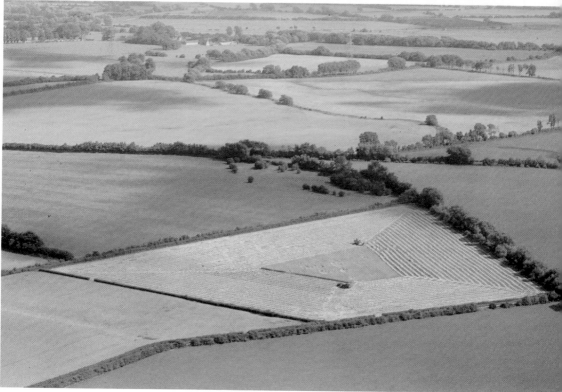

THE COLOURFUL LANDSCAPE

Memories of landscapes often throb with vibrant colour. We reminisce about last spring in shades of green, from the pale tints of new shoots to the black-greens of the yew tree. Summer sunsets are remembered as warm oranges, reds and purples. Seascapes we recall as the deepest of blues and greens. It's surprising then that the most evocative of landscape photographs are often those with subtle colouring of a particular hue.

The hues in a landscape, though, can be elusive, and are changing constantly. Memory is frequently deceptive, and scenes that we remember as vivid turn out to look delicate when we return to them or look at them on film. Often the subject itself changes, as when wild flowers bloom and turn a meadow from uniform green to a pointillist riot of colour. Other times, changing light alters the balance. It all depends on the angle from which you view the scene: with the sun behind you, the subject's colours will be strong and vivid; when against the sun, the subject's shape becomes more important, silhouettes are created, and colours are more subtle. Similarly, a view that seems washed out and pale at noon may seem painted in the richest of palettes in the late afternoon.

Capturing these colourful moods of landscape thus means observing and understanding the cycles of nature, and the direction and colour of the light. Careful selection of the subject and creating a balance between the colours included are often the key. In this way you can fill the frame with colourful elements chosen from a much broader scene that is predominantly monochromatic; or find a small splash of bright colour to react dynamically with otherwise dull hues.

Certain of the skills that you need to enrich colour are uniquely photographic: as explained on page 50, a polarizing filter cuts glare from the landscape, making colours richer and darker. Exposure is crucial, too – on page 28 you'll see how a little underexposure increases colour saturation of pictures shot with slide film.

◀ Hiding distractions with haze
On a clear day, the dark tones of the wooded hills drew attention away from the bulb fields. I returned later, and used haze to soften and diffuse the background, letting the colour shine through. Olympus, 105mm, Fujichrome 50, 1/30, f/5.6.

◀ Exposure and colour
Dark-coloured subjects, such as these olive trees, can mislead a reflected-light meter into overexposing the film, leading to washed out, insipid colours. I used a separate hand-held to measure incident light, setting the camera's controls to 1/125 at f/8. Nikon, 200mm, Kodachrome 25.

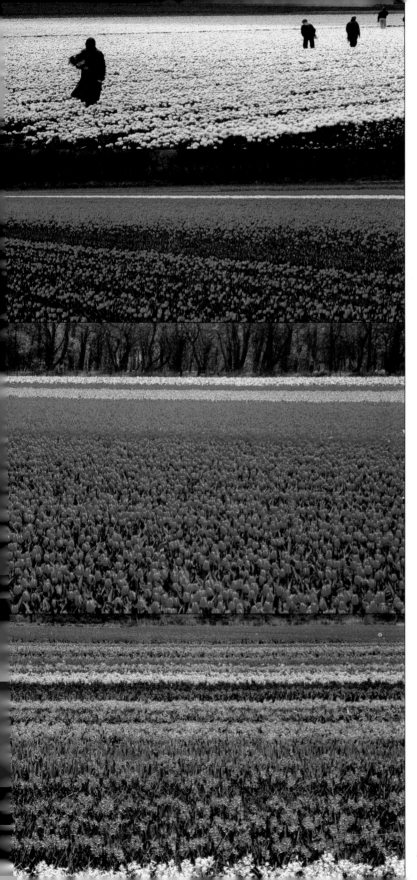

◄ Capturing primary colours on film

Landscapes made up of brilliant hues present special photographic challenges. Bright colours are particularly difficult for film to cope with, and you'll almost certainly notice some loss of intensity in one or more of the primary colours. Exposure is critical – with colour transparency film, slight under-exposure (about 1/3 stop) will increase saturation, but this is a risky technique with certain colours. Yellow subjects turn brown when underexposed. For this sequence of a Dutch bulb field, I took several precautions to ensure that colours were as rich as possible. I used slow film (Kodachrome 25) for the highest colour saturation, rated it at ISO 32, and bracketed at half-stop intervals over a 2-stop range. I used an incident light meter rather than the camera's built-in meter. Finally, I fitted a polarizing filter to cut out any glare that might mask the brightness of the blooms.
Pentax, 28mm and 80-200mm zoom.

SEE · ALSO
Filters pp. 50-3
Exposure pp. 26-7
Film choice pp. 32-3

► The hues of dusk
Daylight makes colours of its own: sunset washed this white house with rose, and I chose to ignore the normal corrective filtration in order to record the subtle spectacle.
Olympus, 50mm, Fujichrome 50, 1/2, f/4.

▼ Filtering for pure colour
These vibrant wild flowers were growing in a grove of trees, and light reflected from their leaves tinged the flowers with green. To prevent a colour cast, I used a pale magenta correction filter.
Pentax, 50mm, Ektachrome 64, 1/60, f/5.6.

◄ Introducing colour
If your subject isn't bright enough, just add some colour yourself! Overcast weather drained the life from this normally sparkling seaside town, and I had to enlist the help of a passer-by.
Pentax, 35mm, Ektachrome 200, 1/60, f/4.

RESTRICTED COLOUR

It's hard to look objectively at the colours of landscape, because our eyes tend to be drawn to the most dramatic hues and to areas of vigorous contrast. But if you can be dispassionate for a moment, you'll notice that in any landscape scene, the colours of the majority of subject elements are broadly similar. For example, a scene of rolling hills might be dominated by the green hues of the foliage, and the blue of the sky above.

The significance of this restricted palette of colours becomes clearer when you set into the landscape a single element of some different colour. The chromatic imbalance introduced by the new colour springs entirely from its context. Think of the brilliant colours of cactus flowers: the dots of colour are tiny, yet they grab the attention simply because they provide the only visual relief from the surrounding areas of brown desert and green succulent.

The photographic lesson to be learned from nature's example is that restricting the background palette to just one or two hues gives special emphasis to small areas of some other hue. A colour that would perhaps look unexceptional if it dominated the frame can arrest the eye when it is a counterpoint.

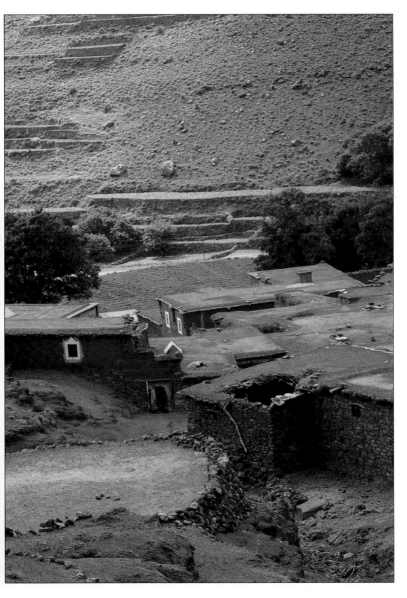

Splashes of green
Arid conditions create a dust-covered landscape that is dramatic in its own way (above), but when the palette of brown and sepia is broken by a rare patch of foliage, there is much more photographic potential (left). Climbing a steep path up above this cluster of huts provided a viewpoint where I could close in on the vegetation growing around the pool. Olympus, 105mm, Ektachrome 64, 1/125, f/5.6.

In practice, selection is the most useful tool for restricting and confining the colours of your images. In a uniformly coloured landscape, look around for pockets of some other colour that will set off the overall scene. Alternatively, start from the other standpoint: when you've found a colour accent, move around and perhaps change lenses until you can frame it against a background dominated by just a few hues. If you are able to print your own pictures, it may be possible to use local colour filtration to subdue any elements that interfere with the restricted palette of the whole photograph.

▼ Storm light
Colours look more saturated in sunlight, so when cloud patterns are fast-moving, wait for sunbeams to strike your subject.
Olympus, 28mm, Fujichrome 50, 1/60, f/8.

▶ Tonal emphasis
To emphasize this splash of pale colour, I moved around and framed it against the darkest background.
Olympus, 105mm, Ektachrome 64, 1/125, f/5.6.

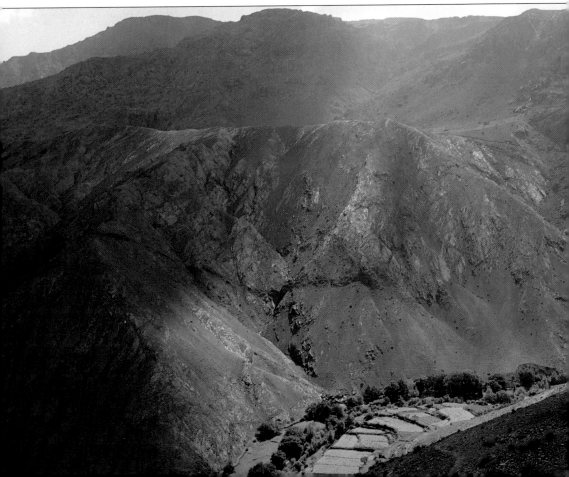

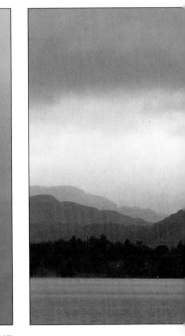

▲ Creating pastel hues

Sunset over a snowscape (above) provided welcome colour after a dull day. I softened the hues still further by choosing a long exposure, so that camera shake mixed together the stripes of pink and blue, and blurred the harsh outlines of the winter trees.
Minolta, Ektachrome 64, 1/2, f/5.6.

To make the colours of the receding hills (above, right) softer, I shot the scene on Kodacolor 400 which has a particularly muted palette.
Pentax, 200mm, 1/250, f/5.6.

SEE · ALSO

Exposure pp. 26-7
Viewpoint pp. 64-7
Filtration pp. 50-3

DELICACY OF COLOUR

Colour film provides such a lively spectrum of hues that there is a great temptation to go looking for landscape images that incorporate nature's most strident colours. Yet subtle colours can weave as powerful a spell.

Creating delicately-coloured images isn't just a matter of spotting suitable subject matter: technique is all-important. You can make things easier for yourself by fitting a telephoto or long zoom. Their restricted field of view makes it easier to crop out brightly-coloured detail that jars against the softness of the dominant hues.

Watch the weather and time of day, too. You'll find that overcast weather creates subtle, more delicate colours than sunlight, and that some of the most beautiful hues appear just after the moment when the sun has slipped down below the horizon.

To double the appeal of delicate colours, look for reflective surfaces. After rain, wet stone, grass and puddles act as crude mirrors – so if the sky is painted in quiet colours your whole photograph will pick up some chromatic theme.

Finally, try experimenting with different types of film. Slow films – particularly reversal emulsions – tend to be high in contrast, so instead pick one of the faster films such as Kodacolor 400 or 1000. These films produce flatter results and have a more muted repertoire of colours.

COLOUR HARMONY

Some combinations of hues look natural-ly harmonious to the eye, while others jar and irritate. However, there's no spe-cial alchemy in combining colours, and if you follow a few simple rules, it's easy to cre-ate harmonious landscape images. Nature gives you a lead, in any case: what could be more soothing than the russets, reds and browns of autumn foliage, or the succession of blues created by distant mountains or hills?

Harmonious colours generally fall into one of two categories: close primary colours; and earth colours. With bright colours, you can choose harmonious combinations by thinking of the rainbow. Any two hues that are adjacent or close together in the rainbow will look good together on film.

Earth colours – those hues muted by the addition of black – make for even easier combinations. Almost all earth colours go well together, so if you restrict your palette to the many different warm browns, golds and dark yellows you can't go far wrong.

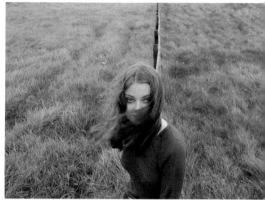

▲ Mixing earth colours
At ground level, this scene presented a naturally harmonious spectrum, but the quiet colours were spoiled by the brilliant blue sky above. I got round the problem by climbing a gate and looking down at the girl. An 81B filter warmed up the skin tones. Minolta, 35mm, Ektachrome 64, 1/30, f/2.8.

▶ Adding white to colours
Moss and lichen growing on the wall make this picture a naturally harmonious study in browns and greens. However, shot normally the scene would have looked rather sombre and morbid. To mix white into the picture and lighten the hues I turned the camera to face the open end of the abbey, and breathed on the front lens element to provide some improvised diffusion. As the mist evaporated, I shot a series of pictures, and in the end chose one of the least diffused. Hasselblad, 50mm, Ektachrome 200, 1/4, f/8.

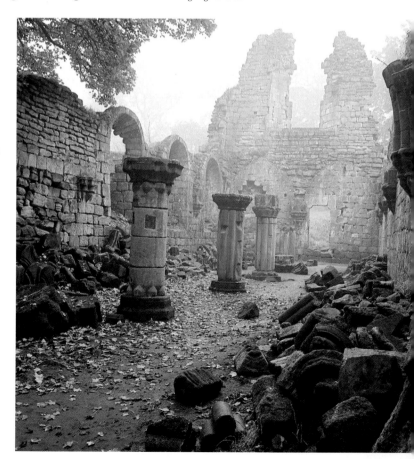

◀ **Filters for autumn colours**
The golden hues of autumn make beautiful pictures when you catch the trees at just the right time. If gales have stripped some of the brightest leaves, the warm colours may need a little help. The most useful filters for this purpose are from the Wratten 81 series, which range from very pale straw (81) to the tobacco-coloured 81EF. For this shot I used the light brown 81C. This put back just enough gold, and subdued the bright evergreens in the foreground.
Olympus, 105mm, Ektachrome 64, 1/15, f/4.

▶ **Tinting the sky**
Graduated filters provide a convenient way of adding a colour that harmonizes with other hues in the scene. Here the light grey sky was an unwanted tonal distraction, so I minimized its impact on the picture by using a tobacco graduated filter.
Pentax, 50mm, Ektachrome 64, 1/4, f/8.

MONOCHROMATIC COLOUR

From a restricted range of colours in a picture, it's just a short step to a monochromatic image. Many natural phenomena create scenes of a single colour: smoke, for example, washes a landscape with a near-uniform grey.

The camera, though, provides other ways to narrow down the range of colours in a scene. Coloured filters, for example, transmit light of just one colour, and absorb light of contrasting colours. Deep-coloured filters eliminate all but one hue.

Diffusion filters create monochromatic images in a different way, by spreading the highlights of the pictures into the shadow areas. So by diffusing a landscape scene that features a bright blue sky, you could tint the whole image blue.

Exposure provides a further control. Normal exposure records colours in their "natural" relationship, but altering exposure distorts the colours in the scene. Cutting exposure – by setting a faster shutter speed or a smaller aperture – is like mixing black in with a brightly coloured paint. The darker pictures that result are suffused and unified by their muted earth hues.

This approach produces sombre, low-key images, and increasing exposure is perhaps a more useful technique. As you'd expect, deliberate overexposure is like adding white, and as the hues in the scene get lighter, colour conflicts are erased, and the picture becomes increasingly monochromatic.

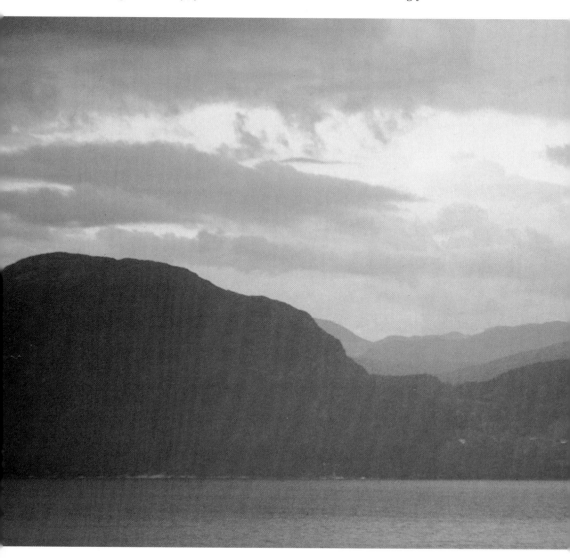

▼ Blue filtration
The far bank of this Scottish lake was a commotion of colour. To my eye, though, the shapes of the hills and the patterns in the clouds were the most interesting aspects of the scene, so I decided to fit a deep blue Wratten 80A filter to the lens, and then cut exposure by a stop in order to hide the trees in a dark blue shadow. Olympus, 200mm, Ektachrome 64, 1/8, f/4.

▼ Picking out texture
Like black and white images, monochromatic colour photographs often say more about tone and texture than about colour. I waited until late afternoon to shoot this image, because at that time the low sun backlit the scene, limiting the range of colours and focusing attention on the furrowed field. Canon, 300mm, Ektachrome 64, 1/250, f/8.

▲ Crop for colour
For this picture, I added a 1.4× tele-converter to my 300mm lens in order to close in on the shades of green. Pentax, Kodachrome 25, 1/30, f/8.

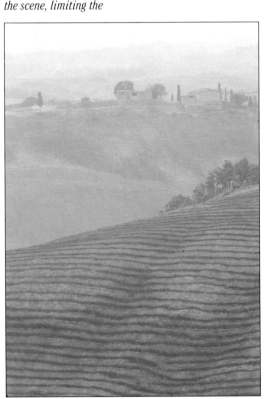

▲ Long lenses for monochromatic colour
Haze and mist restrict colour, acting like pale blue filters, and telephoto lenses enhance the effect still more. Pentax, 300mm, Kodacolor 400, 1/125, f/8.

MONOCHROME LANDSCAPE

Black and white landscapes aren't just colour views without the hues. Photographing landscapes in monochrome requires a mental discipline that is completely different from that needed when there's colour film in the camera.

Monochrome landscape images rely for their strength on differences in tonal values, irrespective of colour. Since our eyes do not automatically separate these values from hue, making the break is difficult at first. To make the distinction clearer, try turning down the colour control on your TV. You'll see colour contrasts fade away, so subjects that usually stand out clearly from one another begin to merge. A blue tie disappears into a red shirt; green letters blend into their orange background. Brightness differences remain, though, so that shadows stay dark, and brilliantly-lit areas still look white on screen.

Another more subtle effect occurs when you drain a scene of hues. You begin to notice aspects of the picture that are normally masked by the colour. In a colour landscape, the brighter greens of spring leaves catch the eye, but a black-and-white image of the same scene is dominated by the patterns of light and shade cast by the woodland canopy above.

▶ *Printing for tones*
Simple monochrome images like this rely for their drama on the interplay of light and shade, so print quality is crucial. I printed the picture using a fibre-based paper, Galerie, which provides richer blacks than resin-coated paper. To emphasize the highlights in the swans and clearing mist, I printed in the sky. Canon, 105mm, Plus-X, f/3.5, 1/125.

▼ *Eliminating the distraction of colour*
Housing clustered under the protective flanks of Dover castle created an attractive, rhythmic pattern, but coloured paintwork made the picture look too busy. I chose monochrome film to highlight the shapes. Rolleiflex, FP4, 1/30, f/8.

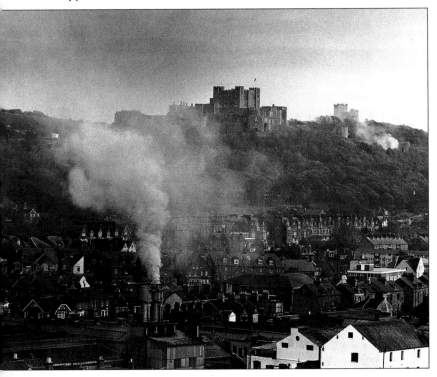

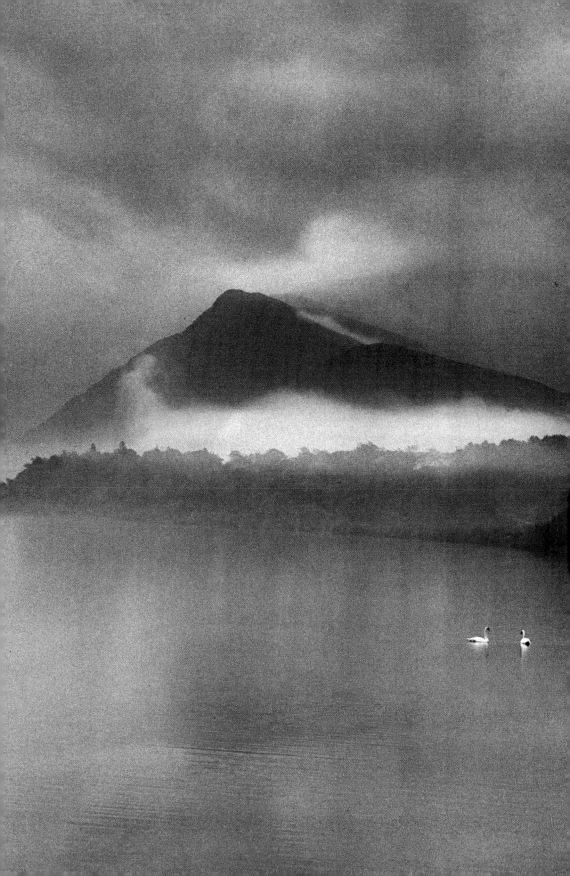

BALANCING TONES

Visualizing and balancing these tonal values as they will appear on the print is the essence of making great landscape images in monochrome. It's a different form of expression, related to colour photography, but with a new set of rules. You'll find more about the factors that are unique to black and white landscapes on pages 44-7.

For many landscape photographers, the attraction of using black and white lies in the degree of control that is possible. Black and white film is very easy to process in a home darkroom, and printing is equally simple. Furthermore, the process of translating a monochrome negative into a print allows the photographer an extraordinary degree of interpretative freedom. For example, brilliant sunlit hills and puffy clouds can be turned into a dark, menacing landscape on the brink of a storm. The pictures on these pages will give you some idea of what's possible.

▼ Study at dusk
The combination of the solitary wayfaring figure and the quality of the light at dusk was what inspired me to take this shot. Just before darkness descends, the light is ideal for creating evocative monochromatic images.

Hasselblad, 200mm, Royal-X, 1/2, f/4.

▼ Control with shading
The curving path at the top of this print leads the eye onwards, exciting curiosity about what's round the corner. I wanted this distant section of road to print lighter than other areas, so I cut its approximate shape from black card,

and taped this to a piece of stiff wire. I then held the "dodger" just above the print surface for ⅓ of the print exposure time, keeping it constantly in motion to avoid a hard outline.
Rollei, FP4, 1/15, f/8.

◄ Cutting contrast
Negatives shot in dull weather generally need harder paper to add sparkle, but this picture works better when printed fairly flat, on grade 2 (normal) paper. Printing in the white houses for ½ the main exposure time ensured that their white walls did not dominate the image.
Canon, 135mm, Tri-X, 1/8, f/8.

SEE · ALSO
Control in black and white pp. 44-7
Focal length p. 19

LANDSCAPE ABSTRACTION

The development of photography eventually led painters to abandon realism for a time in favour of abstraction; so it is especially ironic that most people still cling to the idea that a photograph must be a recognizable view of the subject, with everything included.

In fact, some of the most powerful landscape photographs contain a degree of abstraction and close selection. This is often because minimizing or eliminating identifiable subject elements makes the photograph general, rather than specific. In an abstract landscape we read not a particular field at one spot in the American corn belt, but a landscape that stands for all such fields. An abstracted view of a French château conjures up the idea of gracious houses rather than a particular place.

A crucial factor when experimenting with photographic abstraction is the design element. For example, by cutting out of the picture the perspective clues by which distance is judged, you can convince the viewer that he is seeing just a pattern of marks on the surface of the print, rather than a representation of a real place existing in a three-dimensional world.

These "depth clues" are so familiar that most of us take them for granted, and before we can eliminate them or minimize their effects, it's necessary to step back and look at the scene with the analytical eye of the painter. In Perspective and scale (pages 104-5) you'll find an explanation of how we recognize spatial relationships in the landscape, and how to minimize the sense of depth, to create an abstract image.

◀ Using reflections
Mirror images add an abstract element to landscape scenes, but to catch reflections on water, you'll need a really still day. If you use an autofocus camera, take care when making mirror images, because the camera may focus on the reflecting surface, blurring the distant view. Use the focus lock or focus manually. If there's no still water around, try holding a hand-mirror horizontally against the front of the lens to create an artificial reflecting surface.
Olympus, 28mm, Ektachrome 64, 1/50, f/2.

◀ Look out for lines
Often landscape abstraction is just a matter of identifying suitably geometric subject matter.
Pentax, 50mm, Kodacolor 100, 1/60, f/11.

◀ Using the sky
The sky is never an even shade, and the change in hue is usually enough to make a rigidly formal composition interesting. The variation shows best with a wide-angle lens. Minolta, 28mm, Kodachrome 25, 1/30, f/8.

◀ Balancing tones
The sky is so much paler than the ground beneath that it often appears as white or very pale blue in abstract images such as this one. A strong neutral grey graduated filter redresses the balance, and alters the sky's tone to match that of the ground. Olympus, 200mm, Kodachrome 25, 1/125, f/5.6.

▼ **Abstraction in closeup**

In this picture, moving in closer to capture the subject in isolation strips away the context of the landscape. The gnarled trees become the starting point for the viewer's imaginative adventure. If they are to work well, images of this type should always be critically sharp – in this example shallow depth of field would have hidden the distant tree that is an essential element of the composition.
Nikon, 55mm macro lens, FP4, 1/4, f/22.

► **Making textures contrast**

To show up the rough and the smooth, it's best to choose a time when there is low-raking oblique sunlight. But if the subject matter does not cover a large area, a hand-held flashgun provides a good alternative.
Hasselblad, 80mm, FP4, 1/8, f/16.

SEE·ALSO
Control in black and white
pp. 44-7
Aperture pp. 41-3

▼ **Picking out the unusual**
Don't stick with tried-and-trusted subject matter: often the most unlikely objects make the best landscape abstractions. Careful control at the printing stage helped retain the textures in this shot. Hasselblad, 50mm, Panatomic-X, 1/60, f/11.

MANIPULATING THE LANDSCAPE

Familiarity dulls the senses, and landscape photography is no exception: it's hard to look objectively at a scene that greets you day after day. Manipulating the landscape makes people look afresh at a vista they pass by constantly without a second glance and offers the advantage of surprise.

Mixing genres of photography is a valuable way to exploit this surprise element. People like to be able to give pictures neat labels, and combining different types of imagery undermines this ability, introducing ambiguity – is it a portrait or a still-life? or a landscape?

In making pictures like those shown here, the most important consideration is the relative scale of object and setting. Images such as these work best when landscape and object compete for the viewer's attention. The human figure is the most potent of all introduced objects, and therefore an element that needs to be handled with great care. The figure draws the eye, and can easily dominate the view, so that even a tiny figure

on the horizon is a counterpoint for a towering landscape.

Manipulated pictures are by definition contrived in the broadest sense of the word, yet to be successful, the images must not look conspicuously artificial or laboured. Striking the right balance is largely a matter of experience, but even veteran photographers probably discard dozens of images for every one they use. So you should be prepared to shoot plenty of film, and to edit ruthlessly when you see the results.

▼ Adding a figure
An important element in any landscape that incorporates the nude is textural contrast, so aim to highlight the different surface qualities of skin and bracken, bark, leaves or twigs. Sharpness helps: stop the lens down as far as possible to keep everything sharp, as in the image below. Try also to keep the figure evenly illuminated: shoot on overcast days, as I did for the picture below left; or move your model into shade.
Hasselblad, 50mm, FP4, 1/8, f/11 (below left); 1/2, f/16 (below).

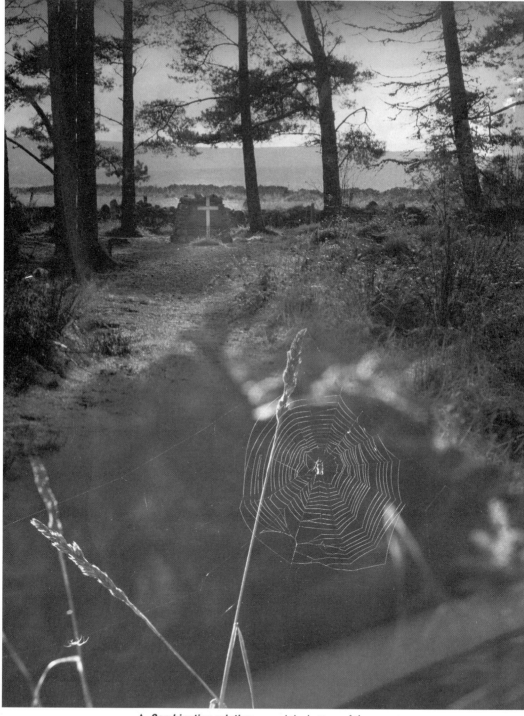

▲ **Combination printing**
Manipulation of the landscape image can continue in the darkroom: this picture combines two negatives. First the landscape was printed, and the bottom of the paper shaded; then the web was printed, and the top shaded.
Olympus, FP4, 55mm, 1/125, f/8 (web) and 35mm, 1/250, f/11.

THE COMMITTED PHOTOGRAPHER

In composing landscape pictures, all of us are commenting on what we see, either consciously or unconsciously. There is no such thing as an objective photograph, and we all make subjective decisions at every stage of picture taking, right from the moment we stop to view a scene and evaluate it.

What we see and select for our photograph and how we take the picture are usually exercises in judgement where the aim is to strengthen the impact of the subject by simplification. Often, what we choose to leave out is more important than what we include, for packing in too much tends to confuse and ultimately weaken the image. However, some scenes generate a strong reaction by their very subject matter and here the priority is on conveying the emotion they provoke. Discovering a pile of rubbish in an isolated wilderness, or an ugly holiday development in an idyllic valley is enough to annoy anyone. When these emotions come through in the pictures we take, the images are often stronger as a result.

Committed landscape pictures needn't make negative comments, either: of course, one photographer visiting a desert area might see only the stumps of trees cut for firewood, thus removing the last barrier that holds the sand back; but another individual might instead focus on a growing oasis where oil billions are helping to turn the desert green again. Neither is right or wrong, but a personal view often creates a potent image that makes a statement.

As with all types of pictures, if you have something to say about a landscape you can use the simplest of equipment, provided you have mastered the basic skills, to produce vital images.

▼ Dividing the frame
A low viewpoint, close to the ears of wheat, ensured that the field's edge made a rigid division between farm and factory; I set a shutter speed of 1/250 to freeze the swaying crop and enhance the sense of gritty realism.
Pentax, 28mm, FP4, f/11.

COMPOSITION

T here's no mystique involved in composing landscape pictures, and even the most visually naive and unaware snapshooters compose images every time they take a picture. Those lucky enough to have a natural eye for composition can look through the viewfinder and instantly arrange the landscape elements into a pleasing and harmonious pattern. Some of these photographers have no formal education, and absolutely no knowledge of the ground rules of composition. How is it, then, that their photographs conform so precisely to time-honoured laws of composition?

The reason is simple: compositional guidelines are not an arbitrary framework dreamed up by a committee of stuffy academics. Many of the rules have evolved through centuries of study of what makes images pleasing to the eye. This century has added a second branch of knowledge – scientific studies have explored the psychology of vision, how we look at pictures, and how we mentally synthesize the original scene from the photographic image.

For the vast majority of us who are not blessed with photographic "perfect pitch", an understanding of the formal rules of composition and perspective is a valuable aid. These compositional rules provide a framework, a scaffolding that can help you to construct your own unique vision of landscape. They also provide a kind of official code – a system to which viewers expect your pictures to conform. So if you aim to make landscape images that shock or unsettle the viewer, you can alter the formal rules of composition and use them as a means to disturb. Your pictures won't suddenly and dramatically improve if you slavishly follow the rules of composition and perspective. But armed with a knowledge of them, and taking into account the demands of the subject and the mood you seek to create, you will find it easier to take effective pictures.

▶ **Following the rules**
This composition follows some rules to the letter – yet breaks others. The interlocking "S" curves made by the river lead the eye back into the picture, and the horizon divides the frame approximately in the proportions of the golden section (see page 96). And although the brilliantly-lit foreground breaks with convention, it's this bright diagonal patch of light which makes the picture different and startling. Setting exposure to suit the foreground ensured that the underexposed middle distance would appear stormy and full of foreboding.
Pentax, 28mm, Ektachrome 200, 1/125, f/16.

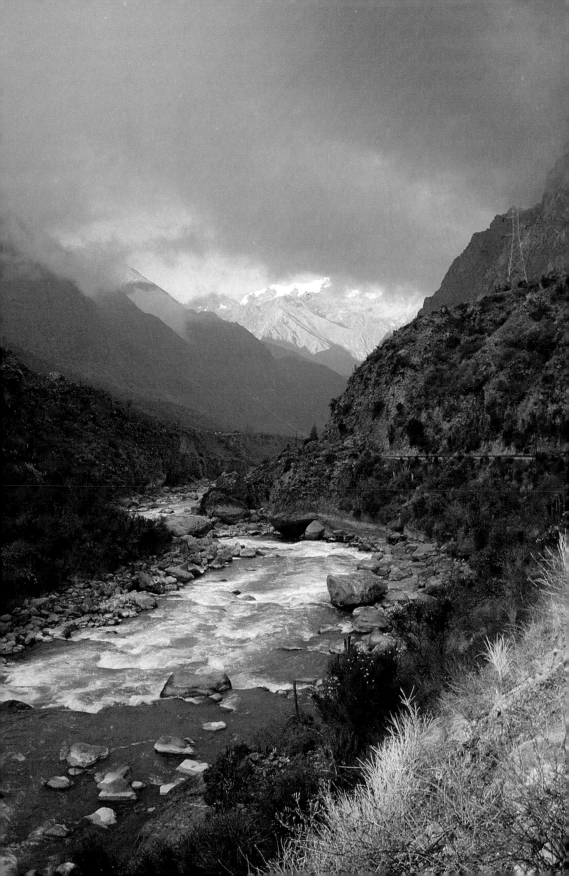

FORMAT

Most cameras have a natural axis. For example, when you lift a 35mm camera to your eye, it feels right to hold it horizontally, so that the horizon runs parallel to the long side of the frame. Turning the camera through 90° feels unnatural – it requires an extra effort, and most photographers turn the camera only when faced with landscape subjects that have a pronounced top-to-bottom emphasis – such as tall trees.

The dominance of horizontal landscape pictures is further strengthened by photographic jargon. By convention, we call all horizontal pictures "landscape format" and vertical pictures "portrait format". But you will find it best, rather than letting the camera or convention decide whether the pictures should be upright or horizontal, to evaluate every subject on its own merits, and then decide for yourself.

The subject matter isn't the only factor that should affect your decision. You should also think about the dynamics of the image, and about the foreground and sky. A horizontal format appears peaceful and stable, and implies tranquillity. By comparison, a vertical picture appears more active and unstable. Vertical pictures also include more of the subject above and below the horizon, so turning the camera vertically is a useful way of emphasizing the sky, or subjects of interest on the ground close to the camera.

▲ Stressing verticals
It is always worth pausing to consider whether a vertical or a horizontal format best suits the landscape in front of you. An upright format seemed natural for this picture: the vertical frame repeats the onward rush of the straight road. Nikon, 24mm, FP4, 1/8, f/8.

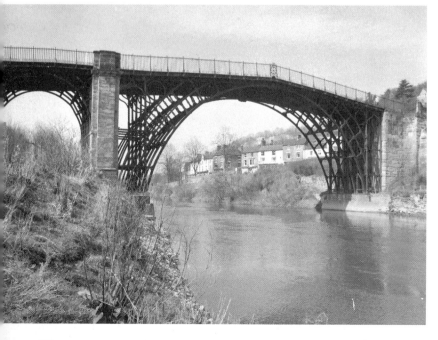

◄ Emphasizing stability
The world's first iron bridge, at Ironbridge Gorge, combines graceful lines with a powerful solidity. The horizontal format reiterates the feeling of strength – a vertical composition has overtones of instability. Canon, 28mm, FP4, 1/125, f/8.

► Linking foreground and background
Here a vertical format was the best way to lead the eye from the figures to the upland farm. Nikon, 200mm, Tri-X, 1/125, f/5.6.

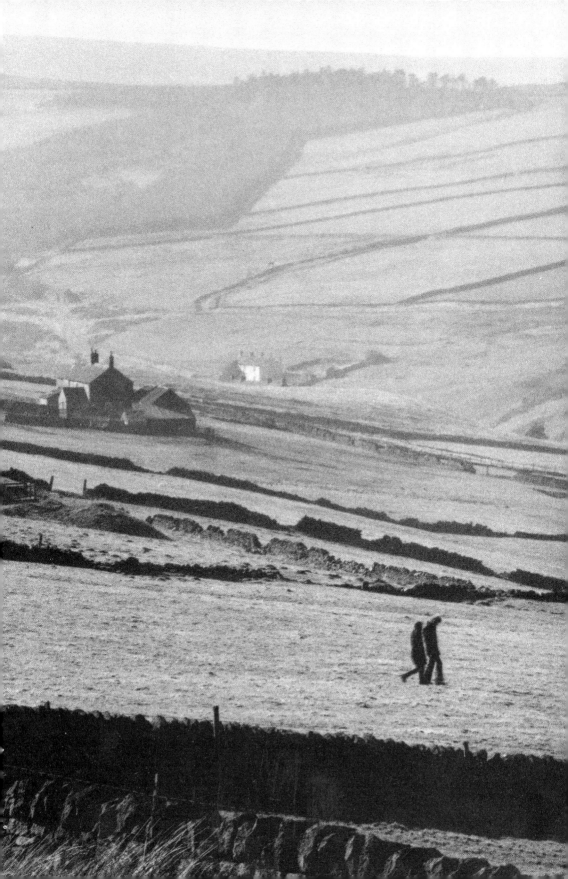

POSITIONING THE HORIZON

The line of the horizon usually serves to separate the fundamental components of a landscape picture, but has no existence independently of them. It forms a natural division between the elements: sky above; land beneath.

The position of the horizon is a major factor in the balance of the picture. With the camera absolutely level, the horizon appears in the centre of the picture, dividing the frame exactly in two. This bisection of the image generally looks static and uninteresting, and unless you are setting out specifically to create pictures that echo stillness and inactivity, it is best to avoid a 50:50 division of the frame.

Lower and higher horizons shift the emphasis of the picture towards the sky and land respectively. Even a small shift of the horizon above or below the halfway mark is enough to give the photograph a more active feel, but the most satisfactory division often lies a third of the way into the frame, or on the line defined by the golden section (see page 96). Remember, though, when you tilt the camera to reposition the horizon, that your new composition will bring into view a greater area of sky or land, and you should check that you're not just introducing a redundant or uninteresting section of the landscape. For example, it's not usually a good

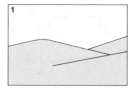

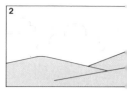

▲ **Dividing the frame**
A centrally-placed horizon (top left) generally makes a less dynamic picture than a slightly lower (top right) or higher horizon. Dropping the horizon (above left) stresses the sky; by contrast, raising the horizon (above right) stresses the land.

idea to use a low horizon when the sky is a uniform, dull grey.

If there's a really spectacular sky, don't hesitate to take a radical outlook and position the horizon line right at the very bottom of the frame. At the other extreme, if the foreground of the picture is especially interesting, it is worth shifting the horizon right to the top of the image.

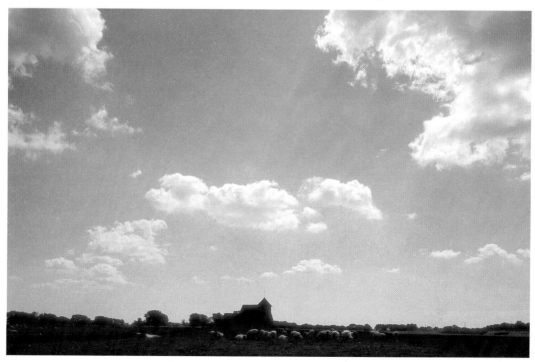

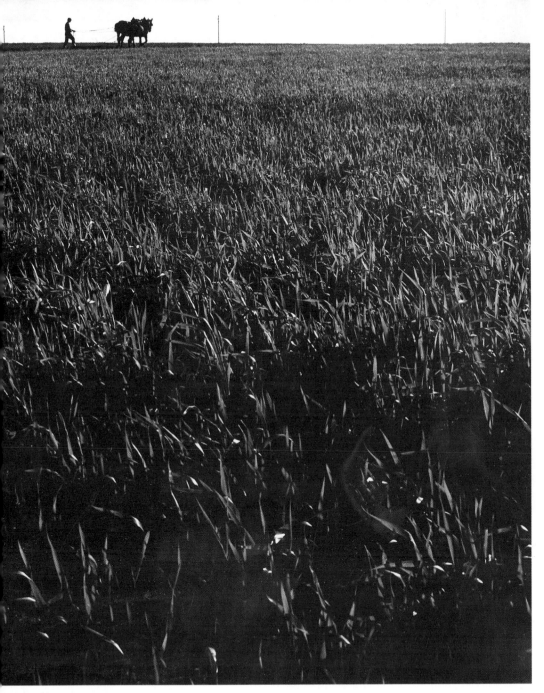

◄ A low horizon shows off the sky and clouds
When the storm clears, the rain-washed clouds make a brilliant foil for the sky's blue hue. Compose pictures with the horizon right at the bottom of the frame, and use a polarizing filter (or a red filter with black and white film) to separate the tones of the sky and the clouds.
Olympus, 28mm, Kodachrome 25, 1/125, f/8.

▲ Letting the land dominate
This archaic plough-team seemed to symbolize man and beast at one with the earth, so it seemed natural to let the soil they were turning fill the frame. A wide-angle lens created a sweeping perspective, compelling the viewer to follow the pointing stubble back to the ploughman.
Pentax, 24mm, FP4, 1/125, f/8.

DIVISIONS AND FRAMES

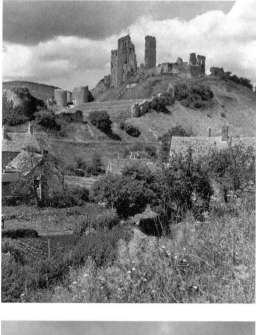

The horizon is the fundamental compositional division of the frame, but in most landscapes there are other boundaries or lines that split the picture into distinct areas. Rivers, roads, walls, paths and tracks are obvious examples, but some divisions are more abstract than these: around the end of the day, the sun creates a sparkling line of reflections on water, cutting the frame vertically. Other divisions of the frame are entirely imaginary, but equally important to the composition. For instance, when two similar objects appear in different parts of the picture, the viewer's eye will draw a line between them, and this divides the image as surely as any wall.

Lines partly or totally surrounding a landscape element create a frame that encloses and isolates part of the picture. Natural frames abound: the shore of a lake, for example, separates water from the land, and a mountain casts a slowly-moving frame on the landscape in its shadow.

Where there's no natural frame to enclose the part of the subject you're trying to emphasize, you can create one yourself. When you stand behind a rock arch, in the mouth of a cave or in a doorway, the solid edges form powerful borders holding together and integrating the picture. Frames needn't be this complete: often you need only enclose the image on two sides, relying on other unconnected lines to bridge the gap. The trunk and overhanging branch of a tree, for example, make a strong frame in conjunction with the physical borders of the picture and the ground beneath.

THE FORMAL RULES

As mentioned in the introduction to this chapter, certain divisions and proportions have proved in the course of time to be especially pleasing to the eye. Compositions that incorporate these proportions have a natural sense of order and symmetry.

The most widely used proportion is the golden mean, or the golden section. This is a number derived by dividing a line or area so that the ratio of the smaller part to the larger part is the same as the ratio of the larger part to the whole. The golden mean is roughly equivalent to 8:5 or 1.62:1.

Other pleasing divisions of the frame lie close to the value of the golden mean. For example, try cutting out from paper first a square, then a rectangle with one side the same length as the square, and the other side the length of its diagonal. However many

▲ Framing for emphasis
Corfe Castle in Dorset is a dramatic and romantic ruin, but a straight shot (top) hardly does it justice. In the foreground, roofs and washing lines compete for attention with the crumbling turrets. Using a wall to

eliminate the foreground (above) creates a much more appealing view, and the frame is completed in the darkroom, by burning in the sky to make a dark area at the top of the frame.
Hasselblad, 50mm, FP4, 1/60, f/8.

◄ Framing with a low camera position
Dropping the camera down close to ground level introduces waving grass in a supporting role. A wide aperture (f/4) reduced depth of field, so that the grass did not vie for attention. Hasselblad, 50mm, FP4, 1/250.

▼ Foliage for frames
Leaves form a more complete frame, and are a useful way of obscuring intrusive objects – such as road signs – which can often mar a landscape composition. Hasselblad, 50mm, FP4, 1/250, f/4.

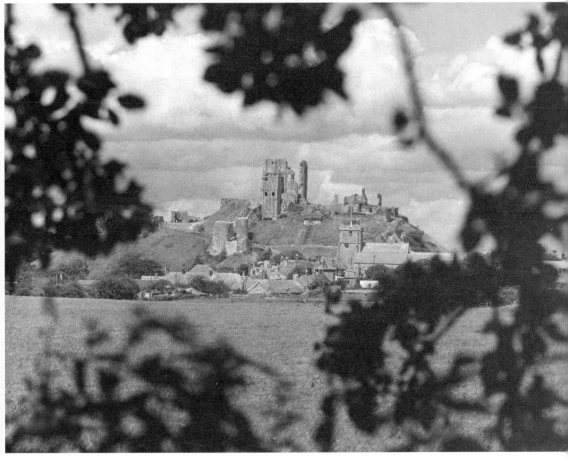

times you cut this rectangle in half, each fraction has the same proportions as the whole, 1.41:1. This perhaps seems like a transparently simple property, but try it with a rectangle of any other size.

An even simpler division is the so-called "rule of thirds", which suggests that dividing the frame in the ratio of 2:1 provides a satisfying composition.

These formal rules are useful if you are trying to decide where to place the horizon or some other important element of the picture, but remember that they are only guidelines. A photographer who applies the golden section unthinkingly to every picture will succeed only in producing images that are boring or, at the very least, predictable.

The golden mean

To make a rectangle with the proportions of the golden mean, draw an arc centred on the midpoint of one side of a square (1). The length of the arc is the distance from the mid-point to the corner (2), and the place where the arc cuts the extended side of the square (3) is the corner of the frame. The harmony and logic of the frame arise from the relationship between the rectangle and the square from which it was derived: in the diagram above, C and A are in the same ratio as A and B. This particular ratio of approximately 8:5 is also the ratio of the lengths of the two sides of the rectangle.

◀ **Application of the golden mean**

Mathematical rules about composition assume a rigidly geometric world to which reality does not really conform. For example, only an infinitely small subject could be placed precisely so as to divide the frame in the correct proportions. Nevertheless, these pictures illustrate how the golden mean and rule of thirds can be of practical value. In the picture on the far left, a line drawn through the sheep's head on the inn sign divides the frame approximately according to the golden mean, creating a pleasingly balanced composition. Similarly, in the image on the left, the break in the trees starts about a third of the way into the picture, and the eye travels easily through the gap to the scene beyond. The picture below is constructed using two such divisions: both focal points, the castle and the larger of the trees, are positioned a third of the way in to the picture, creating a sense of stability and order.
Far left: Nikon, 105mm, Ektachrome 64, 1/125, f/8;
left: Pentax, 50mm, Kodachrome II, 1/15, f/5.6;
below: Leica, 50mm, Kodachrome 64, 1/15, f/4.

SEE · ALSO
Perspective and scale
pp. 104-5
Format pp. 92-3

PATTERN IN LANDSCAPE

The human eye abhors chaos, and searching for pattern is one way of making sense out of a disorderly world; we see "a ring of trees" or "a line of rocks", even where no real connection exists between the objects that we mentally group together. In a photograph, such groupings are especially valuable, being an easily-identified theme from which to start exploring other aspects of the image, such as colour or tonal qualities.

Some aspects of landscape lend themselves naturally to pattern-making. For example, the receding tide leaves a snaking pattern of small ridges and furrows on the drying sand. The wind whips up similar shapes, albeit on a very much larger scale, in loose sand on the ocean's margin. And at the other extreme, many natural phenomena reate patterns at a level measured in millimetres rather than miles – think of the spreading patterns of lichen on rock.

Size and scale, in fact, are the essential factors in making good pictures of all these natural patterns. Pattern on a grand scale, such as sand-dunes, generally demands a distant viewpoint or a wide-angle lens, so that you can explore in your pictures the repetition that goes to make up the pattern. If you're aiming at a really graphic image, photograph such large-scale patterns in sunlight; but if small details in the scene are appealing, favour instead cloudy weather which creates fewer dense obscuring shadows.

With medium-scale patterns you can afford to be more casual about technique – lighting and lenses are less important than a keen eye for the arrangements of landscape elements that will make a good picture, and choice of the best camera angle.

Small-scale patterns take some seeking out too, but once more photo-skills come into play. Hard, raking sunlight reveals textures and patterns that pass unnoticed in cloudy weather, so the early morning or a sunny winter's day are ideal times to take pictures. To close-in on small details, you'll need to use close-up accessories such as a macro lens, extension tubes or close-up supplementary lenses. Sharpness is critical in macro-pattern pictures, so use a small aperture for maximum depth of field.

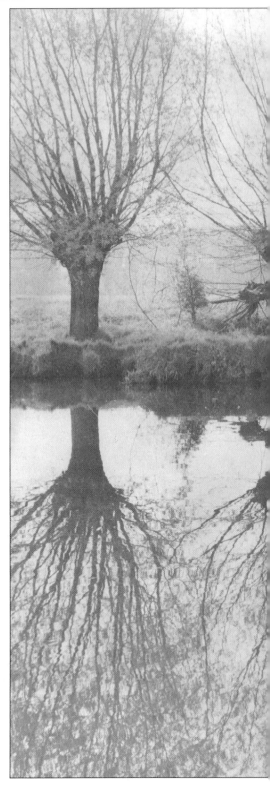

▶ *Repeating rhythms*
These trees were carefully spaced out when planted, and in their patterns of growth they seem to count from 1 to 3.

Photographing the reflection was an appropriate way to multiply by 2. Hasselblad, 80mm, FP4, 1/8, f/8.

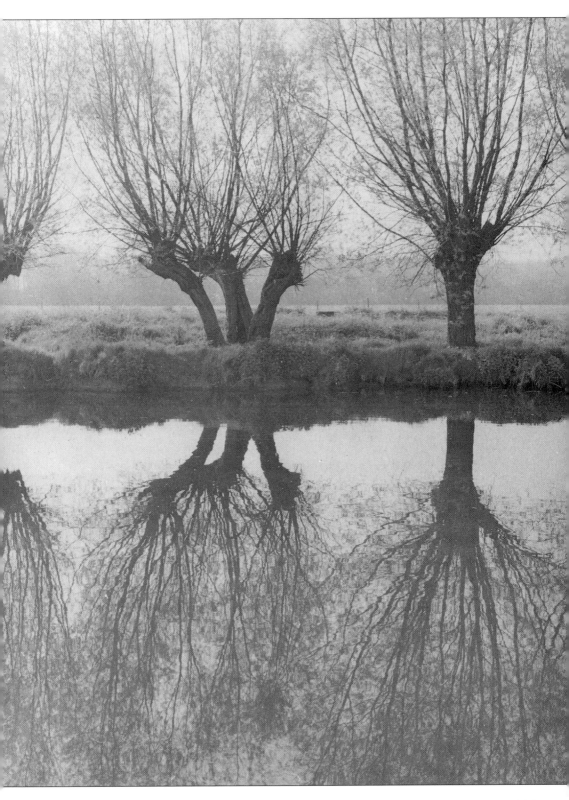

► *Looking for echoes*
These rotting wharf timbers picked up the theme started by the Manhattan skyline. An aperture of f/16 kept both sharp, to highlight the similarity.
Hasselblad, 150mm, Ektachrome 64, 1/250.

▼ *A distant viewpoint to stress regularity*
From nearby, it was hard to see the uniformity of design and diversity of colour in these houses. A distant viewpoint and a 300mm lens made the comparison easier.
Olympus, Ektachrome-X, 1/30, f/8.

◄ Contrasting curves and angles
"S" shaped curves almost always please the eye, and in the terraced fields in the shot on the facing page, bottom right, the curves occur repeatedly.

But cover the hut, and you'll see that its angular shape provides a vital foil for the sinuous dikes.
Canon, 135mm, Agfa CT-18, 1/30, f/4.

▼ Combining pattern and colour
Rigidly formal pattern in a photograph can easily be seen as little more than decoration and not at all stimulating to the eye. Softening and diluting the

pattern, perhaps with colour or human interest, is a way to make a more satisfying and enduring composition.
Nikon, 35mm, Ektachrome 25, 1/60, f/4.

PERSPECTIVE AND SCALE

Looking at a landscape photograph, it's not difficult to pick out which parts of the scene were close to the camera, and which farther away. Often you can even estimate with some accuracy the approximate distances of nearby objects. Most of us take these skills for granted, without really thinking too much about how it's possible to look at a picture that only exists in two dimensions, and visualize the third. It's precisely because we have so little trouble judging depth in photographs that it's worth examining how this discrimination is possible.

The distances between objects in photographs – their spatial relationships – are represented by a system that we call perspective. The geometry of perspective is not of interest to photographers, but some of the methods by which we infer distance from the flat print surface can be useful in a very practical sense. If you understand how perspective works, you can use this knowledge to control the appearance of depth in your photographs. For example, any photographer who owns a wide-angle lens can tell you that such lenses give an illusion of expanded space; not all of these photographers could tell you why, or could anticipate the circumstances under which the illusion would be most pronounced.

In the next few pages you'll find an explanation of this illusion, and of the other components of perspective. Don't be put off by the names and labels of the different effects: as with any discipline, this jargon is just a shorthand form used to describe ways of seeing that you'll quickly recognize from everyday experience.

DIMINISHING SCALE

Most perspective effects work because we know that objects in the real world stay the same size whether we are close to them or far away. The name that scientists give to this experience is "size constancy". If we relied solely on the raw information from our eyes, we'd get quite a different picture: houses and trees would grow as we walked towards them, and people passing by would expand

▲ **Mixing perspective devices**
The pointers that we use to judge distance are most effective when combined. Here the converging lines and repeated shapes give the picture depth, but it's the figure that indicates the scale of the stacked harvest at the right. Olympus, 35mm, Tri-X, 1/60, f/8.

and contract rather like inflating and collapsing balloons.

Of course this sounds ridiculous, but it's exactly what you see on a photograph: the farther away things are, the smaller they appear to be. For example, an avenue of poplar trees diminishes in size in the distance, giving a vivid sensation of receding subject planes.

The degree of shrinking with distance is affected by viewpoint. If you photograph the row of trees from a considerable distance, the spaces between them are insignificant compared to the distance between you and the avenue. The trees appear to diminish slowly in size, and so look closer together; this effect is called overconstancy.

To fill the frame from a distant viewpoint you need to magnify the avenue of trees: you can do this either by using a telephoto lens, or by greatly enlarging the negative or transparency. It's viewpoint, though, not focal length that has changed the perspective.

The opposite effect occurs when you stand at the end of the avenue, between the first two trees. The nearest trees are vast in relation to the most distant trees, and the gaps between them appear to close up rapidly as the avenue continues. A wide-angle lens recreates the broad, sweeping view that you saw when turning your head to look up and down the avenue – so these lenses appear to expand perspective, giving a sensation of depth, or overconstancy.

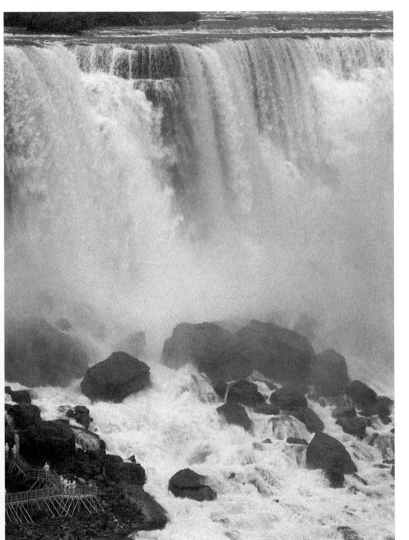

◀ **People as measures of scale**
The human form is consistent in size and instantly recognizable, and is perhaps the most valuable yardstick for measuring distance in landscape pictures, as can be seen in the examples of the people at the foot of the waterfall and the solitary camel in the desert. And though animals don't catch the eye quite so readily, they still form a focal point, and suggest depth. Facing page, below: Pentax, 200mm, Tri-X, 1/125, f/11; left: Pentax, 50mm, Tri-X, 1/125, f/11.

SEE · ALSO
Format pp. 92-3
Positioning the horizon pp. 94-5
Figures and structures pp. 114-15

AERIAL PERSPECTIVE

Only on rare, crisp, winter days is the atmosphere absolutely clear. When the weather's right, though, you'd swear you could reach out and grab that mountain peak twenty miles away. This uncanny sensation of reduced distance on clear days makes you realize how hazy the atmosphere is the rest of the time. This familiar phenomenon of tones diminishing in intensity the further they are from the viewer is known as aerial perspective. It comes about as a result of the change of temperature between the warm earth and the cold air and is best seen early in the morning. In photographs, you'll notice it more when you fit a telephoto lens to the camera; the lens magnifies a small portion of the distant scene, so the haze is more prominent.

EXPLOITING ATMOSPHERIC EFFECTS

You may have observed that brilliant scarlet subjects sometimes seem to jump out of a picture, so that they almost hover above the surface of the print. This is really just another manifestation of aerial perspective: warm colours such as red, orange and yellow are the first to be absorbed by the atmosphere, so we associate them with things close by. Cool coloured subjects – blues and greens – appear to recede from the viewer. When you want to suggest depth you can use this effect to advantage by composing pictures with warm hues in the foreground, and cooler colours behind.

▲ Backlighting for extra depth
Aerial perspective is most marked when the camera is pointed at the light from the sun.
Pentax, 135mm, Ektachrome 64, 1/250, f/2.8.

▶ Helping out with filters
If haze does not tint the distant view with sufficient blue, try adding a pale blue filter such as a Wratten 82A or 82B. A graduated mist filter lightens the top of the image, but the effect is often too extreme for all but nearby scenes.
Canon, 50mm, Fujichrome 50, 1/30, f/8.

◀ Aerial perspective for atmosphere
The gentle effect of aerial perspective in this picture of Ludwig II's Neuschwanstein Castle in Bavaria lends an aura of remoteness and mystery to this fairytale creation. The mountains recede, providing a background that has grandeur yet is not harsh or intrusive despite its scale in relation to the castle.
Olympus, 150mm, Ektachrome 200, 1/125, f/11.

OVERLAPPING FORMS

The simplest perspective effect may seem so obvious that it doesn't merit comment. If you're walking through a landscape, you'll see passing objects move in relation to each other, and at some points, foreground objects partially or completely obscure those behind them. This effect is something we begin to understand when we are still very young: the novelty of playing "peek-a-boo" wears off as soon as we realize that the adult is still there even when hidden by the edge of the nursery door.

Despite its simplicity, this depth clue is a useful way of conveying depth in landscape pictures. When objects overlap, the feeling of depth is implied because the viewer realizes there is space between the different planes.

Choosing viewpoint
By moving around the subject you can see how best to exploit image overlap: moving lower down the hillside for the picture below brought the foreground trees higher up the frame, until they overlapped the hills behind. In the picture on the right, the simple trick of rowing across the lake moved the nearest shore across the frame, aligning its shape with the hills behind.
Below: Canon, 135mm, Plus-X, 1/30, f/8. Right: Pentax, 105mm, Tri-X, 1/50, f/5.6.

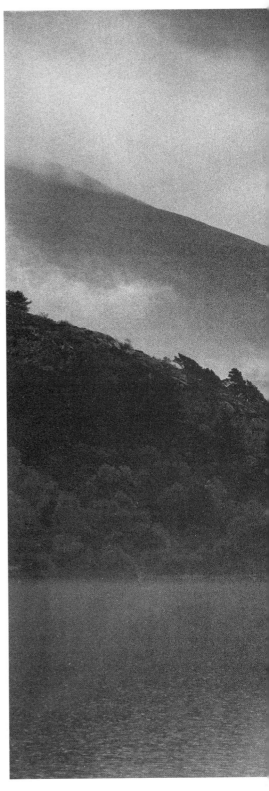

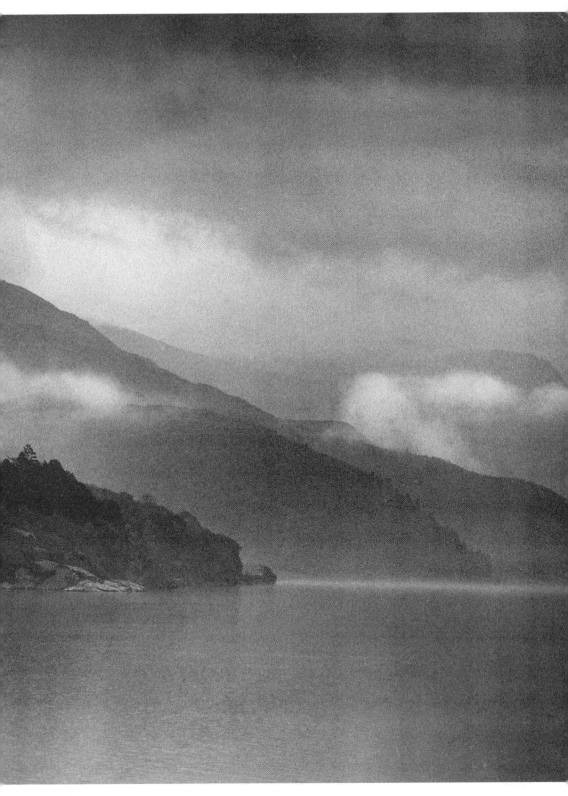

CONVERGING LINES

The apparent convergence of parallel lines is a depth clue that is closely related to diminishing scale. The connection is simple to understand if you think of a paling fence with horizontal bars holding the uprights together. The uprights seem to diminish in height in the distance and, by the same token, the horizontal bars seem to get closer together.

Converging lines, though, have an additional quality that suggests depth in a more subjective way. When we look at a photograph that contains parallel lines converging in the distance, we feel drawn onwards along the track that the convergence produces. Photographed from the side, for example, a path runs as a parallel line from one side of the frame to the other, and doesn't induce a great sense of movement either one way or the other. But stand in the middle of the path to take the photograph, and the sides of the path narrow as they approach the top of the frame, while the converging sides create a strong sense of direction.

Controlling convergence
Viewpoint, framing and focal length together constrain convergence. Close viewpoints and wide-angle lenses (right) make lines appear to converge very rapidly towards the horizon; with distant viewpoints and telephoto lenses, the convergence is less marked (below). Framing and cropping are especially important because they affect whether the vanishing point – the place on the horizon where all lines meet – is visible or not. The sense of distance is greatest if you compose the picture to include the vanishing point, and the
pictures on the right and below fall into this category. Exclude the vanishing point, as in the picture below left, and the illusion is much less pronounced.
Below left: Olympus, 50mm, Kodacolor 400, 1/500, f/11. Below: Canon, 105mm, Ektachrome 64 1/60, f/5.6. Right: Canon, 20mm, Fujichrome 50, 1/30, f/5.6.

REPEATING SHAPES

Massed similar shapes suggest distance very strongly, especially when all the repeated objects appear in the same subject plane. Pebbles on a beach, for example present the camera with a coarse texture in the foreground, and a pattern of gradually increasing density in the distance.

This type of situation is once again an example of size constancy at work (see pages 104-5) we know that the pebbles are broadly similar in size, and from the apparent change in scale we judge that the smaller pebbles are the farthest away. Like the other linear perspective effects, this texture gradient is affected by viewpoint and angle: oblique views of a texture from close to create a far more compelling sense of depth than views from afar at steeper angles.

▼ Juxtaposing similar shapes
Emphasizing the inherent strength of shapes by creating a repeating pattern is a simple method of making interesting pictures, and can be applied to a wide range of types of landscape. In the example below left, this use of repeating shapes also emphasizes the structure and distance of the mountain.
Canon, 20mm, FP4, 1/15, f/5.6.

▼ Making crosses stand out
The repeated cross motif beckons the eye back to the horizon, but with normal exposure, detail in the grass weakened the image. Cutting exposure by two stops served to make the cruciform shapes spring forward from a dark field.
Olympus, 105mm, Plus-X, 1/15, f/11.

◀ Composition with repeating shapes
The simplest shapes when photographed as a pattern, often create the most dramatic images. Here, the monolithic forms of the belching chimneys have taken on a brooding, dreamlike quality, partly because of the very insistence of their shape and partly because of the ominous quality of the louring, smoke-filled sky.
Pentax, 50mm,
Fujichrome 100, 1/125, f/5.6.

FIGURES AND STRUCTURES

In an alien environment, the eye seeks out familiar objects as points of reference. It should therefore come as no surprise to learn that figures and familiar structures are powerful indicators of distance, size and perspective. The human figure is perhaps the most effective of all depth clues in this context, because people are so consistent in size: when we see in the landscape an object that we are confident is between 5 and 6½ feet tall, judging the relative size and distance of other objects is easy.

Buildings are more variable in size than figures, but features that form parts of a building are generally fashioned to suit the proportions of the people that use them. Only in the most grand of buildings are doors higher than about nine feet, and most windows have a similarly human scale. In photographs, these and other details make the size of the building clear, and put the rest of the landscape literally in perspective.

▼ Breaking the horizon
The tones of this stone hut blended so closely with the surrounding hillside that the building almost vanished when seen from higher up. But when the chimney stack just breaks the horizon, the hut instantly catches the eye.
Rolleiflex, FP4, 1/60, f/4.

▼ Contrasting shapes
Besides suggesting scale, buildings inject order into landscapes that are essentially disorderly. The symmetry and straight lines of this isolated house stood out in stark contrast to the organic curves of the surrounding moorland, and a wide-angle lens made the juxtaposition more graphic, by enlarging the rocks, and reducing the scale of the building.
Pentax, 24mm, FP4, 1/4, f/5.6 caption 3.

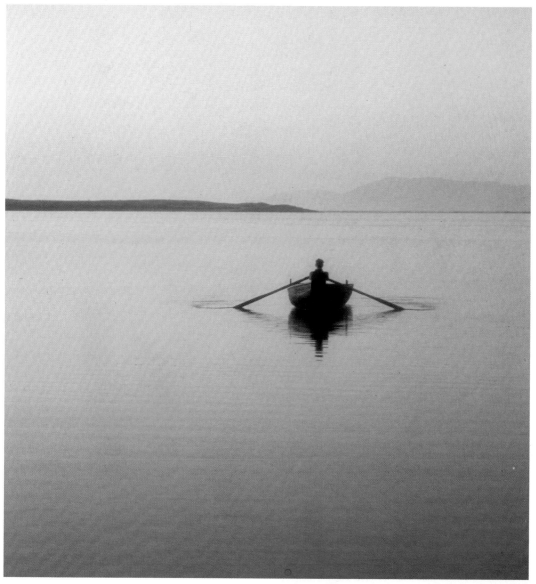

▲ The figure as a focus
Fitting a wide-angle lens emphasized the foreground, pushing back the far shores of this lake, so that the solitary oarsman became the centre-point of a tranquil landscape.
Hasselblad, 50mm, Ektachrome 200, 1/60, f/5.6.

SEE · ALSO
Exposure pp. 26-7
Lens choice pp. 18-21

▶ Positioning buildings in the frame
Human elements – people and buildings – have a tendency to dominate landscape images, so if you want them to play a secondary role, you need to pay special attention to composition. Placed at the foot of the frame, the house gives a sense of depth without intruding.
Pentax, 50mm, Ektachrome 200, 1/125, f/11.

People and townscapes

In a wilderness, the figure intrudes; but townscapes without *people look barren*. In the picture below, the converging roofs form arrows, pointing to the children. A 28mm lens made the convergence more emphatic. When a longer lens is used (right), alleyways begin to seem like canyons, closing in around the figure.
Right: Nikon, 105mm, Tri-X, 1/30, f/11. Below: Nikon, 28mm, Tri-X, 1/30, f/5.6.

▶ Printing people in

Multiple exposure in the darkroom allows you to add figures as an afterthought.
Nikon, 50mm, FP4, 1/125, f/8 (couple); 1/8, f/8 (landscape).

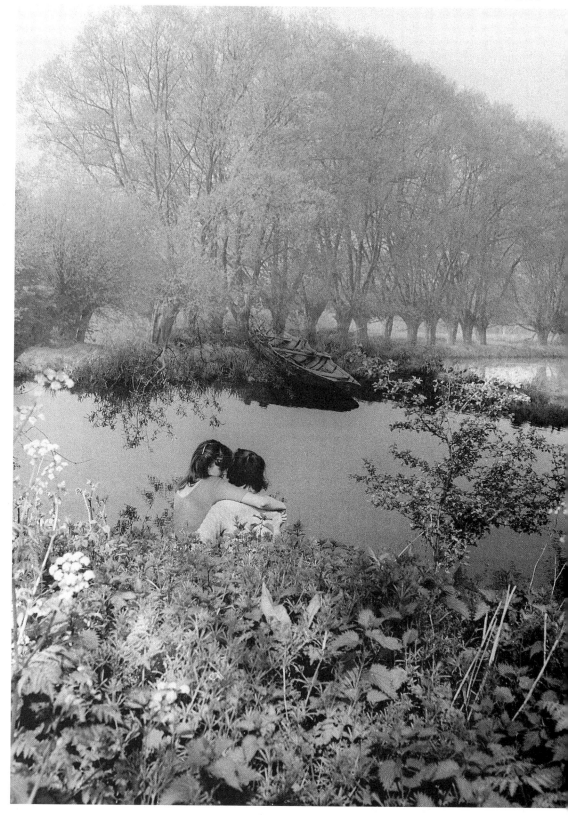

NATURAL FACTORS THAT SHAPE THE LANDSCAPE

O ne of the most enduring attractions of landscape photography is the ever-changing nature of the subject. A passing storm cloud can in seconds infuse a dull, uninspiring scene with sudden drama. The constantly changing play of light reveals and conceals different facets of a landscape, and if you are able to visit the same location over a period of time, it will be possible to take dozens of different images, showing the scene in its many moods and atmospheres.

Just as fleeting clouds can change the appearance of a place instantaneously, so light and therefore the intensity of colour change from dawn to dusk, and the changing seasons

bring with them a variety of effects over weeks and months. This constant changeability of the landscape on several levels is something to which the photographer can become progressively more attuned. In this way he will soon come to recognize that a scene which appears dull in midday sunlight can be exciting at sunset or, equally, calm but very evocative in the early morning mist. In this chapter we take a look at these and other factors that affect how landscape looks on film. You'll see how you can anticipate changes, and use them to your advantage; and how the photographic controls that are described in Chapter 2 can help you exaggerate or minimize these natural phenomena.

▲ *Scouting locations*
Don't ignore the potential of a landscape just because it's unattractive when you visit. In winter this beech-wood was bare, but predictably it was carpeted with gold three seasons later. Nikon, 28mm, Kodachrome 64, 1/30, f/5.6.

THE CHANGING SEASONS

In temperate climates, seasonal variations in the weather create perhaps the largest of all short-term changes to the landscape. A scene that looks dismal and drab in winter may well be bursting with colour just a couple of months later, so that, for example, a warm spell at the end of the winter can easily advance spring flowers by several weeks. Geography is a factor, too, and if you are prepared to travel to your subject, you can follow the spring as the landscape blooms progressively farther and farther north.

SEASONS AND LATITUDE

During the summer in higher latitudes the sun rises and sets rapidly, and travels in a steep arc across the sky, crossing directly overhead around noon. By contrast, in the winter months, the sun barely creeps above the horizon, casting longer shadows even at midday. Latitude changes the sun's position, too: near the equator, the sun is always higher in the sky; farther north and south, seasonal changes are greater, and within the Arctic circle the sun never sets in summer or rises in winter.

Any gardener knows how difficult it is to grow plants on a north-facing wall in the northern hemisphere, but it's easy to forget this simple lesson when you're out taking pictures. If you see landscape features in shadow on an autumn day, take a compass reading before you make plans to return when the light is better – you may have a nine-month wait.

Latitude also affects the colour of the sky. At higher latitudes the sky looks a deeper shade of blue, and the colour deepens in winter when the sun is low. Furthermore, a greater proportion of light from the sky is polarized at higher latitudes and in the winter months, so a polarizing filter has more effect, turning the sky an even richer shade of blue.

Early-summer landscapes are still shot through with the brilliant hues of spring, but as the summer wears on, the freshness of foliage vanishes, particularly at lower latitudes. Vegetation rapidly becomes parched and dry, and landscapes photographed in late summer often have an unattractive, baked appearance. This is particularly obvious in the middle of the day, so try to shoot summer landscapes in the early morning, when dew revitalizes the fading colours.

We inevitably associate autumn with russets and golds, but for the photographer, this phase may be very transient and difficult to predict. Trees don't turn brown and shed their leaves according to a calendar, and the timing of the most spectacular colours may vary by a month or more from year to year. Rainfall, humidity and temperature changes all affect foliage colour, and a sudden storm can strip trees of their leaves overnight.

In areas such as New England that rely on autumnal colours for tourist revenue, you'll find leaf reports alongside the weather forecast in the local papers. In other areas, it's wise to phone a local contact before making a long trip to take photographs of an autumn landscape.

Winter has connotations of bleakness, but a resourceful photographer can reap benefits from even this least colourful of seasons. If foliage hides a landscape feature that you want to photograph, it may be worth making a trip back to the spot when the trees are bare. You'll also find that clear weather in winter provides better conditions for photographing distant scenery, because heat haze doesn't veil the view.

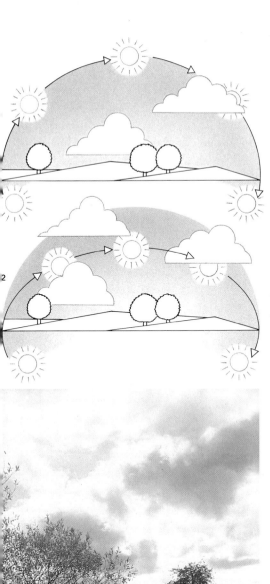

◄ The sun's movement

In the summer months (top diagram) the sun rises rapidly in the sky very early in the day, and at noon casts shadows almost directly downwards; sunsets are brief, and twilight is short. For the photographer, this makes life difficult: the best time to shoot landscapes is when the sun is low in the sky, so there's a long period in the middle of a summer's day when the light is less than perfect. The brief sunsets and sunrises mean that you have to work quickly to catch the sun when it's close to the horizon.

Winter conditions (lower diagram) make photography simpler. Because the sun is lower in the sky throughout the day, you can continue shooting from dusk to dawn. Sunset and twilight linger on, providing more opportunities as the landscape begins to darken. In general, though, I prefer sunrise, because then the landscape is undisturbed by traffic and other people. Furthermore, the light can be just as good as at sunset.

◄ Controlling flare

In early spring, trees block far less light than later in the year, and against the sky, the new leaves are easily hidden by flare. To improve contrast and pick out the shape of every bud, keep the front and rear lens elements scrupulously clean, and avoid using filters. This shot benefits from the clear light that illuminates the landscape between showers.
Nikon, 35mm, FP4, 1/60, f/6.

▲ Setting exposure for winter skies

When farmland is fallow and the trees bare, you'll often find better pictures by looking up. To record maximum detail in the sky, take meter readings from there, rather than from the land beneath. In monochrome, burning in the sky has the same effect.
Pentax, 105mm, Tri-X, 1/250, f/11.

▶ Avoiding autumn clichés

It's easy to lapse into chocolate-box stereotypes in the autumn, so look out for scenes that are a little different. When photographing stubble burning, measure exposure from the unburned field or use an incident light meter: readings from flames produce underexposure, and from the charred field, overexposure. In woodland, look for strong shapes (centre right), keeping fallen leaves in a supporting role. Early autumn (lower right) provides a less monochromatic palette, because trees are just starting to turn.
Top right: Canon, 105mm, Ektachrome 64, 1/30, f/8.
Centre right: Canon, 28mm, Ektachrome 200, 1/8, f/11. Bottom right: Pentax, 50mm, Ektachrome 200, 1/250, f/8.

▶ Filtering for summer greens

In early summer, foliage and crops are at their greenest, and you can make the landscape look especially verdant by using a polarizing filter to cut glare from the surface of leaves. Metering the sunlit area of this landscape made hues even deeper.
Olympus, 200mm, Ektachrome 64, 1/125, f/4.

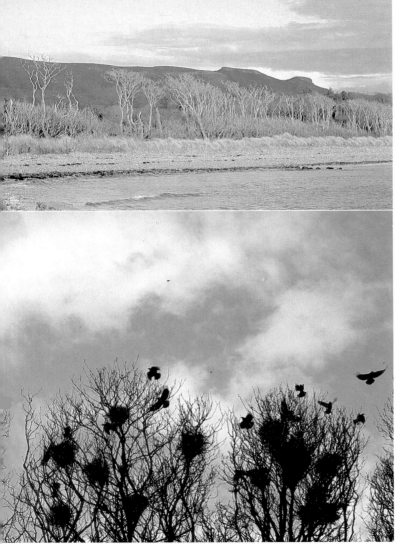

◄ The importance of timing

Winter gales move clouds rapidly across the sky, sweeping shafts of light equally quickly across the landscape. When dramatic sunlight rakes a bleak scene like this, act fast – take a few pictures with the camera set to automatic, in case the moment passes. If the light lasts, there will be plenty of time to take a more considered approach.
Olympus, 105mm, Kodachrome 25, 1/125, f/5.6.

◄ Winter life and colour

In a barren landscape, a rookery provides noisy evidence that life continues through the darkest months. Exposing for the sky has a three-fold advantage: it darkens the blues, silhouettes the birds, and allows you to freeze their wing-beats with faster shutter speeds.
Nikon, 200mm, Ektachrome 64, 1/250, f/5.6.

◄ Winter whites

Like mist and fog, snow makes the landscape almost monochromatic: return to familiar places, and you'll find you're able to take a completely fresh approach to the landscape. If you prefer snow to appear pure white with transparency film in overcast weather, use a pale straw-coloured 81A filter – or omit it if you feel the blue hue makes the landscape look more frigid (top left). Frosty weather (bottom left) doesn't have such a dramatic effect as snow, but you can nevertheless drain the scene of colour by pointing the camera towards the low winter's sun, and overexposing by a stop.
Top left: Pentax, 105mm, Ektachrome 64, 1/30, f/5.6.
Bottom left: Pentax, 200mm, Kodachrome 25, 1/4, f/2.8.

SEE · ALSO
Exposure pp. 26-7
Snowscapes pp. 154-7
Filtration pp. 50-3

HOW DAYLIGHT CHANGES THE LANDSCAPE

Changing light alters the appearance of the landscape and the extent of the transformation as the sun moves across the sky during the day is often radical.

The characteristic that alters most prominently is shadow length and position. In the early morning and late afternoon, the sun casts long shadows that scythe across the scene, picking out subtle textures and the tiniest dips in the land. Towards the middle of the day, the high sunlight cuts shadow length to a minimum, and the landscape looks very much flatter.

We notice changing shadows as highlit areas become darker and previously light areas fall into shadow. However, the changes in the colour of the landscape as the sun moves are less easy to measure, and there-

fore more often go unnoticed. There's another reason, though, why we overlook the effect of daylight on the hues of landscape – a phenomenon that scientists call "colour constancy". This is, in fact, an experience we're all familiar with: colours that we know well always look the same whatever the light, so we see a face, for example, as flesh coloured both in sunshine and in the yellow light of an ordinary bulb. Translate this to a landscape setting, and perhaps you can see why the human eye identifies foliage as green at all times of day.

The camera lens is more objective than the eye, and if you take the trouble to photograph a scene every hour, you'll be surprised at the extent of the changes of hue you see in the pictures.

◀ Unusual sunset images

Towards the end of the day most of us turn our cameras to face the setting sun, and it's easy to overlook some of the more subtle effects of the low light – such as the long shadows. As these two pictures show, low sunlight picks out and exaggerates every undulation, making mountains out of molehills. To increase contrast with black and white film, use a red filter – it will turn the shadows inky black, and brighten those areas lit by the warm sunlight. In the darkroom, print onto hard paper such as grade 4 to increase contrast still further. Here, burning in the areas either side of the road concentrated attention on the sinuous curves of the fence and its shadow.
Rolleiflex, Panatomic-X, 1/60, f/5.6.

SEE · ALSO
Filtration pp. 50-3
Controls in black and white pp. 44-7
The changing seasons pp. 120-3

▼ Variations in the sun's position

When the sun is low in the sky (1), it casts longer shadows from trees, buildings, and other landscape features. Raking light also picks out the shapes of even the most gentle hills. By contrast, when the sun is overhead (2), shadows are small and fall directly downwards, and the contours of the land are far less pronounced.

▶ Rich rewards for early risers

Early in the day the soft light creates subtle landscapes – especially when mist diffuses the sun's rays. For the best results, you should select subjects that have inherently strong outlines. Subjects that rely on texture or form for their impact are weakened in the soft light.
Leica, 50mm, Ektachrome 200, 1/250, f/4.

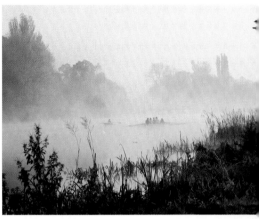

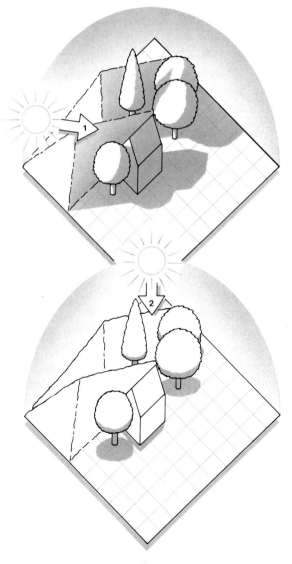

Light's changing colours

When the sun is behind the camera, the landscape is lit both by warm sunlight, and by cooler skylight; combined, the two light sources produce white light, and subjects appear in their normal colours (above left). Backlighting (above centre) picks out translucent objects, such as the petals, but only skylight reaches the shadows, tinting them blue. Very early sunlight is warm in hue (above) so just after dawn subjects look naturally warm. And soon after the sun has set (left) its rays still tint the sky, providing perfect conditions for making colourful silhouettes of features on the horizon. Above left: Pentax, 50mm, Ektachrome 200, 1/125, f/11 (above centre f/16). Above: Nikon, 35mm, Kodachrome 25, 1/60, f/5.6. Left: Pentax, 135mm, Ektachrome X, 1/125, f/5.6.

THE RISING AND SETTING SUN

The appearance of landscapes changes so much during the minutes when the sun is touching or just above the horizon that it's worth giving special thought to photography at dusk and dawn. At these times of day the land itself takes on a very warm glow. In the early morning, dust particles and mist provide a pronounced atmosphere, so that even the most mundane of scenes can be exciting.

Arresting sunrise and sunset pictures are not difficult to take, as long as you don't expect too much of camera and film. When the sun appears in the frame, the brightness range of the scene is enormous, and the deepest shadows may be a thousand times darker than the sun itself. No film is capable of handling such high contrasts.

In practice, this means that you need to decide which area of the landscape is most important to you. If you set exposure to suit detail on the ground, the hues of the sky will appear pastel-pale. Expose for the sun, and the land comes out pitch black.

BRACKETING EXPOSURE

The second approach usually creates images that most closely resemble memories of the scene. Take a basic exposure reading from an area of the sky adjacent to the sun, but exclude the sun itself from the frame; this is easy if you have a zoom lens, because you can use the "tele" setting for metering, then pull back to "wide" for a broader view. Once you've taken a picture at the basic exposure, bracket widely, as explained on page 28, making exposures one and two stops above and below the setting recommended by the meter. Though it may seem profligate to shoot five pictures and just use one, as often

as not you'll find that the frame shot at the basic exposure is among those you discard.

Work quickly when shooting sunsets. Even in temperate latitudes, in summer the sun touches the horizon for less than two minutes after it first appears in the morning, and before setting at night.

The sun always seems bigger when it's low in the sky, but you need a surprisingly powerful telephoto lens to magnify it significantly on film. As a rough guide, focal length divided by 100 gives the sun's size on the negative in millimetres, so with a 200mm lens, a setting sun fills just 1/12th of the picture width. It is worth using a teleconverter to increase the sun's size – needle-sharpness isn't usually crucial in sunset and sunrise pictures.

WARNING Near the horizon, the sun's rays are weak, but high in the sky, sunlight can damage your eyes when seen through a telephoto lens. Take great care when you point the camera at the sun.

▶ **Picking out graphic sunrise subjects**
The best subjects at sunrise are those that have a vigorous, clearly-defined outline, such as these reeds growing at a lakeside. Contrast is high, so it's wise either to meter from the sky using the aim-off technique explained below, or to choose some other area that you want to appear in the print as a mid-grey,
and meter from there instead. In this example, the exposure was set by using a spotmeter to measure the brightness of the distant shore, which therefore appeared as a mid-tone on the negative. Nikon, 35mm, FP4, 1/30, f/11.

▶ **Metering when the sun is in the frame**
The most reliable way to set exposure at sunset and sunrise when you want the sun to appear in the picture, is to turn the camera and meter an area of sky just to one side of the sun (1), but excluding the sun from the frame. Then you should manually set the exposure indicated, and swing the camera back to compose the view as you want (2).

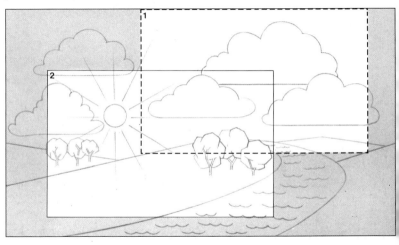

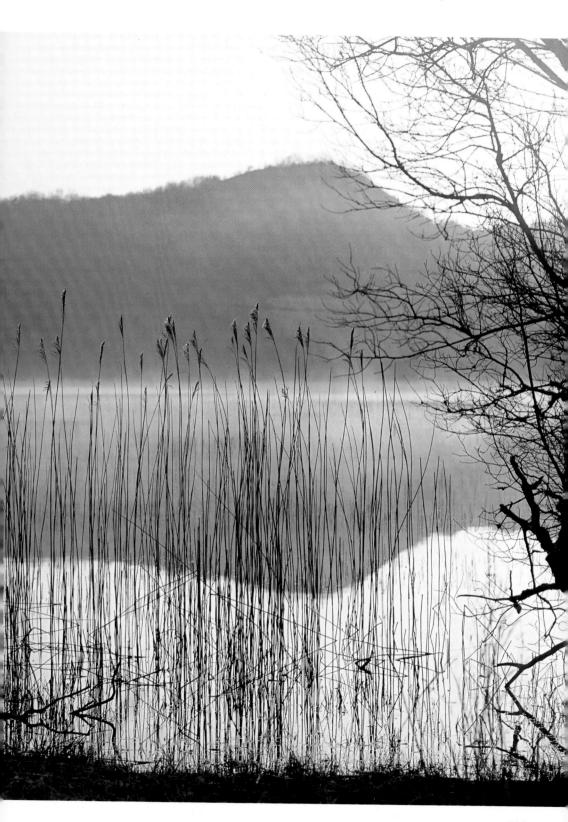

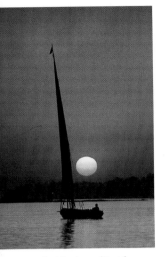

▲ The benefits of bracketing exposure
Making exposures at several different settings is a technique that is usually necessary only with colour transparency film, but contrast at sunset is so high that bracketing is worthwhile with any film. When the sun appears in the picture, it's worth bracketing over a range of seven stops: one, two and three stops over and under, plus the exposure indicated by the meter. This may seem like a waste of film, but the level of exposure dictates how much detail your pictures hold. Both these images were taken from a bracketed sequence.
Above left: Nikon, 200mm, Ektachrome 64, 1/30, f/5.6.
Above right: Leicaflex, 105mm, Ektachrome 200, . 1/500, f/11.

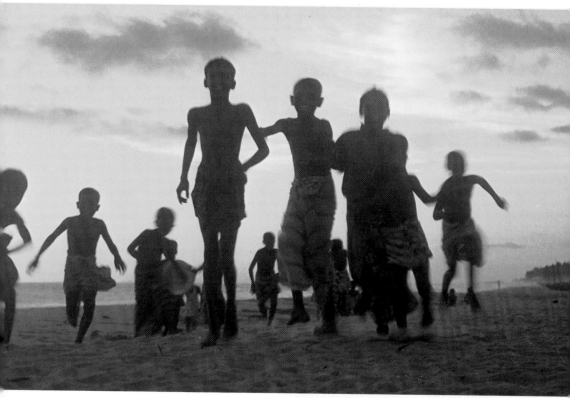

▲ Sunsets and shutter speeds

Pointing the camera towards the setting sun and exposing for the sky is a useful way of squeezing out a little more action-stopping power in dim light. Turning the camera to face in the opposite direction here would have prolonged exposure to 1/4 or so, but with the sun in the picture and the figures recorded in near-outline, 1/250 was possible. Pushing the film by a stop also provided an extra margin of speed. *Nikon, 50mm, Fujichrome 50, f/4.*

◄ Work fast to catch the sun's last rays

You will need to work quickly to catch the sun when it touches the horizon (far left). In temperate areas this period of sunset lasts just 90 seconds in the summer, and is briefer still in the tropics. Load the camera with a new roll of film, and decide early on exactly how you're going to compose the pictures. Keep taking pictures when the sun disappears (left), but check exposure often, as light levels change by the minute. *Far left: Nikon, 200mm, Kodachrome 25, 1/250, f/5.6. Left: Pentax, 300mm, Kodachrome 25, 1/60, f/2.8.*

▲ Throwing the sun out of focus

The setting sun doesn't have to be razor sharp on film, especially if you simply use the sun's rays and colour as a backdrop for an interesting subject in the foreground. Choose subjects that have straightforward shapes, and remember that the sun's disc will appear quite small on film unless you use a lens with a long focal length. Try making pictures over a range of apertures, because the sun's shape may change as you stop down (fit a neutral density filter if you find yourself running out of shutter speeds when you open up the aperture). *Pentax, 300mm, Kodachrome 25, 1/250, f/16.*

RAINBOWS AND LIGHTNING

These two weather phenomena aren't uncommon, but catching them on film is partly a matter of luck: you have to be in the right place at the right time. Stormy weather should alert you to the picture possibilities, and if you remember the tips below, you'll be ready with your camera when lightning strikes, or when a rainbow adds appealing colour to the sky.

Rainbows appear whenever sun shines through falling rain, but the colours aren't always bright enough to make a good picture. The key is the background – you'll see the rainbow most clearly when there's something dark behind. Dark clouds, of course, make a striking background, but even when the weather doesn't oblige, you can often find other landscape features that create sufficient contrast. Unfortunately, there are no tricks that help brighten the colours.

CAPTURING LIGHTNING

Lightning is always startling, but the forked variety makes the best pictures. Don't rely on fast reactions if you're trying to catch the brilliant trails on film, because the flash will be gone before your finger even touches the shutter release. Instead, set the camera on a solid surface – preferably a tripod – and lock the shutter open. If your camera has a "T"

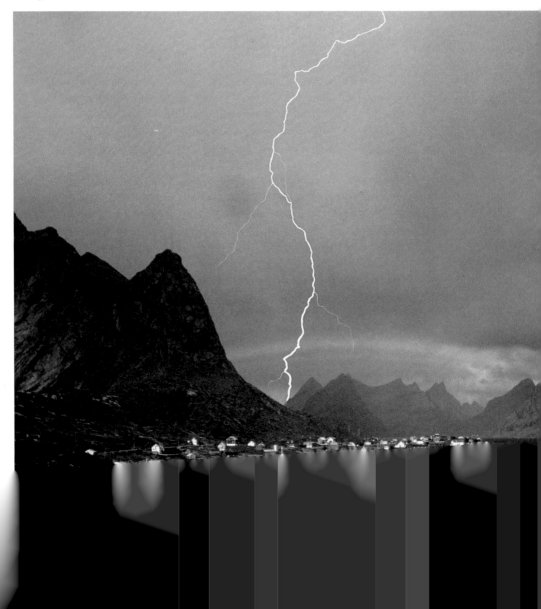

setting, you can use this, otherwise set the shutter speed dial to "B", and use a locking cable release.

Take a meter reading from the sky, and close down the camera's aperture to the maximum, for the longest possible exposure. In a tropical storm where lightning strikes repeatedly, you can take pictures even when the sky is quite bright, but in less ferocious temperate storms, you may need a dark night to get an effective picture. Usually, forked and sheet lightning occur in approximately the same area, but lightning trails in an empty sky don't make for effective pictures. It is better, having located the lightning, to make an object such as a church, a windmill, or a tree the centre of interest, with the lightning as a dramatic background.

Remember to take the usual precautions when photographing storms – if you set up your tripod in an open field or under a tree, you run the risk of photographing lightning at dangerously close quarters!

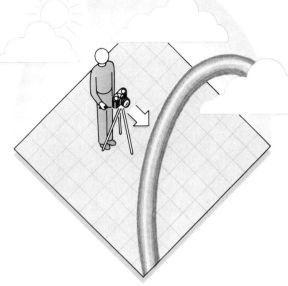

▲ Finding rainbows
Stand with your back to the sun, and if there's a rainbow it will be visible in the sky directly in front of you. Once you've found it, look at the sky outside the main bow: if you're lucky, you may see the secondary bow, paler than the first. Exceptionally, a *third bow appears, but usually it's too faint to be photographed.*

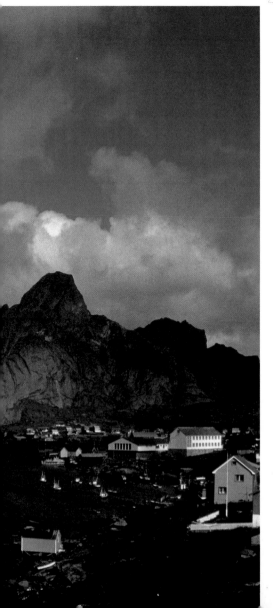

◀ The art of the retoucher
When the storm can't oblige with both a rainbow and lightning, photographic creativity has to continue after the film has been processed! The rainbow arcing gently over this Norwegian fjord was quite genuine: one stop of underexposure made the colours brighter. *The bolt of lightning, though, was shot separately, and then a duplicate transparency was made of the two elements together. Pentax, 105mm, Ektachrome 64, 1/15, f/8.*

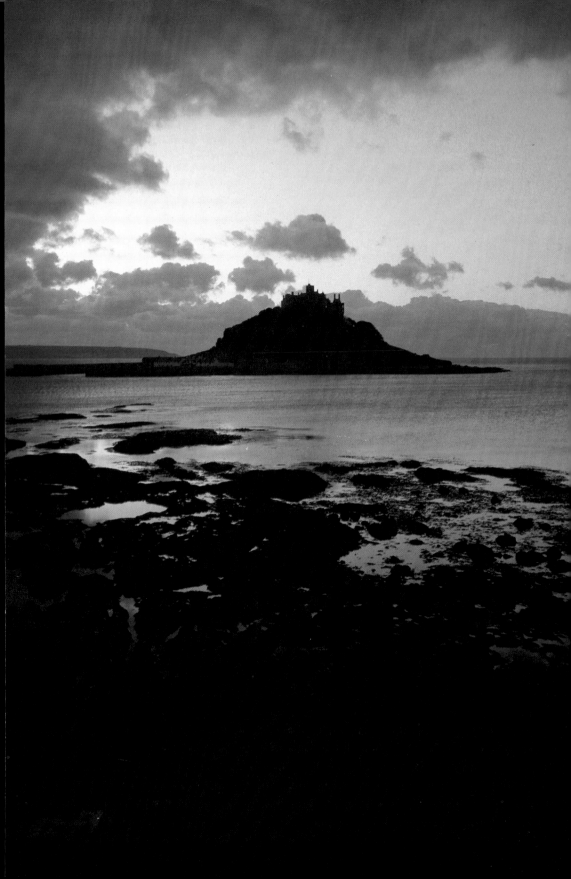

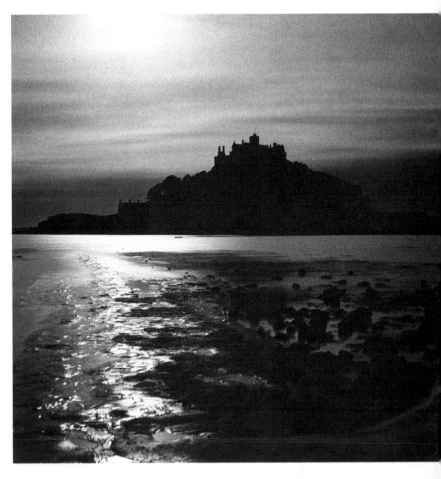

Reflecting moonlight
*Like snow, water reflects light, cutting exposure times in dim conditions. In the image on the left, exposure was set for the sky, and detail is visible on the beach in front of St Michael's Mount only because the receding tide left puddles that reflect the sky. If the sand was dry, the foreground would have appeared black and featureless. When exposure exceeds a couple of seconds, the speed of film gradually drops – and colour film produces unpredictable colour shifts. Black and white film avoids this last complication, so it is good for night-time use. However, even black and white film loses some speed in dim light, and there is also a gain in contrast, so compensate by overexposing and cutting development. For one-second exposures, give one extra stop, and cut development by 10%. When the meter indicates 10 seconds, give two stops extra, and cut development by 20%. At 100 seconds, give three stops extra, and cut development by 30%.
Left: Rolleiflex, Fujichrome 50, 1/2, f/4.
Above: Hasselblad, 80mm, Ektachrome 64, 1/15, f/8.*

STORM LIGHT AND RAIN

Storms can create unexpected lighting contrasts, with the foreground brilliantly lit, and the background dark. Catching these moments requires a camera at the ready, yet it is often in very bad conditions, when most people put their equipment away, that the most exciting landscape shots can be taken.

Storm light creates unusual contrasts that upset the camera's meter, usually with the result that it responds to the extreme highlights and produces underexposed pictures. It is best in such situations to bracket the exposure, taking a series of shots at least one stop over and one stop under the exposure indicated by the meter. There are some cases where a variation of two stops is worth trying for a more dramatic effect.

Picturing rain on film may seem like a simple matter, but it's more difficult than you'd imagine. Raindrops flash past so fast, and, being translucent, are so indistinct, that they often disappear in the picture. However, there are ways round the problem. If you include in the foreground an area of water such as a puddle, you can use a fast shutter speed to catch the concentric circles the raindrops make as they fall on the surface. Another method is to use strong backlighting from the sun, which will show up the raindrops very distinctly. However, if all else fails, flash can be used to capture the droplets of rain.

BATTLING WITH HUMIDITY

In damp conditions you'll need to pay special attention to film and equipment. Humidity softens the emulsion, so that film becomes sticky, and condensation on the camera can seep into delicate mechanisms.

Follow these guidelines to avoid problems:

■ Keep cassettes in their air-tight containers until immediately before loading.

■ Try not to leave film in the camera for too long – use short rolls, and take film out at night.

■ Store exposed film in plastic bags, along with a pack of silica gel. This is a crystalline compound that soaks up moisture, and changes colour when fully saturated. It's usually available at chemists. Squeeze as much air from the bag as you can.

■ To avoid condensation when leaving air-conditioned areas, keep equipment wrapped in plastic bags until it has warmed to the ambient temperature.

■ Process film promptly.

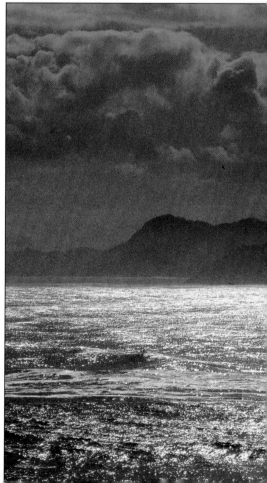

◀ Colour contrasts in storm light
When the distant scene is overcast, and the foreground lit by bright sun, as in this photograph taken during a period of stormy showers, your pictures will have a colour imbalance, with blue in the distance, and warm colours in the foreground. Nevertheless, it is not usually advisable to attempt to correct the colour contrast by using colour-correction filters because, if anything, the two-tone appearance evokes stormy weather better than a picture with perfect colour.
Pentax, 50mm, Kodacolor 200, 1/60, f/11.

▲ Picking out telling details
In the minutes before a summer storm, there's a temperature and pressure drop that sends mammals off to their lairs, and birds to roost. Images of the animal kingdom in search of cover recreate with particular vigour the sense of anticipation that precedes a downpour.
Canon, 300mm, Kodacolor 400, 1/125, f/5.6.

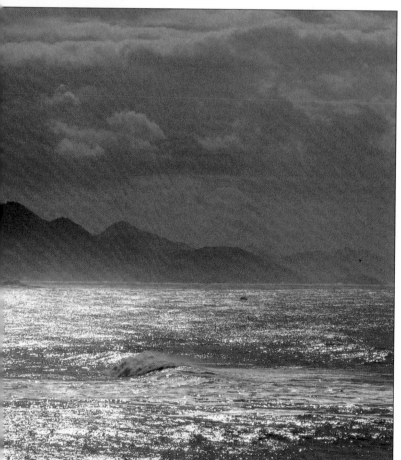

◀ Adding colour with a filter
Storm light frequently turns the sky and the landscape beneath a leaden grey that looks exciting and filled with drama. When shafts of sunlight fall on water, photographs appear in shades of silver. Under these conditions, it is worth trying black and white film. Alternatively, use filters with colour film to strengthen the colour in the scene. Don't just use those normally recommended for colour film; try filters designed for monochrome, too. Often the strongest colours, such as the blue used for this picture, work best of all.
Minolta, 300mm, Ektachrome 64, 1/30, f/5.6.

▲ Rainproofing cameras
To improvise a waterproof coat for your camera, take off the eyepiece lens, and put the camera in a plastic bag. Now screw back the eyepiece and a filter to cut round holes, and discard the circles of plastic. Hold the bag in place around the lens hood with a rubber band.

▼ Using props to make the point
It's not easy to get rain to show up on film, but props and models tell the story quite forcibly enough. To make the weather seem duller, underexpose by between 1 and 1½ stops.
Minolta, 85mm, Ektachrome 200, 1/30, f/4.

Painting with a palette of greys
The grey skies of rainy weather aren't normally regarded as good omens by photographers, but you can nevertheless turn storms to advantage. Look out for subjects such as the hut in the picture at the bottom that have the same neutral grey hues as the sky and falling rain.
Pentax, 200mm, Ektachrome 200, 1/8, f/4.

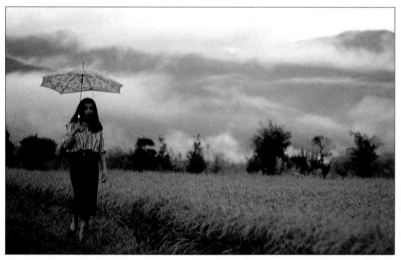

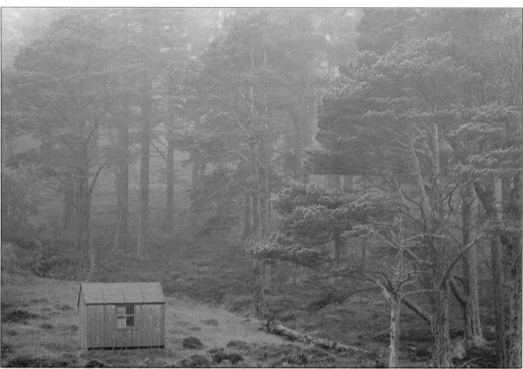

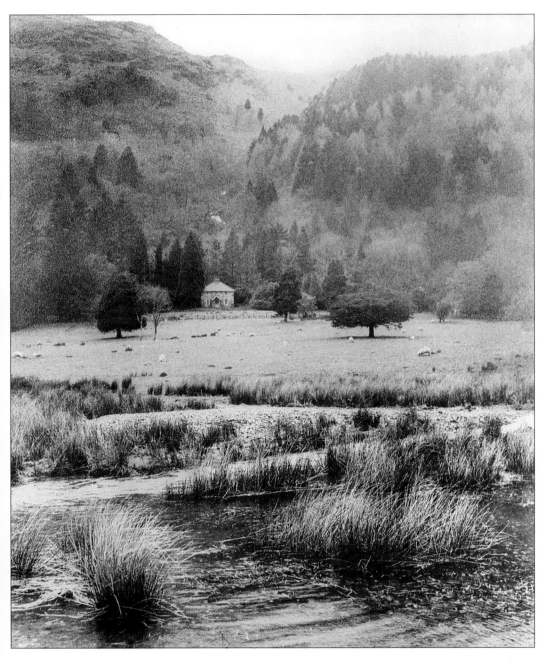

▲ **Framing a rainy landscape**
Composing pictures with puddles or pools in the foreground is a sure way of catching the falling drops on film. Use a shutter speed of 1/60 or faster so that the rings are not blurred as they spread outwards on the surface of the water.
Hasselblad, 80mm, Royal-X, 1/60, f/5.6.

TWILIGHT AND NIGHT

Go out in the brief period after sunset – when it's neither night nor day, when the sun no longer reveals the hard edges of the landscape, but when there's still enough light in the sky to see – and take photographs. Landscape at twilight is painted with the colours of the sunset, but without the glare of the sun itself. As a result, twilight landscapes are subtle-hued across the whole frame, not just in the sky.

At night it's too dark for our eyes to detect colour, so the landscape appears in shades of grey. Photographic film, though, doesn't lose its colour sensitivity in the same way, so if you take pictures at night, you may be surprised at how much more colourful they are than the scene you remember.

To use a camera effectively after sunset you'll need some extra support. A tripod (see page 22) is ideal, but you can often improvise by propping the camera up on a wall or a chair. Don't despair if your camera's meter doesn't display a suitable shutter speed after dark: many cameras will function on "automatic" even when the exposure meter appear quite lifeless.

For less haphazard results, use a separate hand-held meter – these are generally more sensitive than those built into the camera body. You must allow more exposure than the meter indicates, because film speed drops in dim conditions. Film manufacturers supply exact details but, in general, allow half a stop extra when the exposure exceeds one second; one stop extra for exposures exceeding ten seconds; and two extra when the shutter is open for a minute or more.

▼ **Twilight exposure**
*Snow makes night pictures easier to take, reducing exposure times by a stop or two. Just after sunset, you can use your camera's meter to set exposure – to keep the moon round make sure shutter speeds don't exceed about 10 seconds with a standard lens.
Pentax, 50mm, Ektachrome 64, 1 sec, f/6.3.*

▶ **Keeping detail in the moon**
*When the sky is very dark, the moon appears in pictures as a blank white disc. To retain detail, try to take pictures when the moon is just a little paler than the sky.
Canon, 300mm, Ektachrome 200, 1/60, f/11.*

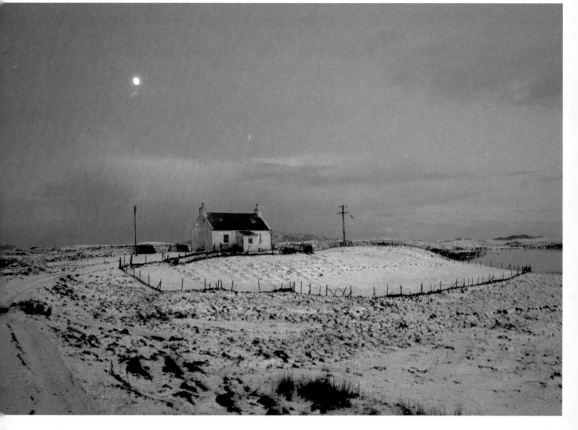

HAZE, MIST AND FOG

These conditions may seem like a hindrance to successful photography, but they can in fact provide the atmosphere for some very exciting pictures. Haze provides a useful way of creating a sense of distance and depth in a picture: it makes distant parts of the scene look bluer and lighter than the foreground.

Light mist adds atmosphere to any scene, especially if it's lying in hollows in the ground. The trick here is to be out with your camera very early: once the sun appears above the horizon, it's only a matter of minutes before thermal air currents lift the mist from the ground.

At first it may be hard to see how thick mist and fog can be an advantage, yet a blanket of white mist serves to isolate and soften the forms of houses, sheds, pylons and power cables, and other intrusive objects, creating an idyllic view of a scene that previously was not worth consideration by the photographer.

When you're photographing a misty view, take special care over exposure. The prevailing white tones easily confuse the camera's exposure meter, so that the resulting pictures tend to look grey and dull. To avoid this, give at least 1 or 1½ stops overexposure, either by setting exposure manually, or by turning the exposure compensation dial to +1 or ×2. Don't forget to reset the dial to the neutral position after the shot.

FILTERS FOR FOG

You'll find that your mist and fog pictures have a bluish colour cast if you use slide film, but you can eliminate this with a straw-coloured 81B filter. Print-film users don't need this filter, because the colour printing process takes care of the correction.

If you want the clearest possible pictures on a hazy day, use a polarizing filter. This often darkens and improves the contrast of distant parts of the scene, creating the impression that haze has been reduced. Mist and fog don't respond to this treatment, because they are composed of suspended water droplets – whereas haze is caused by dust in the atmosphere.

▶ *Separating tones with mist*

Early-morning mist gathers in hollows, in valleys, and over water, so if you want to take advantage of its atmospheric qualities, look in these places first. And since mist is so local, you'll often be able to use it to provide some separation between adjacent landscape objects of similar tone, such as this bank of trees and the hillside beyond: in normal conditions the two areas simply merged together, producing a rather uninteresting and flat backdrop to the Tudor village nestling in the valley. No exposure adjustment is necessary when, as here, mist occupies just a small part of the picture.
Minolta, 135mm, Ektachrome 64, 1/15, f/11.

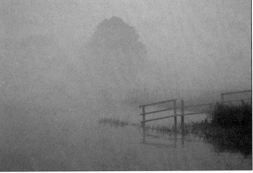

◄ Lightening the mist
Mist can mislead the camera's meter, leading to underexposure. With transparency film, a stop or so of overexposure cures this; with negative film, ask the laboratory to make sure the mist appears white in prints. *Hasselblad, 80mm, Vericolor II, 1/30, f/8.*

▲ Portraying misty gloom
If you want to retain the gloomy atmosphere of a dull grey misty morning, keep to the exposure indicated by your camera's meter. The result is a symphony of pastel tones, with distant objects looming up ominously. *Pentax, 50mm, Ektachrome 200, 1/15, f/4.*

▲ Filtration in mist
Negative film is normally capable of yielding good colours in misty weather even without the use of special filtration: colour correction in the darkroom takes care of any imbalance. If you are using transparency film, however, you'll need to take a little more care to prevent slides from developing a pale blue colour cast. Use a filter from the Wratten 81 series: an 81A in very light mist, or an 81B in heavy mist or fog. *Pentax, 105mm, Ektachrome 64, 1/15, f/5.6.*

SEE · ALSO
Control in black and white
pp. 44-7
Filtration pp. 50-3

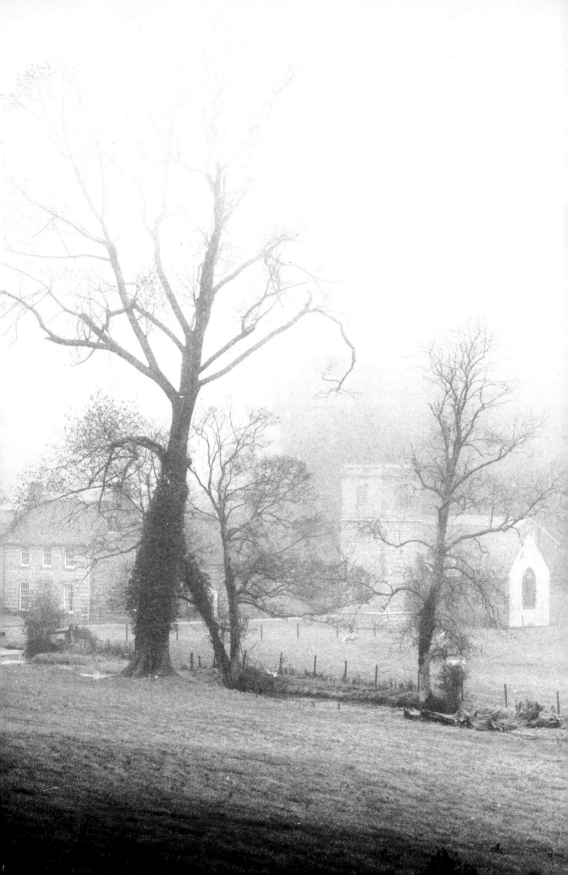

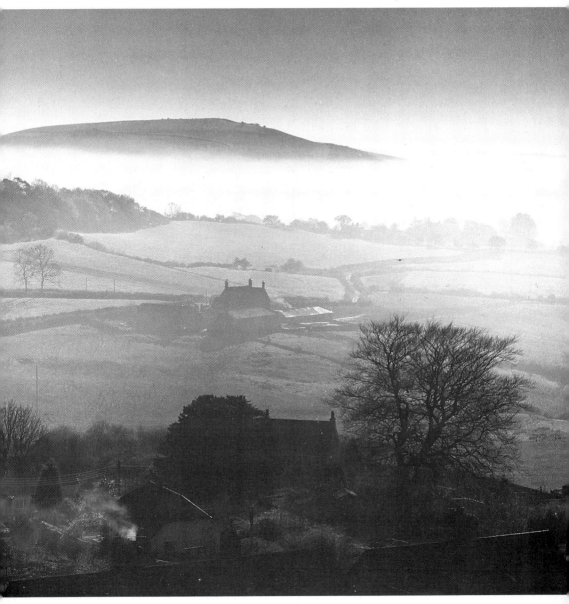

Mist in monochrome

If you use black and white film for pictures in mist, you don't have to make decisions about tone, contrast and composition on location, because final adjustments are made in the darkroom. It's normally wise to give a little extra development to films exposed in foggy conditions, to raise the contrast a little, but if you also have sunlit subjects on the same roll, extra development could make them impossible to print; instead, give normal development and print the foggy scenes on hard paper. Even with extra development, misty views often look very flat: burn in the foreground (left) to add some depth to the scene. Burning in the top of the picture can make far hills appear to rise above the mist (above), but use only moderate amounts of additional exposure, or the effect will look artificial.
Left: Canon, 105mm, FP4, 1/30, f/5.6. Above: Rolleiflex, Tri-X, 1/125, f/11.

SEE · ALSO
Film choice pp. 32-3
Monochrome landscape
pp. 78-9

CLOUDS AND WIND

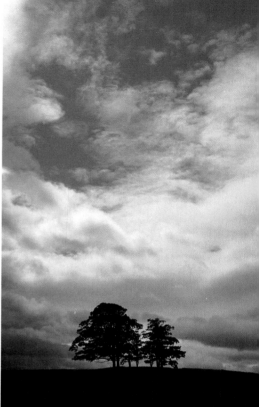

In most landscapes, the sky is just as important an element as the ground beneath. An interesting sky can pep up even a quite boring landscape, and conversely flat, dull skies create the risk of flat, dull pictures.

Broken cloud with strong sunlight provides the best opportunities for landscape photography, especially on a windy day. Strong wind keeps clouds in motion, casting a changing pattern of light and shade on the landscape below, and constantly altering the appearance of the sky itself.

You can make cloudscapes that are every bit as interesting as conventional landscapes. To anchor the scene, it's a wise precaution to retain a hint of the horizon, even if this is just a narrow strip of land along the bottom of the picture. Wide-angle lenses take in the broadest sweep of sky, creating more interesting views than the details that standard and telephoto lenses record.

The sky is usually several times brighter than the land beneath, and you'll normally have to set exposure to suit either the sky or the land. However, a graduated filter helps to retain detail in clouds, even when you expose for the landscape. The most versatile "grad" is a dense one in plain grey; the brighter colours tend to create gimmicky, artificial-looking skies.

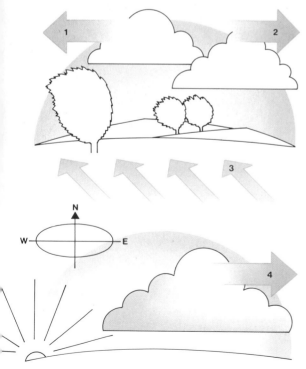

◀ Predicting the weather using clouds
You can often predict from cloud movements how the weather will change in the next few hours, using the "crossed winds rule". Stand with your back to the surface wind (1) or face the wind in the southern hemisphere. Then turn clockwise 30°, and look at the clouds high in the sky. If the upper clouds are moving towards you or away from you the weather is unlikely to change very much. If the upper clouds move from left to right (2) blue sky with fluffy clouds will soon be replaced by high cloud, and conditions for photography are likely to worsen. If upper clouds cross from right to left (3) a cold front is approaching and there are better prospects for photography, with interesting skies above the landscape. Even weather lore can be useful: "red sky in the morning, sailor's warning" is based on the observation that the rising sun is shining through clear sky and illuminating a bank of clouds in the west (4). In the northern hemisphere weather systems move predominantly west to east, so this bank of cloud would be advancing towards the observer.

◄ Taking in more sky
When dramatic clouds fill the sky, it makes sense to let them dominate the picture, by using a wide-angle lens, and tilting the camera up. A polarizing filter darkens the blue sky, but requires extra caution with lenses that have a focal length shorter than 28mm. Light from the sky is not polarized evenly, and with ultrawide-angle lenses a polarizing filter creates a band of dark blue with paler areas each side. A more common problem is vignetting: polarizing filters are thicker than other kinds, and may cause a darkening at the corners of the frame.
Olympus, 20mm, Ektachrome 64, 1/60, f/8.

◄ Exposure for low cloud
At high altitudes, the clouds often blow through forests and valleys, and you'll get the most dramatic pictures if you expose for the clouds themselves, turning the landscape to black, or rich shades of blue.
Minolta, 50mm, Kodacolor 400, 1/125, f/5.6.

▲ Clouds from above
Air travel provides special opportunities for taking "cloudscapes". Get a window seat, well away from the wing, and don't press the camera against the window, or you'll pick up vibration from the airframe. Also, beware of reflections from the window.
Pentax, 50mm, Ektachrome 64. Above: 1/250, f/4. Right: 1/125, f/4.

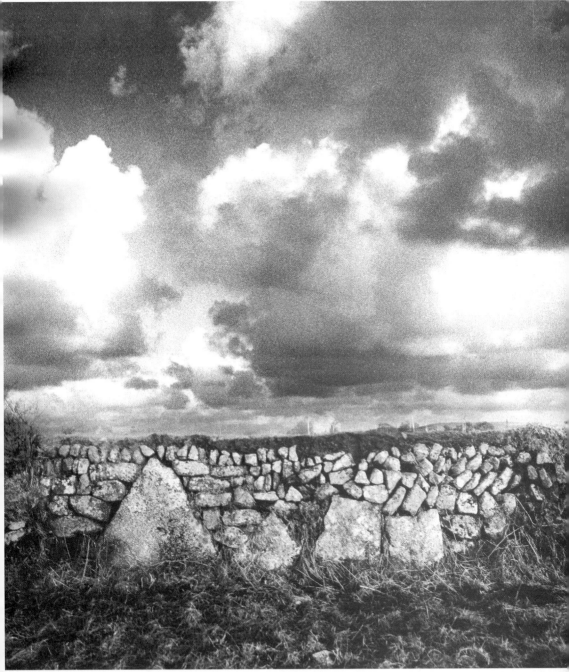

◀ Adding clouds from a second negative

If a dull sky mars a good landscape, there is no need to despair, because you can add clouds in the darkroom, using a second negative. Make the landscape print in the normal way, but shade

the sky. Then replace the negative with a good cloud picture, and make a second exposure on the same sheet of paper, shading the land. *Landscape: Rolleiflex, FP4, 1/60, f/2.8. Clouds: Nikon, 50mm, Tri-X, 1/60, f/8.*

▲ Combining simple subjects with clouds

Really dramatic skies can stand on their own merits, but some detail of the land beneath always provides a welcome anchor for the eye. Choose a simple subject – perhaps a silhouette of

the horizon, and add contrast to the clouds with a red filter. *Rolleiflex, Tri-X, 1/8, f/11.*

REFLECTIONS IN WATER

Water is very versatile and can perform many roles in landscape photography. The effect is often most remarkable on a perfectly still day, when an area of water mirrors the landscape and sky beyond.

Be sure to explore fully the chosen stretch of water, shooting not only general views of the scene, but also tight close-ups in which the reflection and object reflected meet seamlessly at the water's surface. Even when ripples break up the surface, water's reflective qualities still shine through.

If possible, visit the location in a variety of light conditions. When the sky is colour-ful, look for water areas to double the appea... of the view. Even quite small bodies of wate... are suitable, provided that you get the camera down near the water level.

Sunlight turns the colours of water to mercury or liquid gold, but the camera angle is all-important. At the beginning and end o... the day it's easy to include the sun, its reflec-tion, and the horizon in the picture, even with quite a long focal length lens. Towards noon, and especially in summer, you'll need to adopt a higher viewpoint if you're to catch the sparkle of sunlight reflected from the sur-face of the water.

▼ **Using reflections to double autumn's appeal**
Some light is lost on reflection, so subject and mirror image never appear equally bright. Decide which part of the picture is most important, and set exposure to record that area of the image most accurately.
Pentax, 50mm, Ektachrome 64, 1/125, f/5.6.

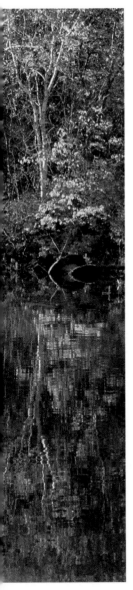

▲ **Eliminating the subject**
If you crop out the reflected object altogether, you can take abstraction to its logical limits, as in this picture of a lake-side boat-house. Pick a subject that has bold, simple shapes, or readily identifiable features. Here the window and the pattern of the shingle roof catch the eye, and the strong lines of the hut remain intact despite the distorting effect of the reflection.
Pentax, 85mm, Fujichrome 50, 1/60, f/4.

▼ **Ripples to break up the image**
Perfectly still water generates identical copies of the landscape above – but unmodified repetition doesn't always make images look twice as good. Try tossing pebbles into the water to break up the reflection. Differential focusing helps, too: use large apertures so that the picture drifts gently out of focus, as at the bottom of this image.
Canon, 50mm, Ektachrome 100, 1/250, f/2.8.

Monochrome reflections
In black and white, shape is doubly important: choose subjects with strong outlines (right and below right) and those that make a new shape when doubled, such as the arches of the bridge below. The contributions that reflections make need not always be overt: in the picture below, they create symmetry and heighten the sensation of tranquillity. And in the picture at right, the reflection draws the gaze from the foreground across the water to the scene beyond.
Near right: Canon, 50mm, FP4, 1/60, f/8. Far right: Canon, 35mm, FP4, 1/60, f/5.6. Below: Pentax, 50mm, Tri-X, 1/125, f/8. Below right: Nikon, 85mm, Tri-X, 1/60, f/5.6. Bottom: Minolta, 105mm, FP4, 1/60, f/4.

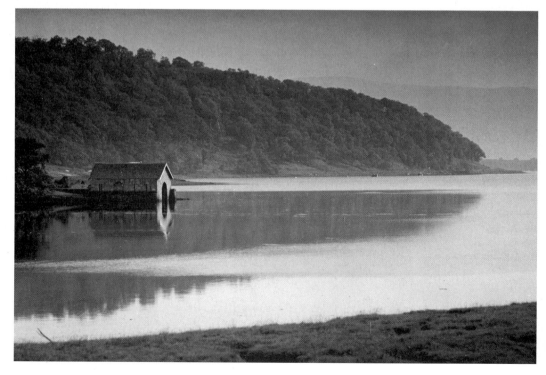

SNOWSCAPES

Much of the world's surface is covered by snow and ice for at least part of the year, and the pristine white tones of these landscapes need quite different treatment from the greens and ochres that make up scenery in warmer areas.

Severe frost and snow transform the landscape, and the places you've known for years become as unfamiliar as a foreign land. But, at the same time, ugly or unexceptional landscapes can reveal a picturesque aspect in winter that makes them well worth shooting. However, much of this strange beauty vanishes as soon as traffic and snow-boots cut the first paths through the fresh white mantle, so an early start is often the key to good winter landscape photographs.

Snow has a unifying effect, reducing the entire landscape to a similar texture and tone. You can exploit this in two ways: either by focusing on the abrupt contrasts where the underlying landscape peeps through its mantle of snow; or by concentrating on the subtle changes and differences within the unbroken snow-field.

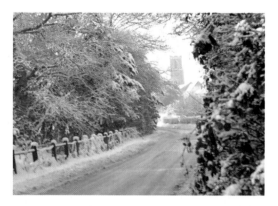

◀ Winter blues
The reflective surface of newly-fallen snow is quick to pick up colour casts: when the sky is blue, shadows will all be tinted the same colour. If the sun is not shining, this is rarely a problem: in such conditions you can fit a "warming" filter from the Wratten 81 series in order to eliminate the colour cast.

Minolta, 50mm, Ektachrome 200, 1/30, f/11.

▶ Coping with contrast
*Scenes dominated by dark or light tones mislead the meter: either use an incident light meter, or take a reading from the snow then overexpose by a single stop.
Right: Nikon, 50mm, Ektachrome 64, 1/15, f/8.*

▶ Catching colours at dusk
*When the sun is close to the horizon, its rays are especially yellow in colour, making a dramatic contrast with the cool shadows lit by the blue sky. The colours will look more vivid if you use a graduated neutral density filter to balance the brightness of sky and snow.
Pentax, 105mm, Ektachrome 100, 1/60, f/2.8.*

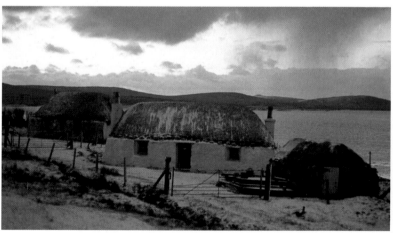

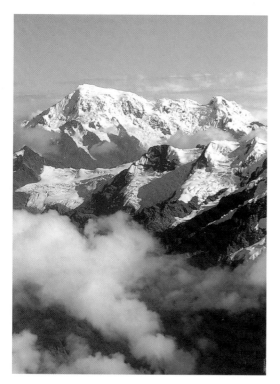

Patterns in snow

A snowfall emphasizes graphic aspects of the landscape: clad in snow, these branches (above) make powerful repeated motifs stretching away from the camera. The softness of clouds (left) draws attention to the rugged outlines of mountains behind; and dead-straight horizontal lines in this icy lake make a powerful counterpoint with the random, organic shape of the horizon. Above: Minolta, 28mm, Ektachrome 64, 1/60, f/4. Left: Nikon, 50mm, Kodachrome 25, 1/250, f/4. Below: Pentax, 200mm, Ektachrome 200, 1/60, f/11.

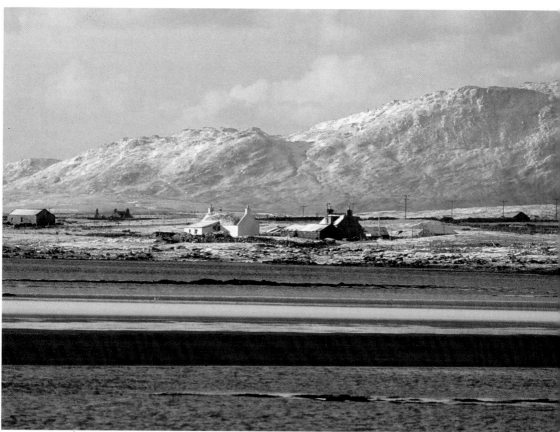

METERING PROBLEMS

Taking the former approach means keeping your eyes open for stretches of bare rock or ice swept clean; for slopes too steep for snow to cling on; and for the patterns made when flowing water keeps the ice at bay. Trees also make useful subject elements: the very shape of conifers has evolved to shed snow burdens. Pictures such as these are generally high in contrast, and you'll need to take special care with exposure metering: decide how much detail you want to retain in the snow areas, then set exposure accordingly. Metering from the snow and overexposing by one stop gives the best possible detail in the snow, but renders other areas unacceptably dark. Two stops overexposure retains a small amount of detail in the snow itself, but should record areas free of snow in realistic tones. Overexposure by three stops burns out the snow to pure white, making it simply a foil or frame to other parts of the picture.

If you choose instead to concentrate on the shapes of the snow itself, you need to take quite a different approach. With colour film, look carefully at the way snow reflects the hues of daylight. Shadow areas pick up the colours of blue sky, while sunlit patches come out pure white on film. Early and late in the day the sun's colour shifts towards yellow and orange, and the white surface of a snow drift picks up these small alterations long before other parts of the landscape. To show these colours at their brightest, you should meter directly from the snow – but be prepared to lose detail in all areas that aren't snow-covered.

The shapes of snow-covered landscape lend themselves especially well to black and white film. With monochrome, metering considerations are similar to colour, and there is the opportunity of additional control in the darkroom. Careful printing, though, can't put back detail that isn't on the negative, so the key with monochrome film is to take a meter reading from the shadows; the exposure latitude of black and white film is wide enough to accommodate even the brightest snow-covered area.

▶ *Snow as a canvas*
Figures in snow look like splashes of paint on a clean canvas – but only if the snow appears pure white and featureless on film. To eliminate detail in the snow, give two stops extra exposure, or shade snow-covered areas on the print.
Rolleiflex, 85mm, HP3, 1/60, f/8.

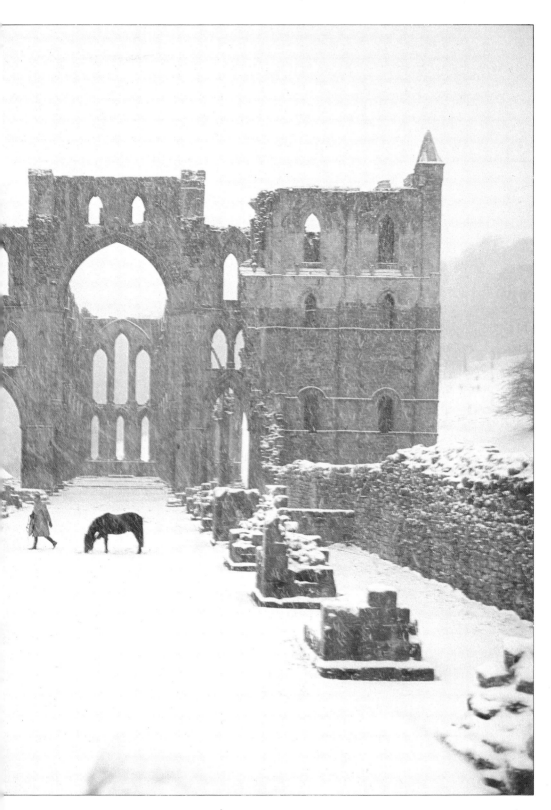

THE ELEMENTS OF LANDSCAPE

The preceding sections of the book consider photographic methods largely in isolation from the landscape subject. There's good reason for this: individual techniques are valuable in many different contexts. The way you deal with clouds, for example, is unchanging whether they are a backdrop to a scene in an Amazon rain-forest or lunch-time strollers in a steamy city; most aspects of camera operation are of even more universal value. Knowledge without practice makes but half an artist, so in this section we concentrate on application.

Landscape is amazingly diverse, and infinitely variable, so generalizations are difficult to make, and any attempt to categorize landscapes into types always meets with limited success. The individuality of your own approach to the landscape subject acts as a further complicating factor, and multiplies this diversity.

In this last chapter I've tried to explain how I see and react to the many different kinds of landscapes, and I've described some of the styles and interpretations that I think work best in each category. You can judge from the photographs how successful I've been. However, the human response to landscape is essentially subjective, and your own approach is bound to be different from those that I suggest: these images thus provide just a taste of what's possible.

The variety of types of landscape may provide you with creative stimuli, but it has other consequences, too: the vagaries of climate and terrain put wide-ranging demands on the photographer and equipment. It is of prime importance to be prepared, working out beforehand what equipment you will need for a given situation.

▶ **The sea's anger**
The ferocity of the ocean is as much of a cliché in photography as in music or painting, so making a picture which sums it up in a new way isn't easy. However, this stricken ship seemed to say it all. Careful burning in lowered the sky, highlighting the drama. Rolleiflex, Tri-X, 1/30, f/11.

MOUNTAIN SCENERY

Mountains dominate a landscape, putting all other terrain literally in the shade. Sheer scale is probably the most impressive feature of mountain scenery, but capturing this might and majesty on film without the shot looking clichéd is a great challenge.

The most important factor in conveying size is context. Taken out of context, a mountain peak might be no more than a sand-hill – so look for things in the scene that will give the viewer clues to the size of the mountain. Human figures are generally too small to act as foils for mountain scenery, but buildings and trees help provide a ruler against which to measure the peak.

Lighting direction profoundly affects the appearance of mountain scenery. A summit that looks benign and almost welcoming with frontal lighting can seem brooding and threatening when the side facing the camera is in shadow. You'll find it pays to monitor your subject throughout the day, taking pictures as the sun moves round.

Mountains usually have an associated weather system that's quite different from surrounding lowlands: it's not at all unusual to drive from hot sunny weather on a coastal plain to chill fog higher up. Patience brings rewards, and if you wait you may pick up a feeling for mountain weather cycles, so that you're better able to anticipate when the clouds will break.

You'll find that mountain views provide plenty of opportunities to exercise any and every lens you can lay your hands on, from ultra-wide to super-telephoto. Pack polarizers if you normally use them, but you'll need discretion in their use: mountain skies are often a deep, saturated blue, and a polarizing filter can turn them almost black. Many books recommend that you use a UV filter at high altitudes, and though it's true that ultraviolet radiation abounds in the peaks, this precaution is no longer necessary. Most modern films have a UV absorbing layer to prevent the blue colour casts that formerly plagued mountain photographers.

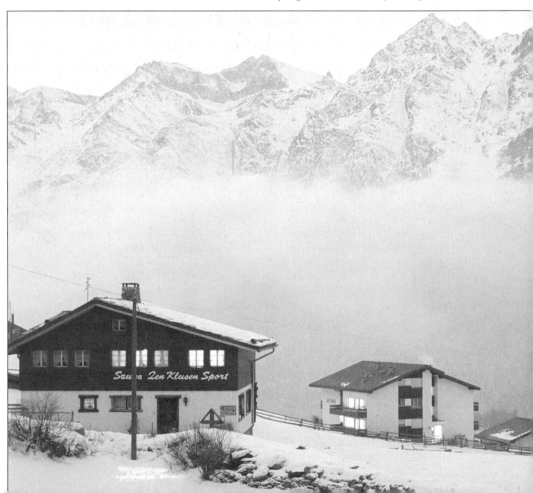

High and low key

Mountains create dramatic lighting and extreme contrast, and careful choice of camera angle and exposure allows you to change their character almost at will. Framing snow-covered peaks from high altitudes makes the mountains look light in tone and almost benign (left) – a stop of overexposure makes the impression more emphatic.

Photographing at the foot of the mountains (top) and exposing for the sky has the opposite effect, so that the peaks look dark and threatening. Wooded mountains provide other opportunities: choose a low horizon, and you can use the rising ranks of trees behind to form a textured backdrop for the landscape in the foreground.

Left: Nikon, 105mm, FP4, 1/125, f/8. Top: Nikon, 28mm, Panatomic-X, 1/30, f/8. Above: Pentax, 100mm, FP4, 1/125, f/8.

UPLANDS

Hills may lack the grandeur of mountain ranges, but in compensation their more modest proportions make them an easier subject for the landscape photographer to tackle. Access to mountain tops is usually difficult, making downward-looking viewpoint impractical. All you have to do is walk up a foothill, though, and you can survey all the surrounding land – including the tops of hills of lesser stature.

Don't just concentrate on general views, because one of the most fascinating aspects of hilltop landscapes is the variety of plant-life. The higher you climb, the smaller are the plants clinging to the thin soil. To feature the bog-plants and lichens as a part of the larger landscape, use a wide-angle lens and a small aperture. The inhospitable terrain also stunts the growth of larger life-forms: look out for slow-growing trees bent double in the force of the wind, and use them to break up the rounded forms of the hilltop landscape.

Warnings about mountain safety are equally relevant here: hills are all the more dangerous because they are somehow familiar and less obviously risky than mountains. For the inadequately equipped walker even a

Controlling atmospheric perspective
In upland areas, atmospheric perspective helps create a strong sense of distance. If you include the horizon, the image will fade to a blue-white at the top, suggesting a scene stretching to infinity (above). A figure further enhances the feeling of depth (left). Above:

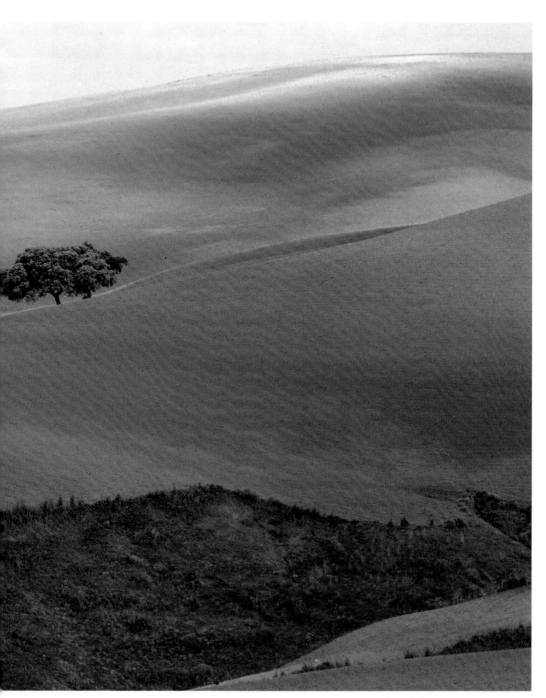

Nikon, 28mm,
Ektachrome 64, 1/60, f/2.8.
Left: Pentax, 105mm,
Ektachrome 200, 1/30, f/11.

gently undulating range of hills can be lethal.

Valleys and passes in upland areas usually make a striking contrast with the hills and peaks that tower above. Valley sides provide high grazing for sheep and cattle, and gaps or passes have traditionally been trade routes since prehistory.

Part of the charm of these places is the shelter they provide, and the relief they afford from wind and driving rain. If you would like to compare the intimacy of a sheltered valley with the bleakness of the hill-tops, try using a low viewpoint and a high horizon, so that the surrounding landscape appears to enclose and protect the spot.

An alternative approach is to try highlighting other features that characterize valley scenery, picking out grazing livestock, and perhaps at dusk using a long exposure so that passing traffic marks the winding roads with glowing trails.

Before leaving, tell someone responsible where you're going, and your estimated time of return – and remember to check with them again when you get back. If you drive to your point of departure, leave a note on the windscreen of your prominently-parked car.

Don't take unnecessary risks: wear proper walking boots; don't carry too much; and don't be too ambitious.

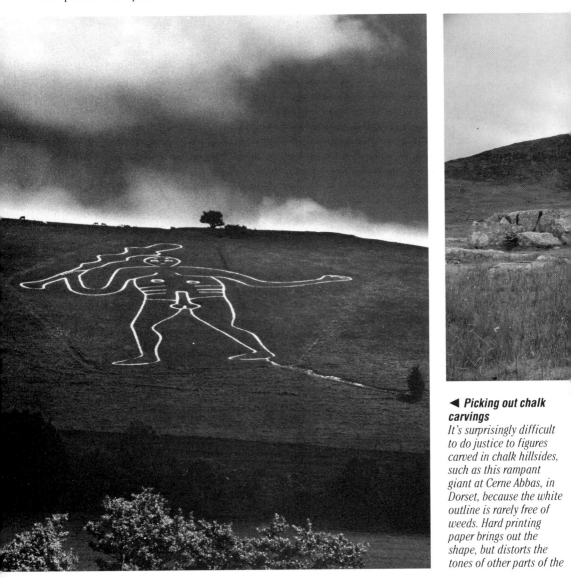

◀ Picking out chalk carvings
It's surprisingly difficult to do justice to figures carved in chalk hillsides, such as this rampant giant at Cerne Abbas, in Dorset, because the white outline is rarely free of weeds. Hard printing paper brings out the shape, but distorts the tones of other parts of the

SAFETY ON HILLS AND MOUNTAINS

If you intend leaving paved roads to take pictures in hill or mountain areas, you must be quite clear that you are running risks, and take precautions to reduce them to a minimum. These are sensible steps for hill walks exceeding a mile – or even less in mountains.

Carry a survival kit containing the following items:

■ Safety blanket. Reflective mylar – doubles as a reflector, and folds into your pocket.

■ Map. The larger the scale, the better.

■ Compass. Make sure you know how to use this and the map.

■ Torch and spare batteries (or electronic flash) plus whistle for audible and visual signalling.

■ Extra clothing. This should suit the climate, but don't set off without extra clothes simply because it's sunny and hot.

■ Food and drink. Again, what's appropriate for a short summer stroll may be totally inadequate for a long walk in winter.

▼ *Cutting through haze*
Haze often forms a veil that hides distant detail in upland pictures. In such conditions, it is worth fitting a red filter on your lens. Burning in the upper parts of a black-and-white print *also helps cut through haze by darkening the area near the horizon. Minolta, 35mm, Tri-X, 1/30, f/8.*

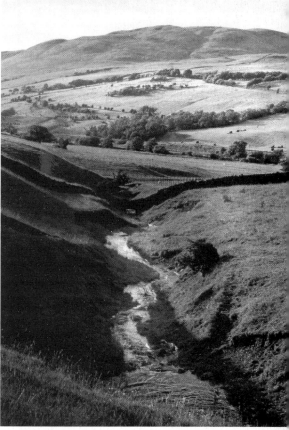

picture. A better answer is to make the print on normal paper, then use a brush dipped in photographic bleach (see Glossary) to lighten and tidy up the white chalk lines. To prevent staining of the print, first paint the metal ferrule of the brush with nail polish. Hasselblad, 150mm, FP4, 1/60, f/11.

▲ *Bleak setting*
If a house, figure, or livestock is included in an upland scene, the bleakness of the surroundings becomes more apparent and the composition easier to define. Pentax, 85mm, Tri-X, 1/60, f/5.6.

LOWLAND

Lowland plains and grasslands are dominated by the sky: you can't fail to be aware of every tiny change in the elements. Capitalize on this by letting the sky rule your pictures: use a low horizon to suggest openness and freedom.

The landscape itself has mixed attractions, and visitors tend either to love or hate the apparently endless stretches of flat lowland. Remember that if you do not interpret the scene thoughtfully your photographs may provoke similar reactions, so try and get as much variety of approach as possible. To break the potential monotony of the scenery, look especially for ways to get camera above ground level. Even standing on the roof of a car provides enough elevation, and gives you a panoramic view over the surroundings. From 50 feet or so above ground level – the roof of a small building takes you up this high – you can shoot the landscape stretching away into the far distance.

PASTURE LAND

Wilderness areas rarely end at clearly-defined borders: more often the human influence creeps in almost unnoticed. The first signs are not direct, like roads and dwellings: instead the landscape is subtly

▼ Adopting a high viewpoint
From a lower viewpoint, the receding lines of these hedges appear stacked on top of one another, hiding the attractive textures and furrows in the fields .
Seen from the top of a railway embankment, though, the landscape is spread out before the camera.
Hasselblad, 80mm, Tri-X, 1/60, f/5.6.

▶ Wide-angle lenses
Lowlands and wetlands often look featureless from afar, and most of the visual interest is on a small scale in the foreground. A wide-angle lens lets you close in on the textures and patterns of bog or marsh, and still include the horizon. Hasselblad SWC, Tri-X, 1/30, f/5.6.

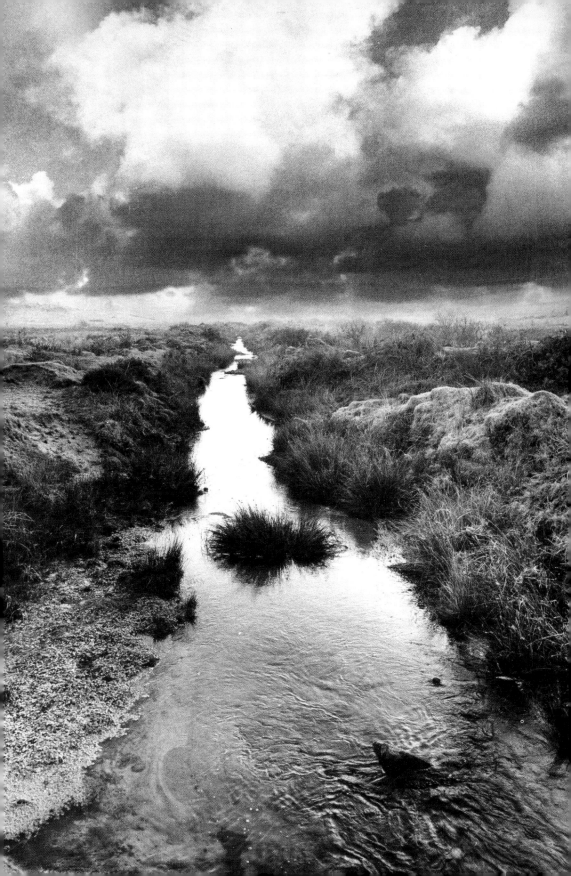

and gradually altered by grazing farm animals.

Pasture land varies enormously in appearance and structure, largely according to its fertility. On marginal upland pastures nimble sheep and goats roam freely, peppering photographs with random splashes of white. Lower down, pasture land is more likely to be enclosed, and the regimented lines of fences and dry stone walls provide opportunities for dividing the frame with geometric precision. Seen from a distance, the hedges, fences and walls are themselves invisible, but changes in the colour of vegetation mark the boundaries between these lowland pastures.

Compared to areas with more productive soil, marginal pasture land has escaped the worst effects of the modern farming methods, and it's worth taking some time to try and evoke this timelessness in your landscape images. Look for traces of the past in old field boundaries, ancient trackways, and the patterns of vanished plots. All these residues of bygone times show up best when the sun is very low in the sky, casting long shadows across the land.

◄ Composition with a low horizon
The experience of walking through lowland countryside is dominated by the sky, so it makes sense to compose lowland images with the horizon low in the frame. If the sky is a uniform blue or grey, and you have your own darkroom, use local exposure control at the printing stage to add a tonal change from the top of the frame down to the horizon.
Pentax, 35mm, FP4, 1/250, f/5.6.

C O P I N G W I T H D U S T

Wind-borne dust is a problem that is not unique to lowland plains, but it can be particularly acute in these areas. The danger areas on the camera are: focusing threads on lenses; optical surfaces; and the film plane. Never put anything down without first checking for dust and grit. Change film and lenses only in sheltered places, and methodically brush or blow out the film chamber and camera back between rolls. Keep caps on the front and rear of lenses when not in use, and protect the front element of the lens on the camera with a skylight filter. At the end of a day's shooting, clean everything methodically – and ideally vacuum out your camera bag to eliminate traces of grit.

You can suffer from sand and grit, too: if you normally wear contact lenses, take along a pair of spectacles as a back-up.

◄ Farmland vignettes
Modern farming methods may have eliminated the haystack and other picturesque agrarian details but they have provided other opportunities for the camera. Scattered over the fields, vast bales (far left) create interesting shapes and textures, and distort the scale of the landscape. And though it's impossible to actually photograph the decline in rural economies and the effect this has on social structure, collapsing cottages and crumbling sheds (left) suggest it in potent metaphors.
Far left: Pentax, 50mm, T-Max 100, 1/60, f/8. Left: Nikon, 105mm, Tri-X, 1/125, f/5.6.

SEE · ALSO
Control in black and white
pp. 44-7
Landscape abstraction
pp. 82-5
Positioning the horizon
pp. 94-5

FORESTS AND WOODLAND

Much of the appeal of natural woodland lies in the experience of walking through it, but the noises, the smells, and the textures of the fallen leaves all stimulate senses that the camera cannot reach. To make good pictures, you must be ingenious about selecting purely visual stimuli.

Simplicity is the key to this. Walking through a woodland area it's difficult to differentiate between the profusion of branches and the undergrowth. To make simpler pictures that are more easily read, seek out clearings in the woodland where you can literally see the wood for the trees. Also try photographing the forest's edge, from the far side of a road or a river, to get a more distanced viewpoint.

Look for contrasts in the forest. A row of vertical pine trees seems unexciting, but the picture will catch the viewer's eye if the diagonal of a half-fallen tree breaks the uniform line of uprights. Equally, a thicket of deciduous trees looks much more interesting if you highlight the single conifer tucked away in the middle.

Forests are surprisingly dark. For pictures in woodland, even in high summer, you'll need to take along fast film or a sturdy camera support if you want to use any but the largest aperture. During winter, try black and

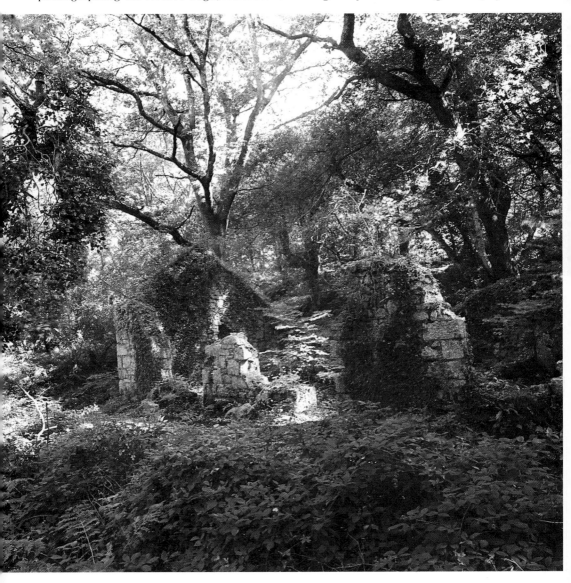

white film; in monochrome you'll find it easier to make the most of the stark patterns of bare branches and snow-covered ground.

If you have a wide-angle lens, you'll find this invaluable for opening up the cramped spaces between trees, but take along a tele-photo too. From outside and above the trees, longer focal lengths help you crop in and flat-ten the foliage into a pattern of green shapes.

FILTERING FORESTS

A canopy of leaves can subtly shift the colour balance of pictures taken in woodland, filtering out the red wavelengths, and boosting green. Some filters can't cope with this change, since they moderate only yellow and blue light. In such cases you need a colour correction filter – a 20 red or 20 magenta. These filters are normally available only in gelatin form.

◀ **Retaining foliage patterns**
Landscape views such as this rely for their impact on the wealth of detail visible in all parts of the frame. 35mm film has a limited ability to retain detail, so if possible, use a larger format.

Stopping down the lens also helps to capture the texture of foliage, not only because there is more depth of field when you select small apertures, but also because few lenses give good results wide open.
Hasselblad, 50mm, Panatomic-X, 1/2, f/11.

▲ **Low viewpoints**
To make the most of a spreading pattern of leafless branches, pick a low camera angle and frame the bare limbs against the sky. Then if you set exposure to suit the tree, backlighting will burn away all but the boldest of lines.
Rolleiflex, 50mm, Tri-X, 1/125, f/16.

SEE · ALSO
Exposure pp. 26-7
Shutter speed pp. 38-9

◄ Quality counts in close-up

If conventional woodland views begin to pall, try looking at the ground beneath your feet: patterns of spiralling intertwined roots and rotting stumps make an abstract foil for figurative pictures of trees and branches. However, if you do so, pay special attention to optimising quality of both the negative and the print, as vital detail and texture soon disappear with lack of definition. Use slow film and a relatively small aperture and support the camera.
Hasselblad, 80mm, FP4, 1/ 8, f/16.

▶ Looking out for the unexpected

Some woodland scenes are so unusual that they look odd even with a straightforward photographic approach. This sapling (right) is one example, and to have used complex camera techniques would have been gilding the lily. A low viewpoint framed the stunted bush against the sky, contrasting its spindly branches with the weight and solidity of the rock beneath. Setting exposure to suit the foreground ensured that the sky appeared a blank white. In a similar way, – but on a completely different scale – it's the contrast of bulk and fragility that gives the picture on the left its appeal. Here too viewpoint is important, because from further away, the rock merged with stones of a similar tone in the background.
Right: Hasselblad, 80mm, FP4, 1/60, f/11.
Left: Nikon, Plus-X, 1/60, f/8.

Subtle hues in fallen leaves *(overleaf)*

Though sunlight decorates the woodland floor with bright shapes, overcast conditions are usually equally good for showing colour, especially when the leaves have shades as subtle as these. To avoid colour shifts in dim woodland, try to make sure that exposures are no longer than 1/2 second – this may mean using one of the faster films in dull weather.
Nikon, 28mm, Kodacolor 200, 1/4, f/8.

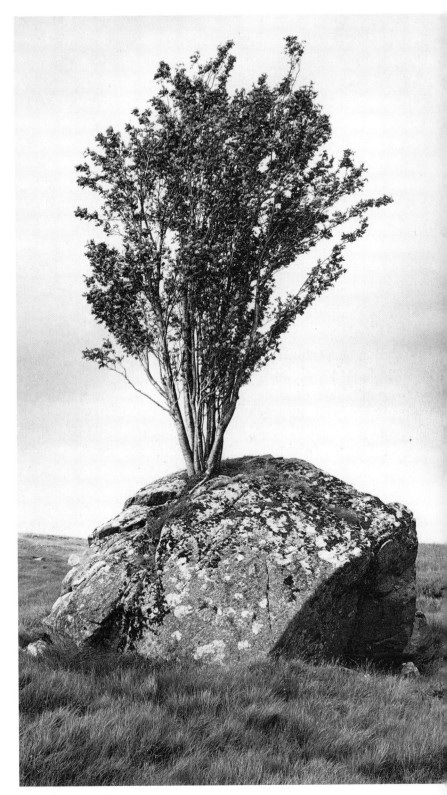

IN THE DESERT

Desert light is so harsh that you'll usually need to work hard to get good pictures. The key is to shoot early and late, not just because you thus avoid the hottest part of the day, but because morning and evening light show the most interesting faces of the desert. Much desert landscape is a featureless, arid wilderness, and towards the middle of the day, high sunlight only serves to exaggerate the lack of focal points. Around dawn and dusk, though, the sun casts long shadows that keep your pictures lively.

If you're photographing dunes, watch where you walk, and park vehicles carefully. This isn't for safety reasons: like snow, dunes look best when they're unbroken by footprints and tyre tracks. There's nothing more frustrating than climbing a high dune in burning sun, only to find that your own tracks mar the best possible composition.

KEEPING A COOL HEAD

Try to keep camera and film as cool as possible when you're working in a desert landscape. Leave film in a refrigerator or air-conditioned hotel room if possible, taking out only what you need for one day's shooting, and keep the day's stock of film in an insulated cool-box. Never leave equipment or film in a car, for the heat can damage film and potentially hardware as well. To avoid colour changes in film, you should process as soon as possible after exposure, and do not use "professional" film, because it has a shorter shelf life.

If you can't find shade on location, cover unused equipment with a white towel to reflect the sun, and if you hire a car, choose a light colour.

In very hot conditions, liquid crystal displays (LCDs) on cameras may fade and become illegible. This is a temporary problem, and the numbers will reappear when the camera cools.

▼ **Telling a desert story in pictures**
In a rock desert landscape, the almost featureless terrain makes composition a problem. One answer, illustrated in these images, is to explore in a picture story how people relate to such a hostile environment. Use long-shots (below) to give an overall impression of a low horizon reaching out to infinity. Closer views (below right) make figures less anonymous, but the flat horizon still dominates. Nikon, FP4. Below: 28mm, 1/125, f/8. Below right: 50mm, 1/60, f/11.

Shoot supporting pictures

If you plan to show a sequence of pictures – perhaps mounted up as a multi-print display – it's worth supporting the key photographs with some background images. An aerial view (above left) sets the scene, and shooting a well-side group at noon highlights the arid nature of the countryside. When sky dominates the image (left), use a polarizer or red filter to add tone. Nikon, FP4. Above left: 50mm, 1/250, f/5.6. Above: 35mm, 1/125, f/8. Left: 105mm, 1/60, f/8.

THE SEA COAST

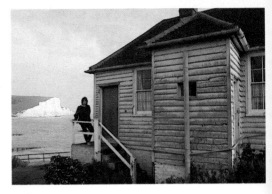

Sea-coast images provide special opportunities for the landscape photographer, because the ocean's surface magnifies and multiplies the effects of changing weather. On a fine day, the sea can look more attractive and inviting than anywhere on dry land; but in foul weather the battle between the elements has a primal drama that an inland storm simply cannot match.

When photographing coastal scenes, time of day is of crucial importance, but there are no hard-and-fast rules about when's best, and only day-by-day observation will reveal the pattern. Frequently, thick morning fog hides every detail of the coastline, but the rising sun clears the view; other weather patterns reverse the trend, so that you have to make an early start before sea mist rolls in.

Coastal conditions may be radically different from the weather just a mile or two inland, and if you need to drive a few miles to the coast, telephone the local coastguards before setting out, or you may find conditions impossible when you reach the sea. Don't just ask for the current conditions when you ring – things change quickly, so the outlook for the day is important, too.

Taking a sideways look
Some coastal views are so well known that it's hard to photograph them in an original way. Try making the famous view a detail, and add some foreground interest (above). Getting down to beach level (below) and exposing for the sky shows that the legendary white cliffs are not as pristine as they are reputed to be. And looking down with a wide- angle lens emphasizes the power of the pounding surf as it chips away at the cliffs.
Pentax, Fujichrome 100.
Above: 50mm, 1/30, f/8.
Below: 28mm, 1/60, f/4.
Right: 28mm, 1/125, f/8.

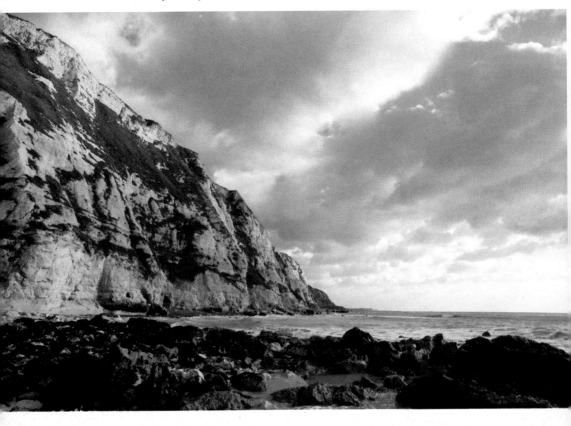

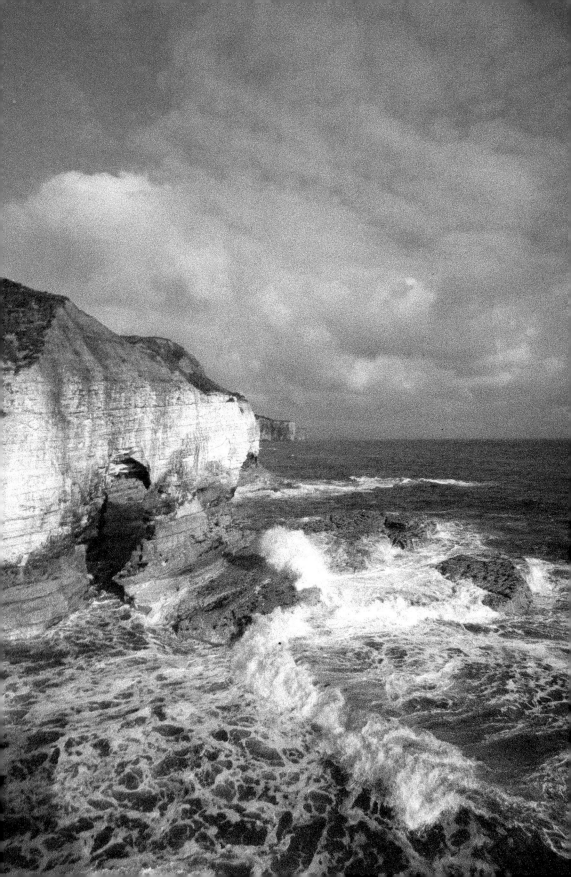

THE TIDES

Remember that time of day also dictates the state of the tide, and this in turn dramatically affects the appearance and accessibility of coastal landscape. Whether high or low tide most favours photography depends on the subject: river estuaries generally look better when the tide is in, hiding extensive mud-flats, and bringing feeding birds closer to the coast; on the other hand, high tide covers the beaches of attractive coves, making them little more than dull dents in the coastline. Knowledge of the tides is also crucial for safety: many small islands and rock plat-forms are accessible on foot at low tide, and totally covered six hours later, so the unwary photographer can easily be trapped.

Local newspapers publish the day's tides, but it's worth paying a little to buy tide-tables. These list tides for a considerable length of coastline, and usually also have the times of sunrise and sunset. If you don't have access to such published information, though, you can work out roughly the time of tomorrow's tides by adding 50 minutes to today's times.

THE FACE OF THE SEA

Tides control the level of the ocean, but wind, waves and sun animate its surface. You'll get the most spectacular pictures in high wind on a sunny day, when large waves throw themselves at the shore, and the sunlight catches the spray. On a still, over-cast day when there is merely a gentle swell the sea can look leaden and grey, and it's best to concentrate on cliffs, dunes, and other coastal features, rather than wasting

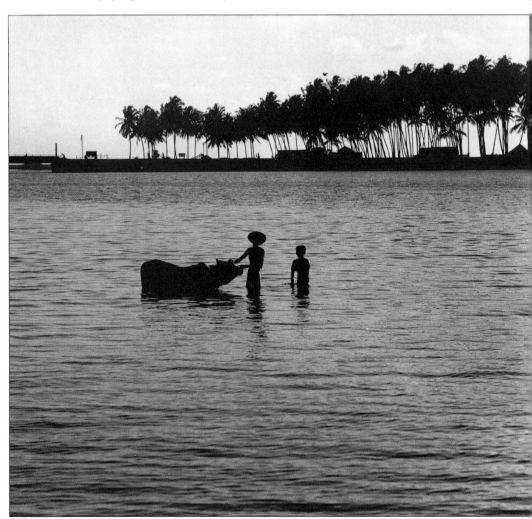

time trying to make a good picture featuring the water itself.

USING MAPS

Maps are an invaluable aid when photographing the seaside. Straight coastlines present limited compositional opportunities, since the land-based photographer looking along the coast always has the sea on one side, and the coast on the other. Using a map, you can pick out every promontory or peninsula that provides a view back towards the land, breaking this pattern.

Whatever the shape of the coast, you can always direct your camera out to sea. Images that feature only sea and sky may not seem interesting at first glance, but the ocean's many moods provide surprisingly wide scope for beautiful abstract images.

PROTECTING YOUR CAMERA

Salt spray and sand are the principal hazards on the sea coast. Use these guidelines to keep spray from damaging your camera.

■ Use a filter. Spray on the delicate optical surfaces can leave permanent marks. Fit a clear skylight filter over the lens for protection.

■ Remove splashes. Use a dry cloth or a tissue to remove salt water immediately.

■ Protect the camera. Remove the eyepiece lens and skylight filter, and put the camera in a clear plastic bag. Screw the filter and eyepiece back through the plastic to cut holes, then unscrew and remove the punched-out circles of plastic. Secure the holes at the front with a rubber band, and at the rear by replacing the eyepiece lens.

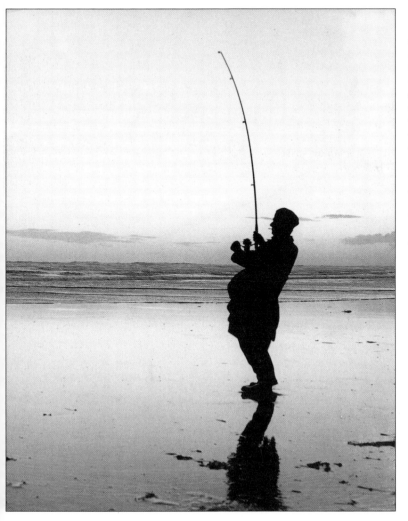

Coastal caricatures

Outlines simplify coastal subjects, and backed by the shiny surfaces of water and wet sand, making silhouettes is straightforward. Face the light, and measure exposure in the normal way. The backlighting will underexpose foreground figures (far left). In the darkroom, you can separately determine the tones of sky, sea and silhouette (left) by shading.
Far left: Rolleiflex, FP4, 1/125, f/5.6. Left: Hasselblad, 80mm, Tri-X, 1/250, f/11.

(Overleaf)
Revealing texture
In order to convey the power of the sea-battered coastline, it is best to include textural detail by exposing for shadow areas.
Nikon, 105mm, XP1, 1/250, f/11.

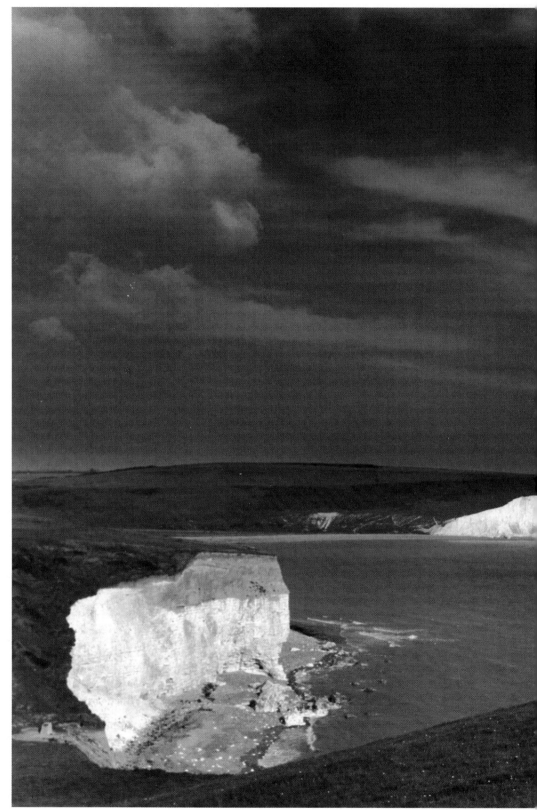

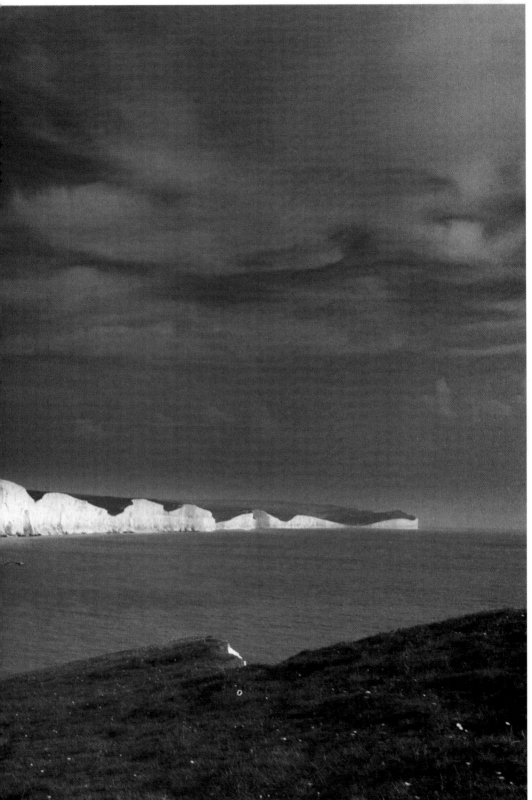

RIVERS AND STREAMS

In the life of a river you can find echoes of the human condition: near the source, the water chatters over the stones like a child at play; further down, the river bustles forward in a resolute, more adult way; and as it approaches the sea the wide waterway meanders like an old man past his prime.

This comparison in part explains why rivers, brooks and streams have an enduring fascination. The other aspect, though, is purely sensuous: moving water enchants the eye and ear. Such favourable connotations make a river an especially appealing subject for the landscape photographer, and you can add power to your pictures by trading on the associations of moving water. Seek out scenes suggestive of the life of the river as it runs from youth to maturity: wildlife on the banks; pools of flood water soaking gradually away in riverside fields; banks of shingle or sediment brought downstream by a storm.

Picturing the sensual aspects of the river requires less thought, but for the same reason, you run a greater risk of creating landscape clichés. By all means shoot the images that have direct and immediate appeal, but then look for details and angles that represent the watercourse in a totally new light. Vary viewpoint as much as possible, switching from a distant glimpse to close-up scrutiny. Look too for "different" perspectives, by pointing the camera directly down from a bridge or an overhanging branch; and perhaps use a polarizing filter to make the river's surface less noticeable, so that the viewer looks into the water, rather than at it.

▼ *Tones and printing*
Water scenes contain extremes of contrast, and how you deal with these widely different tones helps determine the mood of the resulting picture. Keeping contrast down with reduced development or soft paper helps to suggest tranquillity and calm.
Rolleiflex, FP4, 1/30, f/4.

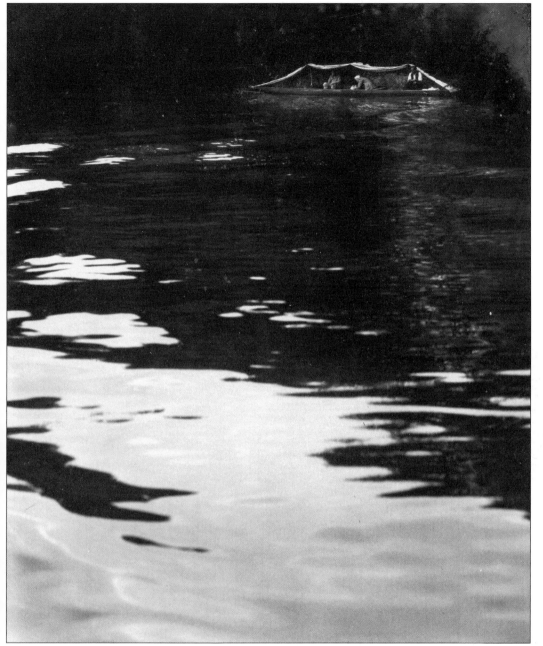

▲ **Framing the subject with water**

On a busy waterfront, interesting details often get lost in a confusion of activity. To frame subjects at the water's edge, tilt the camera down, and use the flowing shapes as an abstract foreground. In black and white, expose the negative for the principal area of interest, and then in the darkroom, use local exposure control to darken or lighten the water. Here the area surrounding the boat was heavily burned in. *Leica, 28mm, XP1, 1/125, f/8.*

ARABLE LANDSCAPES

Modern agricultural methods provide a scene that contrasts vividly with the idea many of us have of the countryside. Gone are most of the intimate and romantic settings, and, in their place, there are vast vistas of uniform, bright colour which sometimes clash dramatically with brilliant blue skies. Most crops are at their most colourful when ripe, so a little research pays dividends. The farming cycle depends on factors such as latitude and weather, so if you're prepared to travel, you may be able to choose when you take pictures.

To make the most of monoculture, try to exclude picture elements that detract from the overall composition: frame the field so that just one or two colours dominate the scene, then use other elements simply as accents. This is easiest with a long lens, which excludes most of the foreground detail, and flattens the scene into simple shapes.

Mixed arable farmland presents a different challenge. Some areas of the world have not seen the same revolution in methods that has turned some western farms into agribusiness, and where traditional ways remain, the smaller plots create an entirely different pattern. To capture the patchwork quality of the small fields, take pictures at harvest time: at the height of the growing season, the ripe crops make the landscape look very uniform. By contrast, as each field is cut and ploughed, the golden tapestry becomes patched with brown.

A PALETTE OF CROPS

Modern agriculture provides the photographer with a versatile palette. Traditional crops such as cereals provide pale green in early spring, ripening through the summer to darker shades. Fruit trees in blossom create riots of pale colours – usually green, pinks and other pastel shades. In warmer temperate regions oil crops create brilliant colours: sunflowers and oil-seed rape make flame yellows. The most colourful and varied

crops, though, are those grown specifically for their flowers: the brilliant purples of lavender, and the multi-coloured stripes of the Dutch bulb fields.

THE COUNTRY CODE

The best viewpoint for a landscape picture is invariably over the hedge in the next field, and there are bound to be times when you want to stray off the path to get a better picture. In many areas – particularly wilderness regions – there's little harm in this, but you should remember that open spaces are often a farmer's livelihood, and place of work. Always observe the Country Code, for respecting it will ensure continued goodwill for photographers that follow you.

- Respect the life and work of the countryside
- Guard against all risk of fire
- Fasten gates

- Keep dogs under close control
- Keep to public paths across farmland
- Use gates and stiles to cross fences, hedges and walls
- Leave livestock, crops and machinery alone
- Take your litter home
- Help to keep all water clean
- Protect wildlife, plants and trees
- Take special car on country roads
- Make no unnecessary noise

The Country Code is reproduced by permission of the Countryside Commission

◄ Picking the right lens
Viewpoint rather than focal length is what really controls how much of the landscape your picture includes, but choice of lens nevertheless influences the kind of pictures you take. A telephoto lends itself naturally to details of the landscape that might be missed in a wider scene (far left), especially if you use wide apertures to limit depth of field. By contrast, a shorter focal length encourages you to take a broad look at the farmland spread out before the camera (left). Far left: Nikon, 300mm, Tri-X, 1/60, f/4. Left: Pentax, 28mm, FP4, 1/15, f/11.

SEE · ALSO
The colourful landscape pp. 68-70
The changing seasons pp. 120-3
Filtration pp. 50-53

CHANNELS OF COMMUNICATION

Tracks, paths and routes perform two contradictory purposes inasmuch as, visually at least, they divide the landscape, and yet, at the same time, unite the settlements at either end. In your pictures you, of course, have the choice of whether you emphasize either one or both of these two functions.

Prehistoric routes follow rambling paths, tracing old field boundaries and connecting long-obliterated settlements. The rambling and apparently purposeless route of these paths is exactly their fascination, so aim for pictures that emphasize every twist and turn. Other old roads take a more determined course. Vanished empires of the past often built roads with autocratic precision, carving dead-straight lines across flat landscapes, and following contours exactly in hill country. Modern highways don't have the romance associated with Roman or Inca roads, but they still have a beauty all their own.

There are numerous ways to pick out the course of a channel of communication. If the route is ill-defined, you may find that a fall of snow makes the track clearer. Paved roads stand out especially prominently when the sun shines after a fall of rain – if you pick your viewpoint, you can show the road as a snaking river of gold. Don't be tempted to use a polarizing filter here – it would kill the reflections and deaden the image.

LIGHTING THE SCENE

The two techniques described above depend on unpredictable weather conditions, but you can highlight roads and highways any day simply by waiting until dark, and locking the camera's shutter open using the "B" or "T" setting. Headlights and tail-lights of passing traffic will then leave colourful trails, picking out the route. If you have time, start taking pictures just after sunset, then continue as light fades from the sky. With successively longer exposures, your pictures will show a greater profusion of lines.

An interesting exercise, if you are prepared to look carefully for your subject, is to compare ancient routes with their modern counterparts. In much of the developing world, but also still in Europe and North America, you can come across a delapidated road disregarded in favour of a nearby multi-lane highway. Such a juxtaposition can produce a poignant image as well as make a comment on the changing landscape.

◄ Leading the eye
*Paths, roads and tracks
can play a vital role in
guiding the viewer's
attention gently but
definitely towards the
subject of your choice.
This technique is
particularly effective
when the principal point
of interest occupies only a
small portion of the
frame, as in this example.
Try to avoid a totally
symmetrical composition
if possible: tracks snaking
in a little to one side of
the frame's centre create
diagonal lines that urge
the eye forward more
dynamically than plain
verticals running up the
middle of the picture. Set
a small aperture to keep
the path sharp along the
whole of its length and
use a wide-angle lens if
you have one, as this
shows more of the path
than a standard or
telephoto lens; when the
horizon appears at the
top of a picture shot using
a 20mm lens, the bottom
of the frame shows the
track directly at your feet.
Nikon, 24mm, FP4, 1/8,
f/16.*

SETTLEMENTS AND DWELLINGS

Like old roads, ancient patterns of settlement fascinate because you can still recognize the motives of the early inhabitants. In big cities the intentions of the founding fathers are obscured by centuries of "progress" but in a tiny village sited near a river ford, you can still see what drew people to the spot.

To catch this *raison d'être* in a picture, choose a broad view – preferably from a distant viewpoint higher than your subject. Spread out in front of the camera like a map, the landscape tells its own story.

Individual dwellings or small groups of buildings have other uses to the landscape photographer. The straight lines and right-angles of man-made structures provide a valuable foil for the organic, rolling lines of nature, whether the building is central to the image, or a speck on the horizon. Remember though that the orderly quality of man-made structures quickly commands attention, so keep the buildings relatively small if you want to avoid the landscape being dominated by man-made structures and the image turning into an architectural study.

▶ *Catching local style*
Domestic architecture reflects local needs and materials, so a landscape that incorporates a house instantly says more about the immediate environment. Don't let the building take over, though: use the background (top right) or the foreground (bottom right) to show the context. And when the shape of the house is

▼ *Scale and format*
When a domestic landscape is laid out on a grand scale, only a panoramic view will really do it justice. Take care, though, to align the camera with extreme care, as even a slight error easily causes parallel

what gives it charm, don't be afraid to emphasize the outline with unconventional framing (far right).
Top right: Canon, 105mm, XP1, 1/125, f/11. Bottom right: Nikon, 50mm, Tri-X, 1/30, f/8. Far right, Canon, 200mm, FP4, 1/8, f/5.6.

lines to converge wildly and ruin the symmetry of the scene.
Linhof Technorama, FP4, 1/8, f/16.

▶ Emphasizing geometry

To make the rigid straight lines of a building more emphatic, look for aspects of the landscape that epitomize chaos and disorder, such as these swirling patterns of grass and wild-flowers. Frame the scene from a distant viewpoint and use a telephoto lens of at least 85mm if you want to prevent parallel lines from converging.
Pentax, 200mm, Plus-X, 1/8, f/8.

Form follows function

Showing a dwelling in context is often the best way to explain its shape. Stepping up a hillside, the houses in the picture above save space, and keep each other cool. Shooting in the late afternoon showed the houses casting long shadows, and thus emphasized their function as rudimentary air conditioners. By contrast, the Scottish castle, right, plays a defensive role, and a low camera position at the loch side gives an impression of its commanding position and easily defended access bridge. Atmospheric perspective separates the castle from the hills behind.
Above: Pentax, 200mm, FP4, 1/125, f/11. Right: Canon, 105mm, Tri-X, 1/125, f/8.

Viewpoint and emphasis

The position from which you photograph a man-made structure profoundly affects how viewers will perceive its function in the landscape. Seen from the top, a Roman aqueduct channels the eye into the distance just as it once channelled water. But from below, the emphasis is on the arch, and on river traffic passing beneath the aqueduct.
Pentax, 28mm, Plus-X. Left: 1/250, f/11. Above: 1/250, f/8.

▲ Using shadows for separation

The turf roof of this house matched perfectly with the valley side in the distance, but lighting separates the two areas: when fading sunlight caught the far side of the valley, the roof appeared darker. The grey wall of the house provided a convenient mid-tone for a key exposure meter reading.
Minolta, 105mm, Panatomic-X, 1/125, f/5.6.

SEE · ALSO
Viewpoint pp. 64-7
How daylight changes the landscape pp. 124-7
Aerial perspective pp. 106-7

TOWNS AND CITIES

What is a cityscape? Personally, I feel that images of towns and cities become cityscapes when they make general points about urban areas, rather than specific comments about particular places. This distinction is purely subjective, though, and you may wish to draw the line somewhere different.

Making such generalizations isn't always easy, particularly when the city streets are crowded, and it's hard to see further than a few blocks. There are some sure-fire techniques you can use, though, to make sense of the city. The easiest is to seek out a large open space. Many cities sit astride rivers, and these provide the landscape photographer with golden opportunities. The river cuts a swathe through the tall buildings, and provides a cross-section of the architecture. Take along a wide-angle lens so that you can portray the whole skyline in a single pass, and a telephoto for distant details.

THE AERIAL VIEW

Looking down from above is another way to get a meaningful perspective. Most cities have a modern eyrie from which you can survey the roof-tops, and from there you'll get fine opportunities for cityscapes. The broad views from such points is usually well-known, so wait for a clear day, take a long lens again, and concentrate on small localities dotted around your high perch.

Sometimes you can find very effective generalizations in extreme close-ups of the city. Start by looking down at the ground beneath your feet: the man-hole covers, kerbstones and gratings of the city are worn smooth by a million feet and twice as many tyres, and the polished surfaces say a lot about the frenetic pace of urban existence. These insights may be peripheral to your main theme, but they nevertheless can be relied on to add interest.

Views in and out of the city often make successful pictures. When you're in town, look out for scenes in the distance that you can juxtapose effectively with the urban sprawl – a patch of vivid green, for example, sets off the greyness of the city streets. The opposite approach is equally successful. Drive away from the city, and you can look across fields at the stumps of skyscrapers rising in the shimmering distance.

CONTRASTING VIEWS

Cities and towns are full of contrasts, so don't neglect these as subject matter for your

▲ **Dim light and movement**
This scene presented me with a dilemma: brighter light would have hidden Liberty's torch and the lights on the tug; a long exposure would have blurred the boat. The only practical solution was to use high speed film. Nikon, 200mm, Kodacolor 1000, 1/125, f/4.

pictures. Building work goes on constantly, so it's never difficult to find the old standing shoulder to shoulder with the new. Other fruitful themes to explore are order and chaos, and the natural versus the artificial.

Don't put your camera away when the city-workers pack their briefcases and board the train for home. This is the time that the city puts on evening dress and assumes a completely new identity. To capture townscapes after hours you'll need a tripod and plenty of film, because the high contrasts of dark sky and bright lights make exposure metering very tricky. The best time to take pictures is at dusk, when there's still light in the sky; later at night there's a danger that the top of your pictures will appear pitch black. To get a starting point for exposure setting, put your camera on the tripod, and scan it across the city lights with the meter switched on. Then take the highest reading and open up the camera's aperture by one stop. Bracket exposures over a two-stop range to be sure of getting what you want.

◀ Long lenses to align landmarks

Long telephoto lenses let you juxtapose widely separated structures, but long focal lengths are disproportionately heavy and bulky. To save weight, pack a 2× teleconverter: though picture quality suffers when you combine a lens and converter, stopping down minimizes losses. Pentax, 135mm, Ektachrome 64, 1/250, f/8.

◀ Adding translucent subjects

City skylines look great when backlit, but you may not always want to render the foreground as a silhouette. To add detail and colour, include in the picture translucent objects such as these drinks. To set exposure, meter the highlight – here the water – and give at least two extra stops, or else use the "aim-off" technique (see p. 128). Nikon, 35mm, Ektachrome 64, 1/125, f/5.6.

◀ Optical illusion

Photograph trompe l'oeil murals like these in New York in weak sunlight to make them more convincing. In bright sun, painted shadows look too weak when seen next to the shadows of real buildings. Nikon, 35mm, Ektachrome 64, 1/30, f/8.

▶ **Big-city patchwork**
*The landscape of a huge
city like New York can't
be defined in such narrow
terms as a forest or a
field. In place of
hedgerows there are fire
hydrants; parked cars
replace contented cows.
To paint a comprehensive
picture of this concrete
and steel landscape, start
with the general, and
progress to the particular.
An overall view that
includes a really distant
horizon (near right)
makes a good starting
point, because from street
level, buildings usually
hide the horizon. Pick a
high viewpoint, and use a
telephoto lens to
compress subject planes.
Moving down to just
above street level
(opposite, top) paints in
the details with a smaller
brush, but again, a
telephoto is handy for
cropping out intrusions.
Sidewalk studies add a
human (and canine)
element, and here a wide-
angle lens makes grab
shots easier (opposite
centre). Finally, don't
forget to complete the
tapestry with some close-
ups (far right).
Pentax, Tri-X. Right:
200mm, 1/250, f/11.
Opposite top: 135mm,
1/125, f/8. Opposite
bottom right: 20mm,
1/125, f/16. Opposite
bottom left: 35mm, 1/30,
f/5.6.*

SEE · ALSO
Focal length p.19
Viewpoint pp. 64-7
Figures and structures
pp. 114-17

PARKS AND GARDENS

Urban parks and formal gardens provide limited opportunities for "natural" landscape photography within the context of the town or city. However, it would be foolish and contrived to exclude all evidence of the urban setting from such photographs. A more sensible approach is to deal with the park as a specialized form of urban landscape, perhaps by concentrating on the ironies of these small green oases set into vast deserts of grey concrete and tarmac.

You can also make very effective pictures in city parks by keeping one eye on the fringe of buildings, especially in modern cities, where very often the surrounding skyscrapers dwarf even the largest trees in the park. Equally, a view from the outside provides a valuable insight into what city planners think the landscape ought to look like!

GARDEN DESIGN

When you're framing these green oases in the city, you'll get better pictures if you spend a few moments analyzing the design of the garden, and the motives of the planner. Modern parks in cramped city spaces are often designed to be seen in their entirety during a brief visit, perhaps with small details such as waterfalls to charm the eye and ear. In such new parks, the best pictures are those that either show the whole environment in a single sweep, or crop in on close-ups of the small corners that get overlooked by lunchtime strollers.

Older parks were created with more generous proportions, to suit visitors with more leisure. The best way to walk round a mature formal garden is usually to stick to the widest and most well-trodden paths. These tracks provide the equivalent of grandstand views, and as you walk, you'll find yourself led through a succession of stage-managed vistas and set-pieces. Eighteenth and nineteenth-century garden planners used perspective to great advantage, so take a broad range of lenses with you: long lenses help to compress attractive avenues, and focus the viewer's attention on the subjects at the end of the walk – typically a fountain or statue. Wide-angle lenses on the other hand provide a panoramic look at the whole garden, much as you'd see it when you stand at the epicentre and turn your head from left to right.

Don't overlook people in city gardens: the formal structures of clipped yew and neat flowers can seem dry after a while, and a figure or two gives welcome relief.

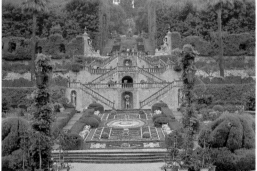

▲ **Two approaches to formality**
There are basically two ways to capture on film the structured environment of a formal garden: either emphasize the symmetry in your images, or choose a technique that introduces a discordant element. A figure (top) is a good way to break an over-rigid pattern, especially if you

also have the advantage of an unusual viewpoint, and an off-centre prop like this seat. Centring the camera on the axis of the garden (above) epitomizes the other approach.
Top: Pentax, 24mm, Ektachrome 64, 1/30, f/8.
Above: Nikon, 50mm, Fujichrome 50, 1/15, f/11.

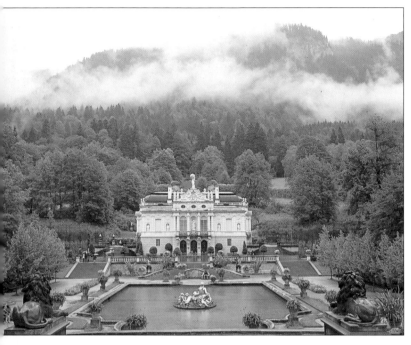

Showing the context

*Many formal gardens are
set in wild locations and
a broad view, taking in
both garden and
surroundings, adds a
grand perspective. Take
care with forested
backdrops, though (left)
as the dark tones can
easily lead a TTL meter to
overexpose the scene.
Meter from a mid-tone, or
use an incident light
meter. Don't ignore the
view from the "big-house"
(below). After all, this
was how the owner
viewed his estate.
Left: Pentax, 105mm,
Ektachrome 200, 1/30, f/8.
Below: Leica, 21mm,
Kodachrome 64, 1/15,
f/5.6.*

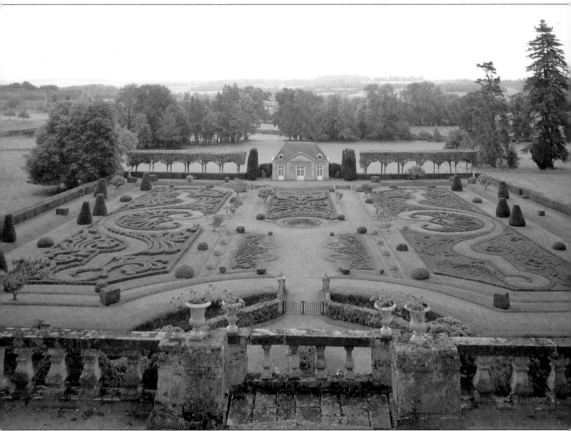

▶ *Lighting dew-soaked cobwebs*

Rise early to catch cobwebs picked out with dew; frame the web in sunlight against a dark background for maximum detail and contrast. Pentax, 100mm macro, Plus-X, 1/125, f/8.

Garden details

Often you'll find the best pictures in the unkempt areas of formal gardens, where nature soon reclaims control (below). When blooms and foliage contrast, you'll have little trouble separating them on monochrome film (right), especially if you print on harder than normal paper. But if flowers and leaves have similar hues they may merge together in black and white.
Below: Nikon, 55mm, FP4, 1/15, f/11. Right: Pentax, 85mm, Plus-X, 1/30, f/11.

LANDMARKS

Some landscape themes are universally familiar, and these special subjects present the photographer with either a head-start, or a challenge – or perhaps both.

The advantage of a famous landmark is that whoever looks at your photograph will immediately identify the subject. This means that there is no struggle for recognition, and no need to explain what the picture is about. Familiarity creates the challenge, too: these places have been photographed so many times that they have become tourist clichés.

To take successful pictures of landmarks you need to harness and control the "familiarity factor". Ironically, a good first step is to buy postcards, and see where everyone else stands to take the picture. Then you can pick some other viewpoint. Try also to think of new twists on the old theme: for example, most postcard views show famous places in holiday weather, with sunshine and blue skies; so try to visit the spot in different conditions – perhaps in rain or veiling mist.

Composition is another key factor. By all means take the usual general views, but then look for new ways of seeing the place – perhaps an unexpected background, or a tight close-up of a detail. The shape of the Great Pyramid, for instance, is so familiar that viewers can quickly spot it on a print, even when only the apex pokes up above a forest of taxis and TV aerials.

New approaches to age-old landmarks

The only way to innovate is to experiment, and it's significant that the three landmarks on this page are all instantly recognizable, despite having been photographed from the air, from behind and in silhouette. Occasionally, though, a conventional viewpoint, as in the picture on the right, does a landscape just as much justice.
Top: Pentax, 50mm, Ektachrome 64, 1/250, f/8.
Above: Nikon, 28mm, Kodachrome 64, 1/60, f/4.
Left: Nikon, 300mm, Fujichrome 50, 1/250, f/8.
Right: Minolta, 28mm, Kodacolor 200, 1/250, f/11.

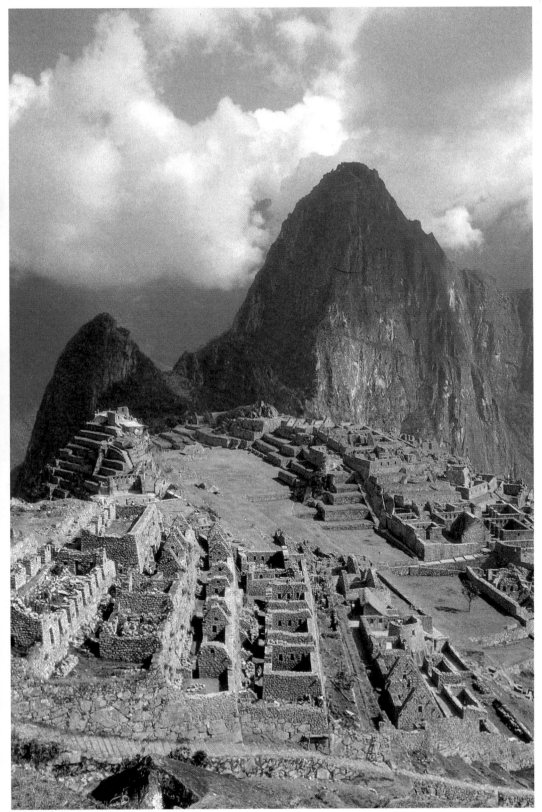

SIGNS OF LIFE

Figures and vehicles are valuable indicators of scale in landscape photographs: they help you express the vastness of the scene in a way that the viewer can understand. To use people in this way, though, you need to make them anonymous so that their personalities do not intrude. Do this by keeping faces out of the picture wherever possible: wait till people turn to face away from the camera before pressing the shutter release; make the figures tiny in the frame; or manipulate exposure to create a silhouette.

Moving figures and vehicles are useful in another way. They provide a sense of direction in the picture and lead the viewer's eye across the frame to a secondary point of interest. Things moving into the picture generally provide the most satisfactory and stable compositions, but if you're aiming for an unsettling or unconventional image you may prefer to compose the picture with the activity on the edge of the frame, moving away from the centre.

Figures and vehicles are sometimes seen as an unwelcome intrusion in a landscape photograph, especially in otherwise entirely natural scenes, but the human influence needn't be direct. Evidence of recent activity is less intrusive, but nevertheless dispels the sense of bleakness and isolation that wilderness pictures sometimes create. Look for tyre marks, footprints, stone cairns and perhaps the scorch marks of a recent fire. Vapour trails from high-flying aircraft provide a potent symbol of the modern age, especially when they cross primeval emptiness.

▼ *Using scale*
Placed solidly in the foreground, everyday objects become part of the landscape. Here the eye jumps between the figures and the industrial complex, while the empty pushchair has a slightly ominous feel. A small aperture was needed to keep everything sharp. Nikon, 35mm, Tri-X, 1/60, f/11.

▶ *Filters for emphasis*
Filtration is a valuable way to bring chosen subject elements into prominence. A red filter, for example, darkened the blue sky and grass, so that the tracery of washing lines in the foreground stands out like flapping bunting on a fête day. Pentax, 28mm, FP4, 1/125, f/11.

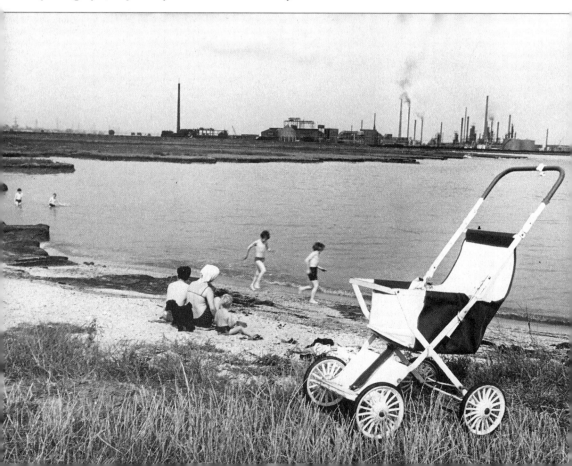

▼ **Making enigmatic images**
Landscape pictures needn't be self explanatory, because unanswered questions intrigue the intelligent viewer. This enclosed pool was itself a puzzle: is the barbed wire there to keep out the inquisitive? Or does it fence something in? Choosing a low viewpoint reflected the clouds in the pool's surface, making the water look almost inviting. This seductive quality was enhanced by careful printing.
Olympus, 35mm, FP4, 1/60, f/11.

Ship shapes

It's hard to resist decorating the landscape with small boats when the opportunity arises: they have a pleasing symmetry and sense of orderliness that is made more emphatic by the bustle of a natural landscape, as at left. For this photograph, the technique of shading with a static dodging tool created the pale line that separates shore from hillside. The curving lines of boats are especially pleasing when the landscape includes both organised and disorderly elements. The gondolas in the picture above contrast with both the angular lines of Venice behind, and with the organic shapes of their stakes. Crouching near water level to take the picture above left gave a duck's eye view of the wildfowlers' punt and its low lines.
Left: Pentax, 35mm, Plus-X, 1/30, f/8. Above: Minolta, 50mm, XP1, 1/125, f/8. Above left: Pentax, 200mm, Tri-X, 1/60, f/5.6.

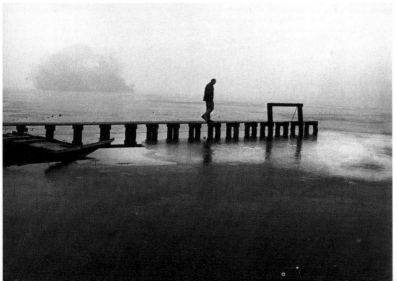

Printing and detail
Complex subjects need to retain detail if the picture is to be "legible". The field above was a mess of mud, but a light print on hard paper makes sense of the scene. By contrast, simple subjects (left) are easy to read even when heavy printing hides the detail.
Above: Rolleiflex, Tri-X, 1/30, f/5.6. Left: Nikon, 105mm, FP4, 1/30, f/4.

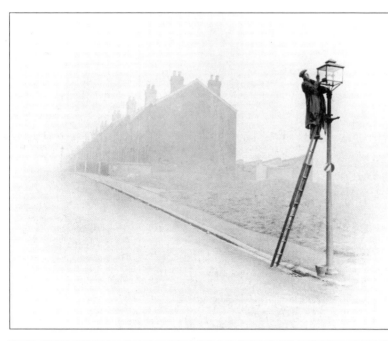

◄ Adding impact with shading
Local exposure control is usually used to add detail to shadows or highlights, but in an extreme form, dodging and burning in can totally alter the emphasis of a picture, as in the shot on the left. Here, shading all but a small area of the print for 80 percent of the exposure time has vastly reduced the importance of the background landscape, focusing attention on the figure. Enough of the landscape remains, though, to provide a context for the man's outmoded task.
Nikon, 105mm, FP4, 1/125, f/8.

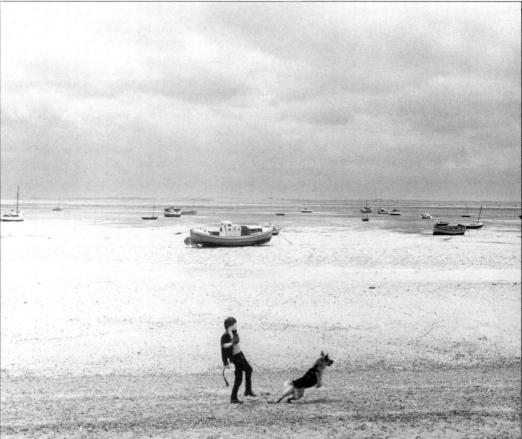

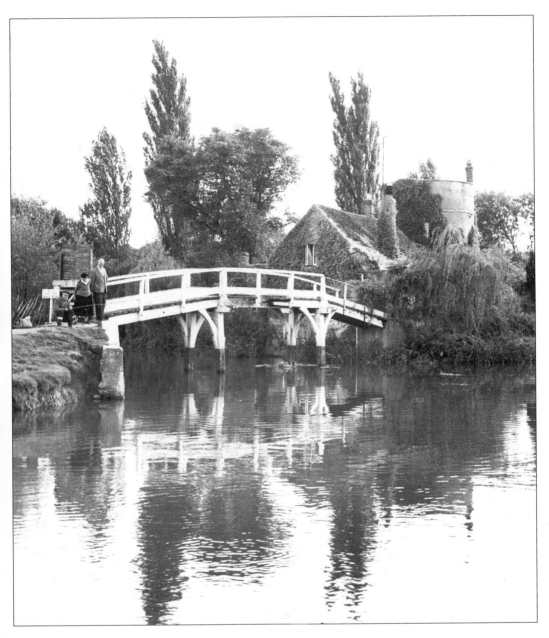

◄ Activity brings the landscape to life

A static, flat landscape that would look dull on its own, springs suddenly to life when you inject a little activity. The vigorous antics of this boy and his dog make a dramatic counterpoint to the total lack of animation behind, and careful selection of shutter speed gives a sense of movement and tension without sacrificing important detail in the subject. *Pentax, 135mm, Tri-X, 1/15, f/11.*

▲ Building bridges

The role played in a photograph by bridges, roads, and other lines of communication closely parallels the function of these things in real life. Here the viewer's gaze crosses the bridge from one side of the picture to the other, tying together the house and the figures on the left of the frame. Extra negative exposure "cleaned up" the grubby white paint on the timbers of the bridge. *Rolleiflex, FP4, 1/30, f/8.*

INDUSTRIAL LANDSCAPES

Industry creates its own mountains – of steel, brick and glass, and often belching smoke and steam. These "dark, Satanic mills" have themselves inspired plenty of poetry and prose in the past and they certainly make a worthy subject for the camera.

Don't be afraid to let your opinions show in the images you make of factories and industrial areas. You may choose to convey a condemnation of industrial sprawl or you may see evidence of a lifestyle that pulsates with energy and has a magic all of its own.

There's beauty and drama even in oil refineries and ship-yards: towering cranes and spiralling pipes create powerful graphic shapes against the sky, especially when they're picked out with lights against the night sky. Take along a wide-angle lens if you have one, and a polarizing filter if the sky is blue. At night, choose film balanced for tungsten light if you want floodlit areas to appear in their natural hues.

However, don't feel bound by convention when an industrial scene is lit by several different light-sources. At dusk in particular, you can make very striking pictures by exploiting the differences in colour of the fading daylight and the various lamps. Shot on daylight film, sky just after sunset appears a rich blue; tungsten lamps (ordinary light bulbs) look a warm yellow; mercury-vapour lights appear in shades of blue and green; and sodium lamps come out a monochromatic orange. When two or more of these light sources illuminate even simple subjects such as oil storage tanks, they create dramatic coloured patterns. Experiment with filtration, and bracket exposures over a wide range, using a meter reading from the sky as the starting point. If you're not confident about exposure, use negative film, which is more forgiving of exposure errors than slide film.

Juxtapositions and contrasts can make industrial scenes look especially striking so you should keep your eyes open for incongruous details that you can use to add irony or pathos to your images. For example, some industrial developments such as oil refineries pose a potential risk to people living nearby, so they are generally surrounded by a cordon of wasteland or green fields. Wildlife

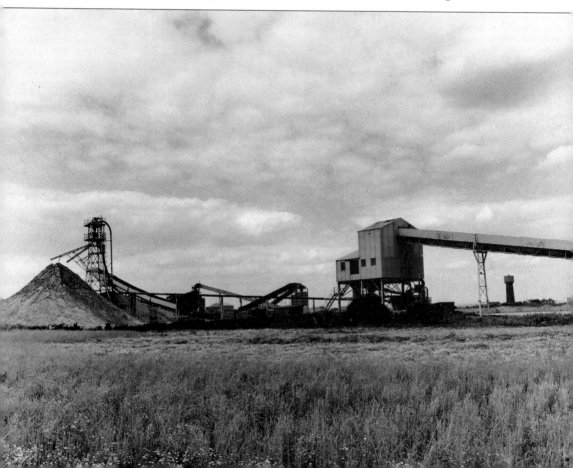

thrives in these areas, and on pastureland, livestock graze contentedly; both make ironic foregrounds for a panorama of soaring chimneys or factories. To bring the two subject elements together, use a telephoto lens, and spend time moving round the subject until you get the juxtaposition you want – a car is virtually essential.

MINES AND QUARRIES

Mining and quarrying operations are considered by many to create massive blots on the environment, frequently in areas of exceptional natural beauty. Nevertheless, there are ways to turn even the ugliest of sites to your advantage. Quarrying exposes a bedrock that is usually quite different in colour to the topsoil and vegetation above, and the borderline between the two surfaces provides a striking and unusual feature. This is especially true when quarrying operations make clean and regimented cuts through the rock, in contrast to the sometimes random growth of vegetation and foliage above. Though the scale of such digging operations seems vast from the foot of the quarry or slag heap, they are puny by comparison with the natural forces that shape the earth.

If you're proposing to photograph on commercially-owned land, take care to outline: why you want to make the pictures; what the images will be used for; and what benefits might accrue to the owner. Don't be surprised if you're asked to sign an insurance disclaimer absolving the company from responsibility for accidents, and be prepared for restrictions on time, and what you can and cannot photograph.

▼ *Monochrome realism*
Colour film tends to make even unpleasant subjects look glamorous, so black and white is perhaps a better choice when you want to give an impression of pithy realism. Composing the picture below left with a foreground of wild-flowers suggests the intrusion of quarrying in a rural landscape. In the picture below, choice of a low camera angle made the railway track and crane's jib and chain form a broken triangle, which creates tension in an otherwise quiet image. Below left: Hasselblad, 80mm, Tri-X, 1/125, f/8. Below: Canon, 50mm, Plus-X, 1/125, f/8.

▶ *Printing to enhance geometry*

Variable-contrast printing paper provides an extra control over the appearance of landscape prints. Not only can tone be controlled locally, but contrast as well. For example, atmospheric perspective reduces the contrast of distant scenes, but has little effect on the foreground. As a result, you might want to print the foreground on a soft grade of paper, and the background a grade harder, as in this example. With variable contrast paper, such as Ilfospeed Multigrade, you can do this by simply exposing each area of the print through a different filter, so that the contrast of the background is raised to match that of the foreground.
Nikon, 200mm, Tri-X, 1/60, f/8.

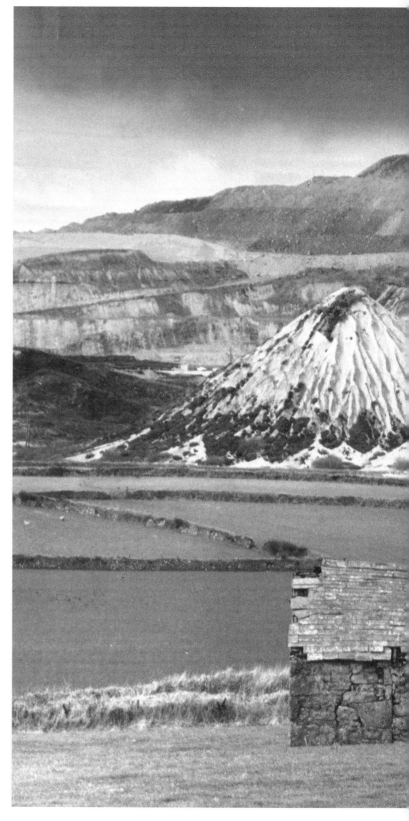

SEE · ALSO
Control in black and white
pp. 44-7
Converging lines pp. 110-11

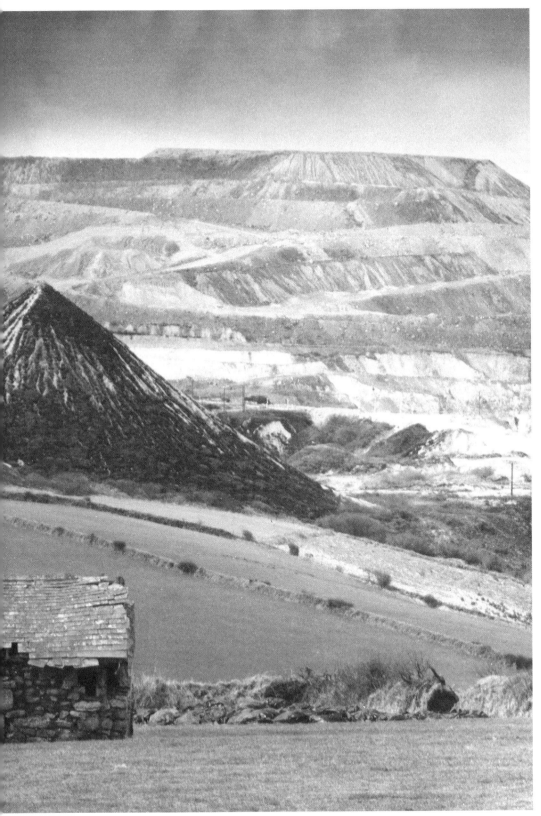

▲ Finding wit in everyday landscapes
Every photographer should make room for a little humour. Railways are a textbook example of parallel lines converging at infinity, and diverging tracks provide an
opportunity to make a gentle joke at the expense of those who take perspective theory too seriously.
Hasselblad, 50mm, Plus-X, 1/60, f/8.

▶ Putting back the shine
Cobbles on the "Auld Brig" at Ayr have been polished by the passing of millions of weary feet, and shooting the bridge so that it is backlit by the sky picks up the lustre on
the stones and iron rails. Printing the photograph on hard paper enhances the shine.
Nikon, 28mm, FP4, 1/15, f/8.

GLOSSARY

Aerial perspective Tendency of objects to look progressively lighter and bluer with increasing distance.

Aperture Variable-sized hole formed by blades of the DIAPHRAGM in a camera lens. Used to control EXPOSURE.

Aperture priority Exposure control system in which the photographer sets the aperture, and the camera picks a shutter speed that will yield correct exposure. See also SHUTTER PRIORITY.

ASA Abbreviation for American Standards Association: system for measuring film speed that is numerically equal to, and now superseded by, the ISO system.

Autofocus Method of automatically focusing camera lens without manual intervention from the photographer.

B setting See BULB SETTING.

Backlighting Form of lighting in which the principal light source shines directly towards the camera.

Bleach Chemical used to reduce density of negatives or prints. Made by mixing 10 per cent Potassium Ferricyanide and 20 per cent Sodium Thiosulphate solutions just before use. Thorough washing follows bleaching.

Bracketing Taking additional pictures at exposures above and below the optimum setting to improve chances of an acceptable result.

Bulb flash Form of flash photography using disposable bulbs containing fine metal wire that burns to create a brilliant light.

Bulb setting Shutter setting, often marked as "B" on the shutter speed scale, that causes the shutter to stay open as long as the shutter release remains pressed.

Camera movements Relative movements of lens and film used to control shape and distribution of sharpness in the image. Only LARGE-FORMAT CAMERAS have such movements, though PERSPECTIVE-CONTROL LENSES offer limited movements on smaller cameras.

Chrome See REVERSAL FILM.

Chromogenic film See DYE-IMAGE FILM.

Clip test Method of checking correct exposure by processing short length of transparency film in advance of the rest of the roll. Density of the balance is adjusted if necessary by PUSHING or PULLING.

Close-up lens See SUPPLEMENTARY CLOSE-UP LENS.

Colour balance The colour of light that will yield natural-looking results when used to expose any given film. See also TUNGSTEN LIGHT BALANCED FILM and DAYLIGHT BALANCED FILM.

Colour cast An overall wash of unwanted colour usually covering the entire film area. Generally caused by exposure of film in incorrect lighting conditions.

Colour conversion filter Filter used on camera lens in order to expose film in lighting conditions for which it was not manufactured – for example, DAYLIGHT BALANCED FILM in TUNGSTEN LIGHT.

Colour correction filter Filter used to make small corrections to colour rendition when using TRANSPARENCY FILM – for example, to prevent a blue COLOUR CAST when taking photos in overcast weather.

Colour temperature System of expressing the colour of the light falling on the subject, or the colour balance of the film. Bluish light sources such as blue sky have a high colour temperature; reddish light such as candles have a low colour temperature. Colour temperature is measured in KELVINS.

Contrejour See BACKLIGHTING.

Contact sheet Print made by exposing sheet of photographic paper in contact with negative(s). With small format film, this is a useful way to produce a small reference print of every frame on the roll.

Contrast Difference in brightness between the lightest and darkest areas of the subject, negative, transparency or print.

Databack Device for imprinting date, time, or number on the film at the moment of exposure.

Daylight (balanced) film Film with a COLOUR BALANCE suitable for taking pictures in daylight or with electronic flash. See also TUNGSTEN LIGHT BALANCED FILM.

Dedicated flash "Intelligent" flash unit that exchanges information with the camera, to set the FLASH SYNCHRONIZATION SPEED or to measure

exposure through the lens.

Definition Measure of how faithfully the camera has recorded fine details of the subject in a photographic image.

Density Measure of the darkness or paleness of a photographic image.

Depth of field The distance between the nearest and farthest parts of the subject that will appear acceptably sharp on film.

Diaphragm Circle of sliding blades inside a camera lens arranged to form a variable-sized APERTURE for the control of exposure.

DIN Abbreviation for Deutsche Industrie Norm, a measure of film speed now superseded by ISO.

Diopter Measure of the magnifying power of a lens. In photography, generally used only to specify strength of SUPPLEMENTARY CLOSE-UP LENS or EYESIGHT CORRECTION LENS.

Dye-image film Black and white film such as Ilford XP1 that forms an image using coloured dyes rather than the metallic silver of conventional film.

Emulsion The light sensitive coating that actually forms the photographic image on film.

Exposure The amount of light that reaches the film in the camera. Exposure is controlled by the brightness of the image falling on the film (which is in turn controlled by the APERTURE); and by how long the shutter is open – the SHUTTER SPEED.

Exposure latitude The film's tolerance for exposure levels greater or less than the optimum.

Exposure modes Different ways of setting exposure, such as SHUTTER PRIORITY or APERTURE PRIORITY.

Eyesight correction lens Simple lens fitted over the camera eye-piece to make the viewfinder image clearer for photographers with imperfect vision.

f-number Measure of APERTURE: small apertures have a large f-number such as f/22. Large apertures have small f-numbers such as f/2.

f-stop See STOP.

Field camera Type of LARGE-FORMAT CAMERA that

folds down into a lightweight, portable form, making it especially suitable for landscape photography.

Fill-in flash Use of flash in daylight to illuminate shadows and reduce CONTRAST.

Film speed The sensitivity of the film to light. Measured using the ISO scale.

Filter Glass, plastic, or gelatin sheet fitted over the camera lens to control the colour or other qualities of light reaching the film.

Filter factor The amount of light absorbed by a FILTER.

Flare Unwanted pale areas on a picture caused by components within the camera or lens reflecting bright light sources.

Flash synchronization The firing of a flash unit at the exact instant when the shutter is fully open.

Flash synchronization speed The fastest speed at which a FOCAL-PLANE SHUTTER simultaneously exposes the entire film area – and therefore the fastest speed at which flash can be used.

Fluorescent light Light formed by a continous electric spark within a gas-filled enclosure. See also INCANDESCENT LIGHT.

Focal length A measure of the field of view of a lens. Lenses with short focal length take in a wide field of view, and vice versa.

Focal-plane shutter Common form of shutter in which opaque blades or blinds are positioned just in front of the film. At faster speeds the blades form a slit that travels across the film, exposing portions of the image sequentially. See also LEAF SHUTTER.

Focusing Movement of the lens towards or away from the film so that a selected part of the subject appears sharp.

Focusing screen Matt glass or plastic screen in the camera, on which an image of the subject appears. Used to monitor focusing and composition.

Fog Overall unwanted exposure of the film to light.

Grain Granular, gritty texture of silver or dye particles that appears when pictures are greatly enlarged.

Grey card Piece of card that reflects exactly 18 per cent of the light that falls on it, used as a reference

tone when included in a picture, or to measure INCIDENT LIGHT with a REFLECTED-LIGHT METER.

Guide number (GN) Measure of the power of a flash unit, determined by multiplying the subject distance by the aperture that will yield correct exposure. Powerful flash units have high guide numbers.

High-key Type of image dominated by light tones. See also LOW KEY.

Highlight Brightest parts of a subject or picture.

Hot shoe Accessory shoe incorporating electrical contacts for FLASH SYNCHRONIZATION.

Hyperfocal distance Closest distance at which subjects are sharp when the lens is focused on infinity. Setting the lens to the hyperfocal distance produces the maximum possible DEPTH OF FIELD at any given aperture.

Incandescent light Light formed by heating a metal filament to a high temperature.

Incident light Light falling on the subject, as opposed to light reflected from it.

Incident-light meter Meter held at the subject position and facing the camera in order to measure light falling on to the subject and thus determine the correct exposure irrespective of subject reflectance.

Infinity Lens setting for subjects a great distance away. Marked with a ∞ symbol on the camera lens.

Internegative Intermediate negative made from an image on REVERSAL FILM, and used to make a print.

IR Abbreviation for INFRARED.

Iris See DIAPHRAGM.

ISO Abbreviation for International Standards Association, and measure of FILM SPEED. Films that are very light-sensitive (fast films) have a high ISO rating, and vice-versa.

Kelvin Unit of colour temperature. Reddish light such as candle-light is rated low on the Kelvin scale.

Key reading Exposure meter reading from the most important area of the subject.

Large-format camera Any camera that uses individual sheets of film, rather than rolls or cassettes.

Latent image The invisible image formed on film by the action of light, and revealed by subsequent processing.

Leaf shutter Type of shutter incorporated into the camera lens, comprised of several blades which open to expose all areas of the film simultaneously. See also FOCAL PLANE SHUTTER.

Lens Curved glass or plastic element that focuses an image of the subject on the film.

Lens hood Device used to shade the lens from light sources outside the field of view, thus preventing FLARE.

Lens shade See LENS HOOD.

Low-key Description of image that is dominated by dark tones. See also HIGH KEY.

Macrophotography Generally, the photography of small objects.

Macro lens Lens designed to give optimum results at close subject distances.

Mid-tone Any part of the subject or image that has a brightness falling mid-way between the HIGHLIGHT and SHADOW areas.

Mired Measure of the colour of a light source or of the COLOUR BALANCE of film. Numerically equivalent to the COLOUR TEMPERATURE divided into a million.

Mirror lens Compact and lightweight type of TELEPHOTO LENS that forms images using a combination of mirrors and conventional refracting lens elements.

Modes See EXPOSURE MODES.

Neutral Density (ND) filter Grey filter used to cut down the amount of light reaching the film, without affecting colour.

Normal lens See STANDARD LENS.

Panchromatic film Black and white film that is equally sensitive to all colours of the spectrum. Virtually all modern camera films are panchromatic.

Parallax error Error in framing or composition caused by the fact that the viewfinder of a non-SLR camera is slightly displaced from the lens that takes the picture.

Perspective-control lens Lens that can be moved at right angles to its axis, to change the field of view without turning the camera.

Photomontage The assembly of a picture using elements chosen from several other pictures.

Polarized light Form of light in which the waves vibrate in a strongly directional manner. Usually created by reflection from a surface. See also POLARIZER.

Polarizer/Polarizing filter Filter that cuts out POLARIZED LIGHT, to eliminate reflections, darken skies, and enrich colours.

Pulling Deliberate underdevelopment of film to increase DENSITY.

Pushing Deliberate overdevelopment of film to reduce DENSITY.

Reciprocity failure Loss of FILM SPEED causing underexposure when exposure time exceeds about a second. On colour film reciprocity failure also creates COLOUR CASTS.

Reflected-light meter Any meter that measures light reflected from the subject. Light meters integrated into cameras are all of this type. See also INCIDENT LIGHT METER.

Refraction Bending of a ray of light as it moves from one transparent medium into another in which light travels at a different speed.

Reversal film Film that creates a positive image directly, without an intermediate negative stage.

Roll film Film wound on a spool with a paper backing; generally produces negatives or transparencies 2¼in (60mm) wide.

Selective focusing Deliberate use of shallow DEPTH OF FIELD to restrict sharpness and thus direct the viewer's attention to one particular part of the picture.

Shadow In photographic terms, the darkest part of the image – even when this is not a shadow in the conventional sense.

Sheet film Large piece of film, generally 4×5in

(100×125mm), exposed individually in a LARGE-FORMAT CAMERA.

Shift lens See PERSPECTIVE-CONTROL LENS.

Shutter Device used first to prevent light from striking the film until the photographer presses the shutter release, and then to control the duration of the exposure.

Shutter priority Exposure control system in which the photographer sets the shutter speed, and the camera picks an aperture that will yield correct exposure. See also APERTURE PRIORITY.

Shutter speed Actually not a speed at all, but the time for which the shutter remains open, measured in seconds or fractions of a second.

Single-lens-reflex (SLR) Type of camera in which one lens is used both for viewing and composition, and for taking the picture.

Slave unit Compact electronic device that makes possible cordless SYNCHRONIZATION of several flash units.

Slide film See REVERSAL FILM.

SLR See SINGLE-LENS-REFLEX.

Speed See SHUTTER SPEED and FILM SPEED.

Spot meter Exposure meter that measures the light reflected from a very small portion of the subject.

Standard lens A lens that has a focal length roughly equal to the length of the film diagonal.

Stop Generally, a comparative measure of exposure, one stop representing a halving or doubling of the light reaching the film.

Stop down To close the APERTURE to a smaller setting.

Substitute reading Measurement of the light reflected from a convenient area which has the same tone as the subject, where this is itself inaccessible.

Supplementary close-up lens Simple lens fitted over the main camera lens, in order to reduce the minimum focusing distance.

Synchronization See FLASH SYNCHRONIZATION.

Synchronization speed See FLASH SYNCHRONIZATION SPEED.

T setting See TIME SETTING.

Teleconverter Device fitted between the main lens and the body of an SLR to multiply the FOCAL LENGTH, usually by a factor of between 1.4 and 2.

Telephoto In general terms, any lens that forms a bigger image on film than a STANDARD LENS.

Time setting Shutter setting that starts the exposure when the shutter release is pressed, and ends it when the release is pressed again, or the shutter speed dial is turned to a new speed. Usually marked with a "T".

Transparency film See REVERSAL FILM.

TTL Abbreviation for through-the-lens.

Tungsten light Form of INCANDESCENT LIGHT using a tungsten filament.

Tungsten (balanced) film Film manufactured to give natural colours when exposed to subjects lit by TUNGSTEN LIGHT.

Ultraviolet radiation Radiation that forms a continuation of the visible spectrum, but to which the human eye is insensitive. Ultraviolet radiation can cause FOG or COLOUR CASTS on film.

UV See ULTRAVIOLET.

Wide-angle lens Any lens that takes in a broader field of view than a STANDARD LENS.

X setting Shutter speed setting marking the maximum FLASH SYNCHRONIZATION SPEED.

Zoom lens Any lens with a variable FOCAL LENGTH.

INDEX

STOCKTON - BILLINGHAM

LEARNING CENTRE

COLLEGE OF F.E.

ACKNOWLEDGEMENTS

Illustrators: Stephan Chabluk, Andrew MacDonald, Janos Marffy

Manufacturers: Olympus (UK) Ltd, 2-8 Honduras Street, London EC1Y 0TX

Additional photography: Alastair Laidlaw (pp. 10-11)

Associate writer: Richard Platt

Editor: Richard Dawes

Art editor: Tim Foster